# ICELAND

18 km

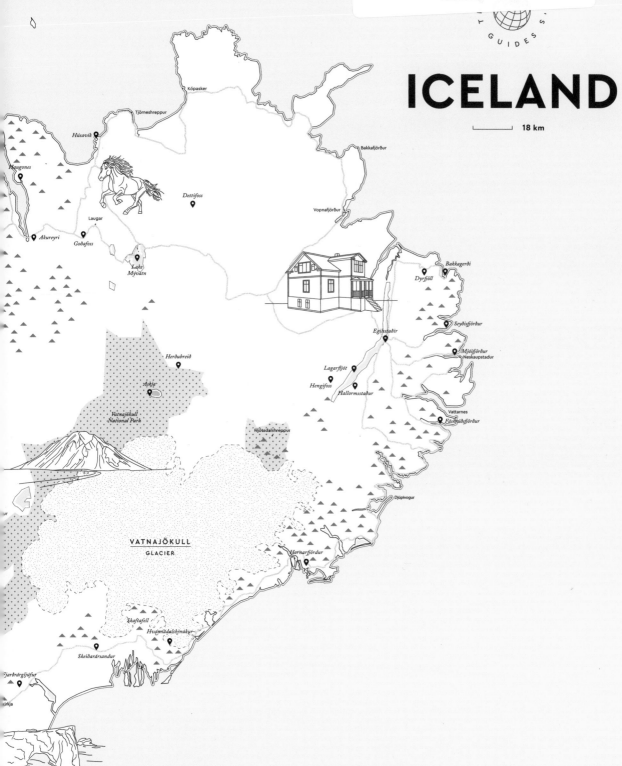

Kópasker

Tjörneshreppur

Húsavík

Bakkafjörður

Haugones

Dettifoss

Vopnafjörður

Laugar

Akureyri

Goðafoss

Bakkagerði

Lake
Mývatn

Dyrfjöll

Herðubreið

Seyðisfjörður

Egilsstaðir

Askja

Mjóifjörður
Neskaupstadur

Lagarfljót

Vatnajökull
National Park

Hengifoss

Hallormsstaður

Vattarnes

Fáskrúðsfjörður

Fljótsdalshreppur

Djúpivogur

VATNAJÖKULL

GLACIER

Hornafjörður

Skaftafell

Hvannadalshnúkur

Skeiðarársandur

Fjarðrárgljúfur

kirkja

# STUNNING ICELAND

THE HEDONIST'S GUIDES

+ THE HEDONIST'S GUIDE +

# STUNNING
# ICELAND

BERTRAND JOUANNE | GUNNAR FREYR

Harper
DESIGN

An Imprint of HarperCollinsPublishers

# INTRODUCTION

Iceland is situated just south of the Arctic Circle, between North America and continental Europe, a location many would describe as the edge of the world. Puzzling and paradoxical, this remote island of just over thirty-eight thousand square miles (one hundred thousand square kilometers) was created from the convergence of the mid-Atlantic ridge, and an enormous amount of magma erupting from its rift onto the sea floor, beginning about twenty million years ago. The last eruption happened in March of 2021 and lasted for more than six months, becoming the longest eruption in the country in the past fifty years.

As *Homo sapiens* began wandering about seventy thousand years ago, Iceland was one of their last conquests: Discovered in the seventh century by Irish monks, the island was not sustainably exploited until the ninth century by settlers from Norway, the Vikings, bringing along their Celtic slaves and livestock. These first inhabitants called it Snæland ("Land of Snow") before definitively naming it Iceland ("Land of Ice"). Starting with them, Iceland entered into history, although recent discoveries have shown that the Greek navigator Pytheas had landed on the island in the fourth century BC.

In AD 930, several farmers on the island created an assembly of free men, the Althing, which met in the open air in Þingvellir to establish laws and settle disputes. It is to them that the country owes the establishment of the Þjóðveldisöld, the Icelandic Commonwealth, and the adoption of Christianity as the official religion in the year one thousand. But the bad soils, barely twelve thousand years old, and the struggle with an inhospitable land of ice and snow quickly overshadowed this independence. A rapid deterioration in living conditions instigated feuds among great families who eventually passed the island to the control of the king of Norway in 1262. A century later, in 1380, Iceland and Norway became part of Denmark. Subject to the absolute power of the Danish rulers, who gradually took over the monopoly of trade with the island, Iceland eventually sank into a dark period of isolation spanning seven centuries, during which the Commonwealth disintegrated and Icelanders turned inward toward themselves, living more than ever at the edge of the world. From that point forward, Icelandic history can be summed up as a relentless struggle against natural disasters, epidemics, and famine.

Despite this economic decline and misery, Iceland was a land of exceptional literary activity. The first settlers had brought poetry with them, which was ideal for oral transmission. Then came the age of writing and the beginnings of the "Icelandic miracle" stories. The first handbook of grammar of the Icelandic language was written in the twelfth century, followed by the *Landnámabók*, the "Book of Settlements," and the *Grágás*, a collection of laws. Next followed the era of sagas, a literary genre that appeared at the turn of the thirteenth century, which combined historical reality and fiction from oral traditions. By the time these began to be recorded, the golden age of the Icelandic Commonwealth had come to an end. The novelist Patrick Chamoiseau nevertheless notes their importance, indicating that their language and stories allowed the Icelanders to survive through the centuries and to continue to open themselves up to the world, even during the country's worst moments. These sagas were, in short, their treasure, connecting them to each other.

During the second half of the nineteenth century, Iceland struggled for independence under the leadership of Jón Sigurðsson, now a national hero. In 1843, the Althing was restored. The island peacefully gained autonomy in 1874 to control their internal affairs, then gained independence in 1944. Undoubtedly, none of this could have been accomplished without the development of the fishing industry. For a thousand years, Iceland had remained a sheepherding civilization. During this period, fishing, which was a very risky venture, had changed very little. The arrival of Norwegian and Danish shipowners, however, allowed the country to gradually modernize and build a powerful fishing industry. During the Second World War, the arrival of the British and then the Americans definitively initiated the country's recovery and anchored it to the modern world, allowing it to develop an impressive educational, health, and social system.

The rebirth of the island during the twentieth century coincided with its second golden age of literature as well as the emergence of other forms of artistic expression, the foundation of modern Iceland's cultural life. In this respect, the famous singer Björk became the island's most memorable ambassador. Managing an ancient yet young nation, Icelanders resolutely looked toward the future, influenced by both its past and present.

At the beginning of the twenty-first century, Iceland had a prosperous economy, but the global financial crisis of 2008 hit it hard, forcing the country to nationalize its three largest banks and to seek help from the International Monetary Fund (IMF). Icelanders had to contend with a series of drastic events: layoffs, wage cuts, and

significant reductions in social budgets, all leading to massive emigration of its youth. Worsening the situation, the eruption of Eyjafjöll in March 2010 caused several ripple effects on European and world air travel. It was then that the tourism industry, until this point still in its infancy in Iceland, became a lifeline. Playing on its status as a land of adventure, the country developed a welcoming infrastructure. In 2012, six hundred seventy-two thousand tourists ventured into the land of the Vikings, doubling the population of the country! Since then, the numbers have continued to grow, to the point that tourism has now become one of the pillars of the Icelandic economy.

Now that Iceland is a hyperconnected country returning to growth, many questions arise about the future of this independent nation of three hundred fifty-five thousand inhabitants. What will be the effects of climate change on its landscape? How will Icelandic authorities cope with the influx of tourists (two million in 2017!) to avoid disastrous consequences to the environment? What will happen to a language spoken by only three hundred thirty-five thousand people, with a bilingual youth that has abandoned its traditional sagas and literature in favor of Netflix and video games in English? What will become of the island the day public authorities deem it too costly to defend? And finally, what will the Icelandic society of tomorrow look like?

Thirty years ago, foreigners accounted for just over one percent of the population, compared with twelve percent today. The majority come from eastern European countries, with the Polish accounting for almost forty percent. Iceland has become an El Dorado for many, situated on the edge of the world. Foreigners now occupy almost twenty percent of jobs. Icelanders welcome them and are not surprised that their island has become a land of immigration after having been a land of emigration for a long time. The explanation is quite simple. Long left to their own devices and isolated for a very long period of time, Icelanders knew to seize, with great enthusiasm, the opportunity that was offered to them at the turn of the twentieth century to leave behind their indigent past. They are a people who love to work, and anyone who comes looking for a job is welcome. They move forward resolutely and never question technical progress or modernity, because they are aware of how far they have come in a century. It is never easy to grasp the soul of a people. But it is without question possible to say that to be Icelandic today, apart from speaking the same language, is to be resolutely individualistic within a specific framework, where the sense of community is important to maintain the upper hand over a capricious and unstable natural environment where nothing is assured. And if there is a sense of collective anguish, it would be the fear of returning back to isolation.

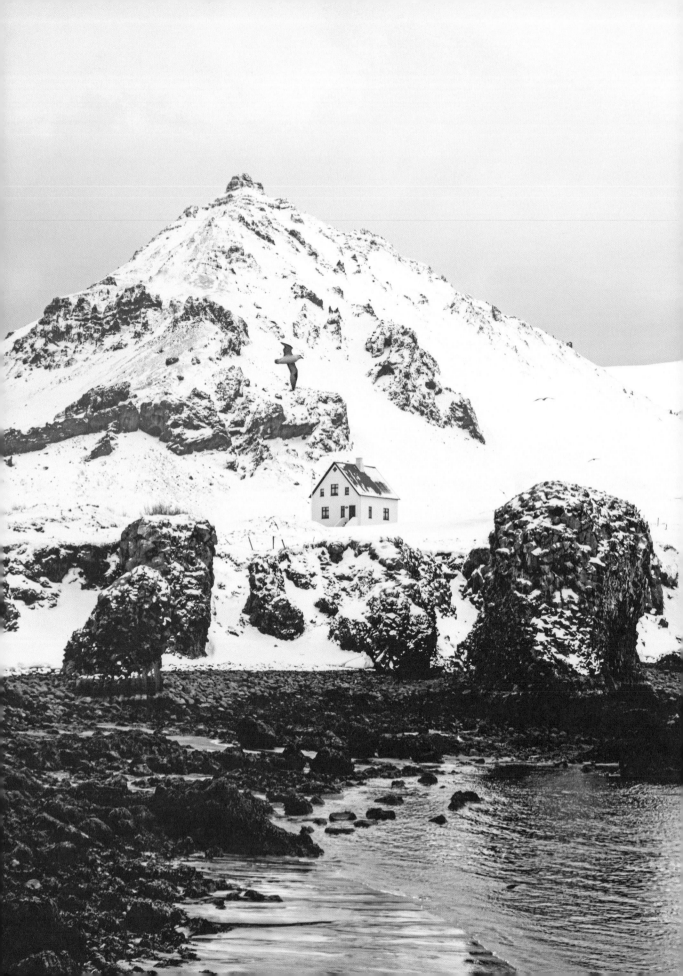

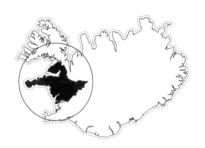

ACTIVE LAND

# THE WEST

On a clear day, a long mountain range,
which remains snow-covered for most of the year,
is visible against the horizon just a few dozen miles outside of
Reykjavík. It ends at its furthest point at Snæfellsjökull,
a glacier-capped volcano towering majestically in the distance.

P. 10

*A small house in Arnarstapi in the middle of winter. Behind it rises Stapafell,
a volcanic mountain of subglacial origin.*

RIGHT

*When the fishing industry was booming, Iceland had many wooden docks,
such as those of the Hvalfjörður.*

In 1864, Jules Verne chose the summit of Snæfellsjökull, a glacier-capped volcano, as the starting point for his famous novel *Journey to the Center of the Earth.* Closer to home, the Icelandic writer Halldór Laxness featured this lonely giant and its environs. The tip of the peninsula on which it is located is believed by many to be one of Earth's seven chakras, a physical place where the planet's energy is concentrated, as many travelers claim to experience a sense of soothing calm when arriving here.

This part of Iceland, made up of lava reefs beaten by the surf, serves as a link: It connects the south coast of the Snæfellsnes peninsula, with its long beach of golden sand lined with meadows studded with several farms, to the north coast, with its succession of small fjords and bays where a few fishing villages are lined up, opening to the Breiðafjörður Bay, the "wide bay," scattered with large and small islands. It is here where the clear nights of endless circumpolar summers experience a sunrise followed, in the blink of an eye, by sunset, and where the shrill cry of arctic terns and the cacophony of kittiwakes fill the crystalline sky, only to be interrupted by the flapping wings of the snipe and the noisy cry of the oystercatcher.

Humans quickly took possession of this region, which was easy to access compared to so many other places in Iceland. They also settled inland in the valley at Reykholt. The valley was appreciated for its fertile soils as well as the abundance of geothermal springs. Today, greenhouse crops are fed by these natural hot springs, which also provide a soothing source for a moment of relaxation for visitors. And though still amid farms, the landscape's proximity to the capital has encouraged the construction of many wooden chalets that serve as vacation spots where travelers can conveniently recharge their batteries for just a weekend or the holidays.

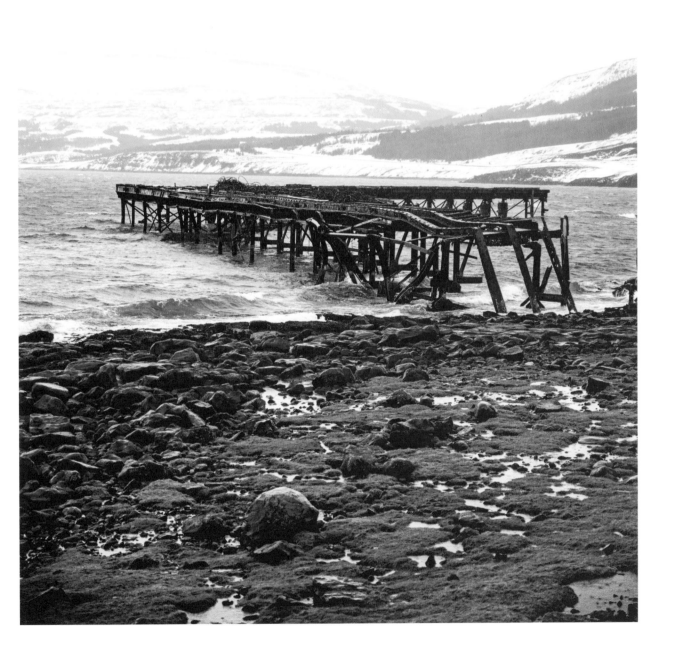

# THE ESSENTIALS

## 01

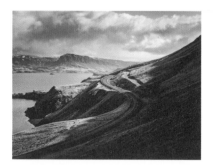

### HVALFJÖRÐUR

The northern lights can be seen from this fjord located just north of Reykjavík. Its landscapes are an excellent introduction to the region.

## 02

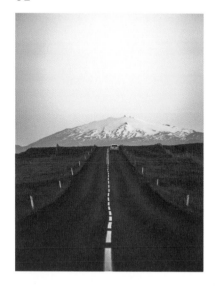

### SNÆFELLSJÖKULL

This glacier-capped volcano, immortalized by Jules Verne in *Journey to the Center of the Earth*, could disappear quickly under the effects of climate change.

## 03

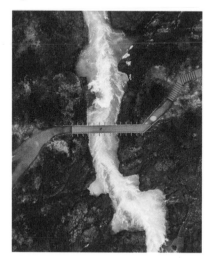

### BETWEEN BARNAFOSS AND HRAUNFOSSAR

This footbridge allows you to admire these two waterfalls and access the vast lava field that borders them.

## 04

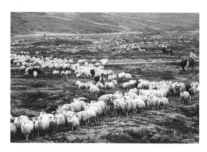

### FLJÓTSTUNGA

September marks the season of sheep-herding. This immutable spectacle is resistant to modern ways.

## 05

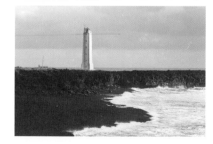

### MALARRIF LIGHTHOUSE

Begin a walk along the peninsula here, bordered by beautiful reefs carved by the beating surf, to the black-sand beach of Djúpalónssandur.

## 06

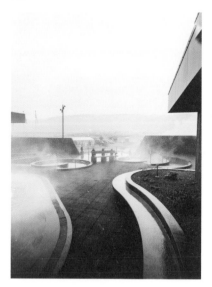

### DEILDARTUNGUHVER

At the Krauma baths, you can enjoy the pleasures of both hot and cold waters, just like the first inhabitants of the island.

07

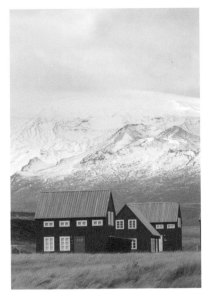

### HELLNAR

In this hamlet at the foot of Snæfellsjökull, black timber houses, such as those of Danish traders, serve as vacation rentals.

08

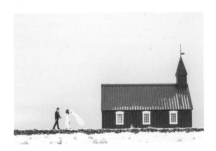

### BÚÐARKIRKJA

In every type of weather, this small black timber church charms, lending itself to daydreaming.

09

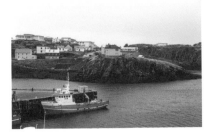

### STYKKISHÓLMUR

The ferry *Baldur* heads to points north across Breiðarfjörður Bay from this port, located on the north coast of the Snæfellsnes peninsula.

10

### AROUND ARNARSTAPI

Between Arnarstapi and Hellnar extends a coast made up of reefs and basalt columns.

11

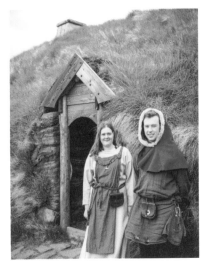

### EIRÍKSSTAÐIR LIVING MUSEUM

This museum reenacts the daily life of the first settlers from Norway and their Celtic slaves from a thousand years ago.

12

### BJARNARHÖFN

As in the past, sharks fished from Greenland are hung on this farm, respecting a centuries-long Icelandic tradition.

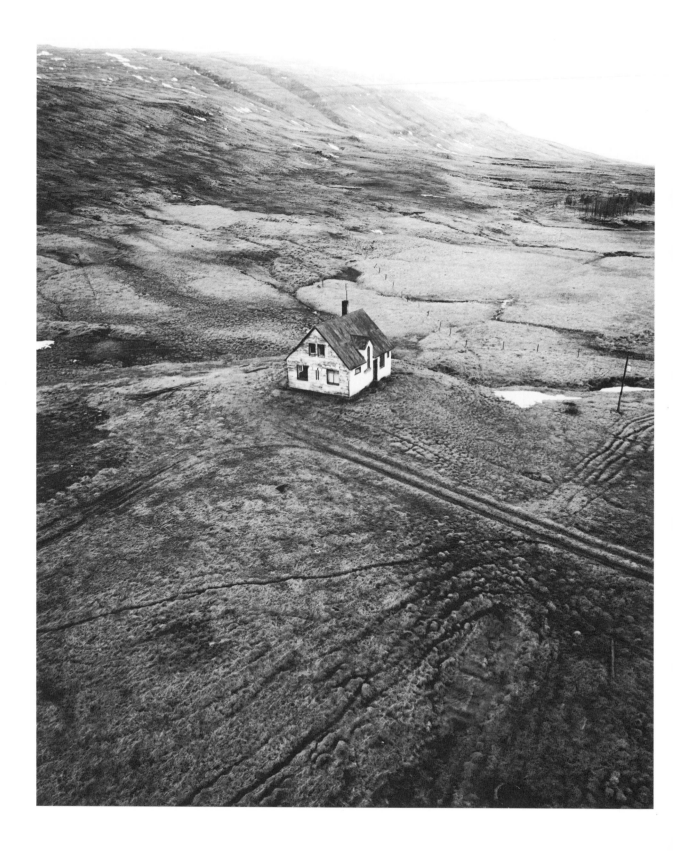

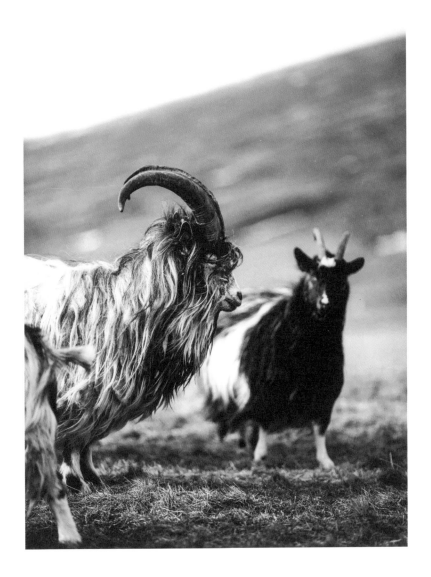

**ABOVE**

*Goats arrived from Norway with the first settlers. There were 3,000
on the island in 1930 and three times fewer by 2012.*

**LEFT**

*This abandoned farm in Lundarreykjadalur is an
example of rural Iceland.*

# THE LAND OF SAGAS

**Asking Icelanders to talk about the history of their country can leave them uncertain about where to begin. . . .**

Iceland's history can be broken down into two important eras: the glorious times of the age of the Icelandic Commonwealth of the first three centuries, after the arrival of the first settlers from Scandinavia; and its modern history, starting with the struggle for independence beginning in the second half of the nineteenth century. Between these eras stretched seven centuries. Originally they were considered a dark time for the island, but in recent years historians have reexamined this time period and now view it as something more than just a long pause in the country's history.

Arriving in Iceland, settlers brought with them an already rich culture. Their stories, whether religious, secular, or epic in nature, were passed down through the generations by way of oral communication, and when stories are transmitted in this way, the language used becomes rather poetic. People tell the stories, through time, according to strict metrical styles. This creates powerful texts such as those of the *Poetic Edda*.

Next came the age of writing, the beginning of what has been called the "Icelandic miracle." As early as the eleventh century, one of the leading authors of medieval Iceland, Ari Fróði Thorgilsson ("Ari the Wise"), wrote *Íslendingabók*, the "Book of Icelanders," which recounts the beginnings of the history and Christianization of the country. He also participated in composing *Landnámabók*, the "Book of Settlements," which describes precisely,

albeit briefly, the settlement of the first four hundred inhabitants of the island. This was followed, during the same century, by the writing of an Icelandic book of grammar, written anonymously. A century later the *Grágás*, a collection of laws, was printed.

Icelandic literature began to emerge with the birth of sagas. When they were beginning to be written down, the golden age of the Commonwealth was ending. Christian scribes documented the heroic deeds of pagan heroes. These great prose narratives trace the history, habits, and life of medieval Iceland and take place over several generations. Unknowingly, these scholars recorded on their parchments Icelanders' greatest treasures, creating an original genre within world literature. The declining golden age of the Icelandic Commonwealth corresponds to the golden age emerging from Icelandic literature.

Copies of manuscripts were copied again and appeared through the ages, revealing remarkable writers such as Snorri Sturluson (1179–1241), or tracing the lives of illustrious characters, such as the Viking poet Egill Skallagrímsson. The famous *Saga of Burnt Njáll*—whose protagonists are Gunnar of Hlíðarendi and Njáll, their wives Hallgerður and Bergþóra, the sons of Njáll, and many others—describes a bloody battle that takes place over fifty years. For those who want to experience them up close, these characters are still present within the cultural landscape of the island.

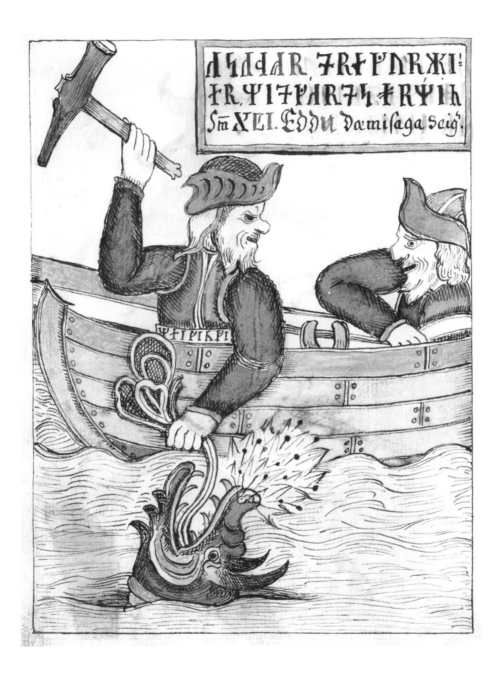

Thor and the giant Hymir catch the Midgard Serpent in this illustration from the *Poetic Edda*, taken from the *Codex Regius*.

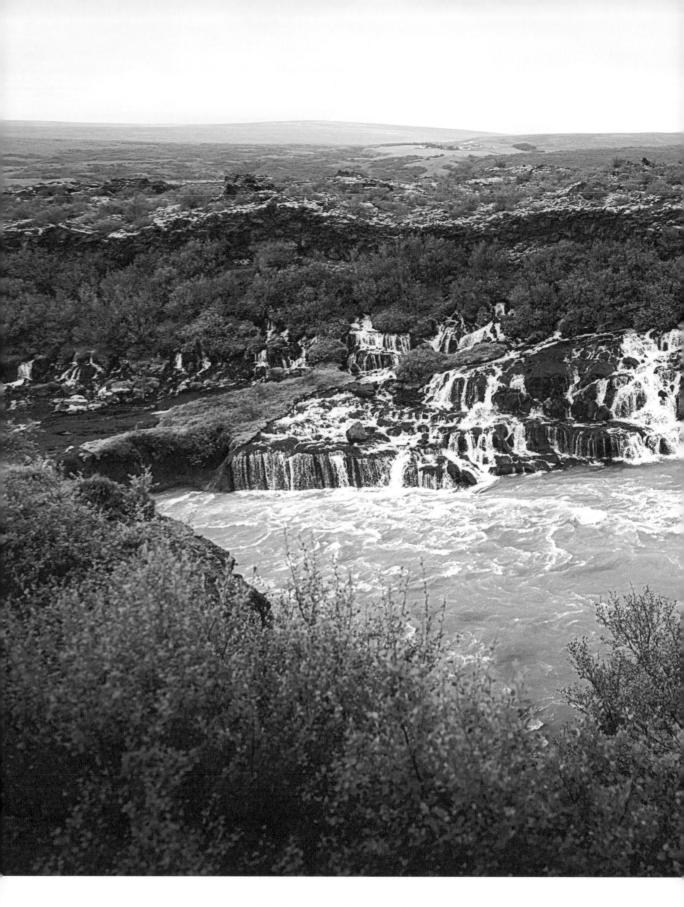

*The clear waters of Hraunfossar flow over the*
*Gráhraun lava field and into the Hvítá river.*

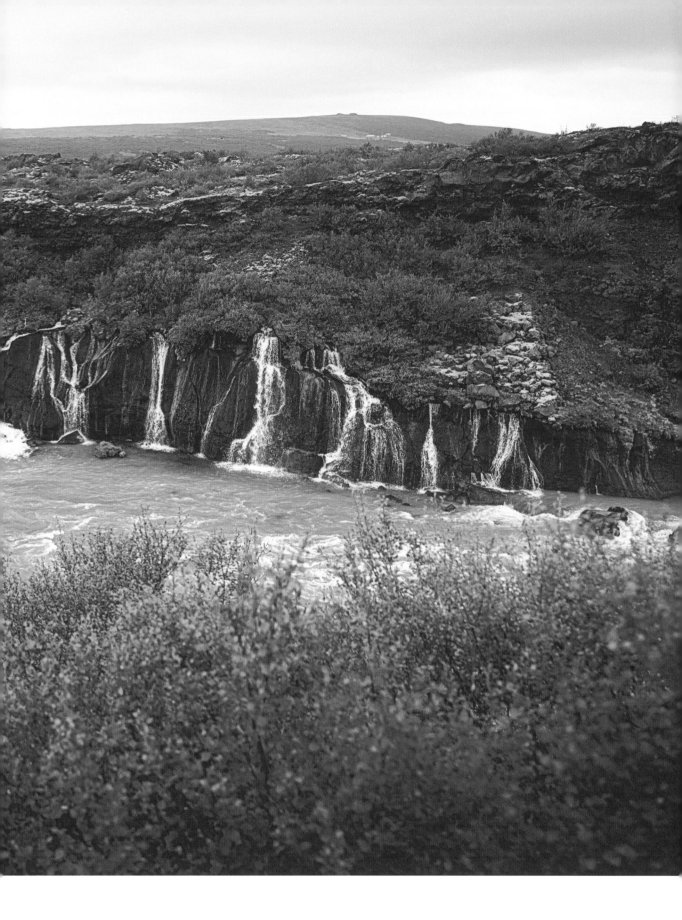

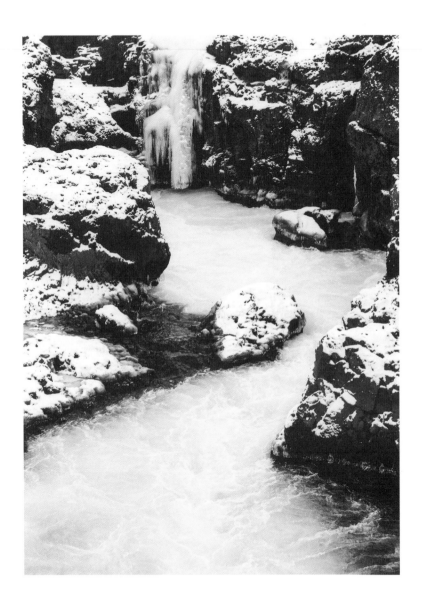

**ABOVE**

*The name of Barnafoss (the "Childrens' Falls") comes from a legend that
two children fell and drowned here.*

**RIGHT**

*To cross Barnafoss, a wooden bridge replaced the natural
lava bridge, which had collapsed.*

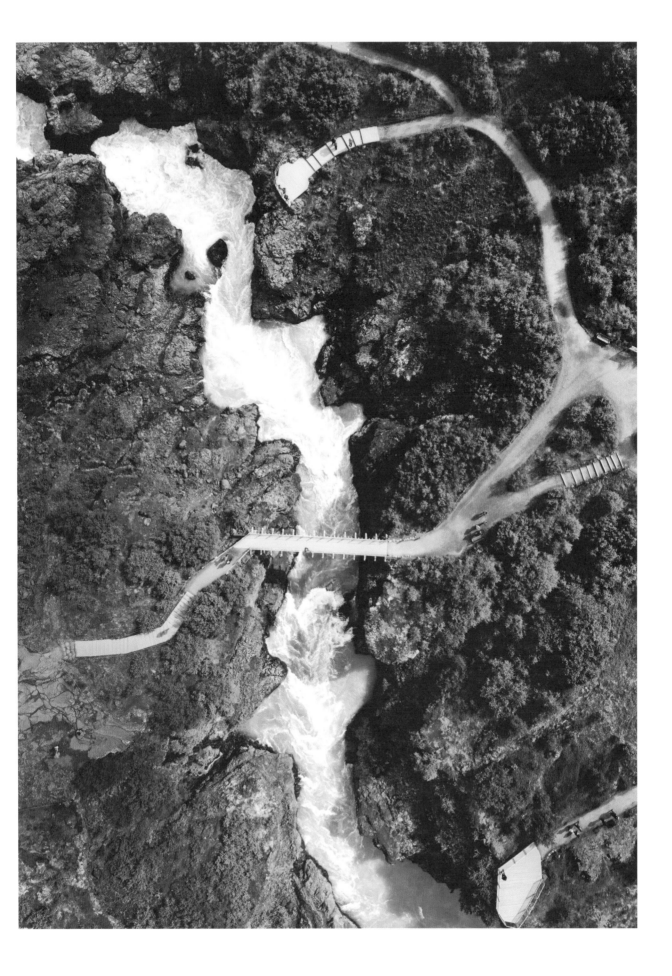

PROFILE

# PÁLL GUÐMUNDSSON

## SCULPTING NATURE

**Páll Guðmundsson is one of those artists who is viscerally attached to his birthplace, almost as if his feet were as firmly planted in place as the Húsafell stone.**

Everyone can agree that Páll's home, nestled at the bottom of a glacial valley with groves of arctic birches marking the entrance to a desert of rock, water, sand, and ice, is inspiring; it's a place where two worlds collide. Like many Icelanders, Páll lives at the edge of the habitable world.

Páll left the valley in the 1970s to study at the Academy of Arts in Reykjavík, then moved to Germany to learn all the intricacies of sculpture before returning home. While some carve marble, Páll sculpts the erratically placed blocks left behind by retreating glaciers. He sculpts these blocks into what he sees in them. In other words, he "reads" nature. His sculptures are a matter of revealing to the eye what the stones' forms suggest and inspire, often reminiscent of images from ancient folklore.

He quarries his stones from the small canyon of Bæjargil above Húsafell farm. Here, he unearths various shapes of stone he may also find in tones of blue and red. Like the ancient Vikings who, to make their boats, cut trees where they grew, he sometimes carves a stone where it lies. It is therefore not unusual for hikers to come face to face, in some places, with a totemic face frozen in rock.

Páll is proof that, although one may be but a mere sculptor, it is possible that an artist—at a time when humans have walked on the moon and dream of doing the same on Mars—can perpetuate a millennia-old connection to our planet and remind us that, within each of us, lives a child of nature. But the question remains: For how much longer?

Connecting sculpture to music is but a small step artistically, and Páll was inspired to sculpt a "stone harp." The Icelandic writer Þorbergur Þorðarson claimed that stones spoke. Páll Guðmundsson shows us that they also emit sound. The country's iconic band Sigur Rós affirmed this by teaming up with him for a concert held in the Surtshellir lava cave.

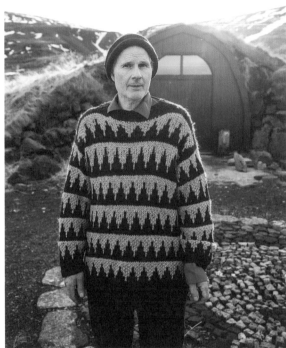

## A RAW MATERIAL OF STONE

Gathered pebbles, small stones, irregular-size blocks—any type will do for Páll as long as the material is stone.

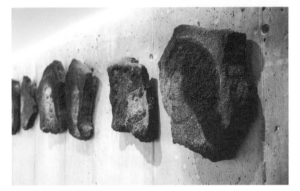

### PÁLL IN FRONT OF HIS STUDIO

Páll's workshop mixes genres: the half remains of traditional turf houses as well as partially remaining bunkhouses from the Second World War, with their rounded shape.

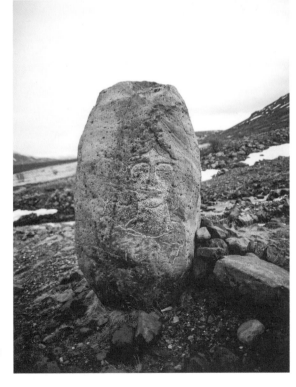

ABOVE

*At a flow rate of 48 gallons (180 liters) per second, Deildartunguhver has the most powerful flow of any spring on the island. The water temperature reaches 212°F (100°C).*

LEFT

*In autumn, sheep begin their trek alone to the plains before being herded in the districts.*

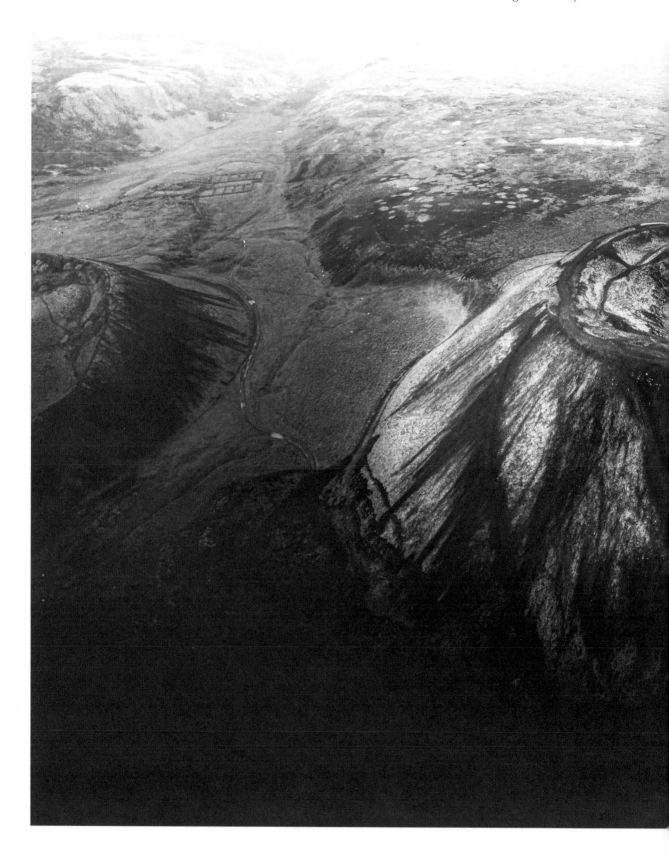

*Around 3,400 years ago, the Grábrók crater leaked a 4½-mile (7.2 km) lava flow.*
*From its summit, the magnificent view extends to the town of Borgarnes.*

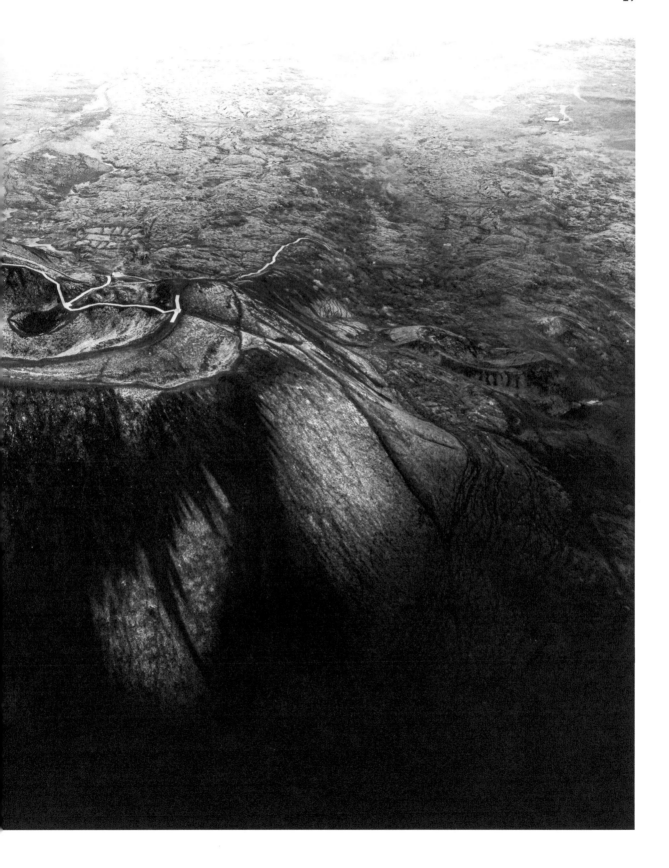

NATURE

# ICELANDIC WILDLIFE

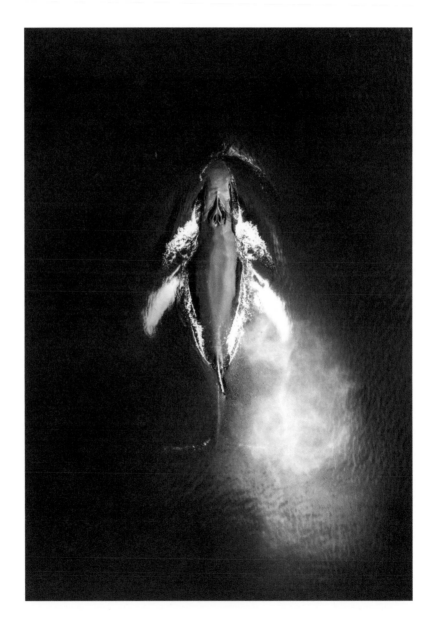

### BLUE WHALE

Twenty-three species of cetaceans frequent Icelandic waters, a dozen of them on a regular basis.
Their population is estimated at about three hundred thousand, one-third of which are blue whales.

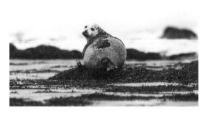

### SEALS

Two species are found on the Icelandic coast: the harbor seal and the gray seal.

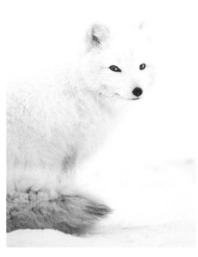

### ARCTIC FOX

This fox is the only terrestrial mammal to have colonized Iceland.

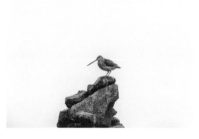

### SNIPES

This plains bird is recognizable by its quavering tune in flight.

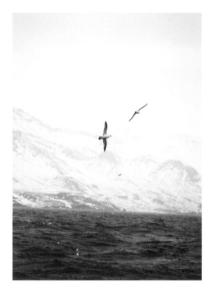

### STORM PETREL

With hundreds of species, Iceland is the land of birds.

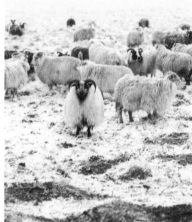

### SHEEP

The Icelandic sheep is one of the purest breeds in the world.

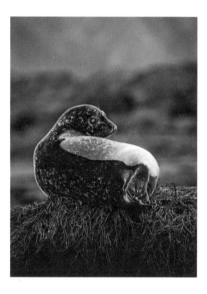

### SEAL IN PERIL

The seal population is experiencing a worrying decline.

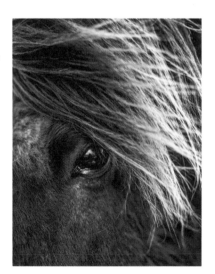

### ICELANDIC HORSES

In Iceland, the horse has always been man's best friend.

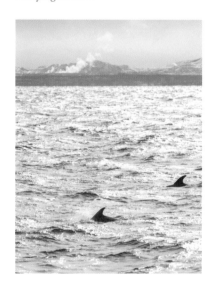

### KILLER WHALES

Orcas, or killer whales, are easy to spot on the Icelandic coast, especially in spring.

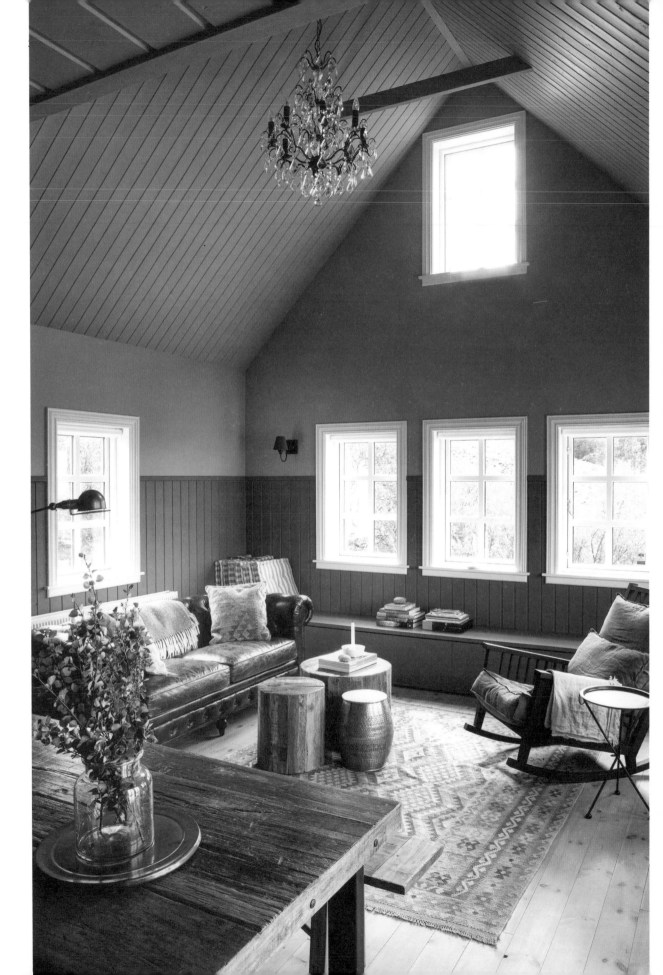

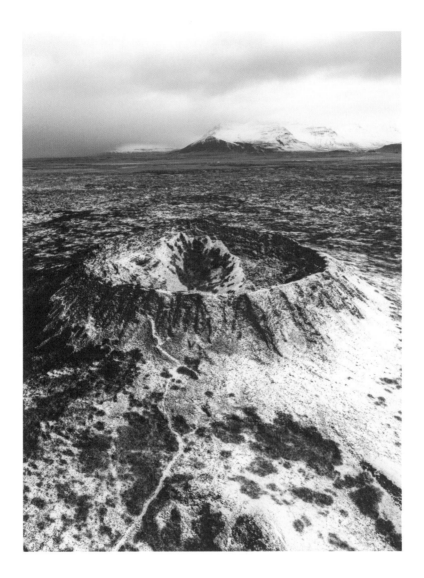

*The Eldborg crater marks the boundary to the Snæfellsnes peninsula.*
*Arctic birches have taken up residence here, as has the common raven.*

*Tourism in Iceland is booming. Today it is easy to find a house with*
*Scandinavian charm for spending a holiday on the island.*

# BÚÐIR

## THE SPIRIT OF A PLACE

The history of Búðir dates to the time of the Vikings, when it was a place of commerce where ships had been present since the first settlements. Until 1933, the Greenland shark was fished here. Today, the hamlet has disappeared, and only a church and hotel remain.

The church at Búðir is one of the most beautiful on the island. Its black color is as black as the lava field on which it stands. Jón Vídalín, Bishop of Iceland, authorized its construction in 1701. Since agreement could not be reached on its exact location, legend has it that an old woman suggested marking one of three arrows then entrusting them to a man to launch them after spinning around. The church was built where the marked arrow landed. It fell into disrepair and was rebuilt in 1848. As a wood structure rather than a stone structure, the church was easier to move, and it was relocated in the 1980s while fully constructed.

The hotel was also built entirely of wood. Constructed at the end of the Second World War, it was an immediate success, but its use declined before becoming popular once again, offering a delicious dining spot during the 1970s. Icelanders spread the word about the hotel, and Búðir became a destination. As the seventies passed and the next decade arrived, the hotel maintained its reputation as a culinary destination thanks to its chef, Rúnar Marvinsson, and his merry team.

In 2001, the hotel caught fire and burned down entirely. It was quickly rebuilt but under a different design using less wood but with the goal of maintaining the spirit of the former place and its reputation as a culinary destination.

As soon as you leave the main road, the charm of the surroundings becomes instantly apparent. The sea offers the spectacle of its infinite expanse. The traveler then notices a few jagged pieces of lava emerging here and there from the grass only to see it quickly switch to grass emerging from the black lava rock. The Búðahraun lava field skirts the hotel and the church, while the Snæfellsjökull glacier-capped volcano dominates the amazing landscape.

By the sea, a seemingly red-sand beach delineates the territory for tens of miles, while the mountain range that faces it marks its upper limit. The hotel was built in one of the most beautiful landscapes on the island. You can stop here to spend the night, and you will sleep even better after a walk along the sea and in the thick lava field with surprisingly lush vegetation; Iceland is also a land of excess. And if, by chance, your walk takes place on a summer evening accompanied by the plaintive sound of the golden plover, the cry of the whimbrel, or the chuckling of eider ducks, then your night will feel all the more pleasant.

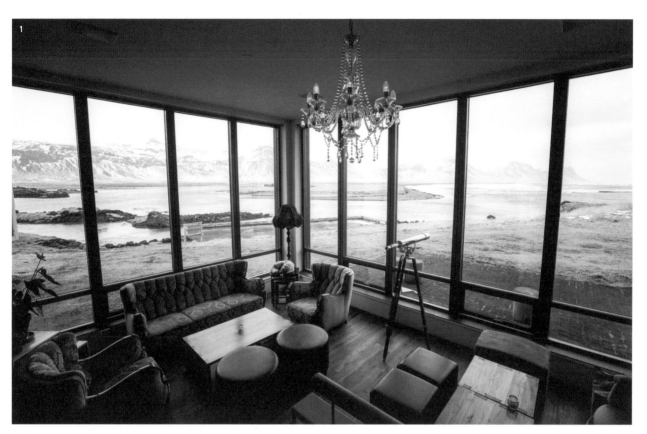

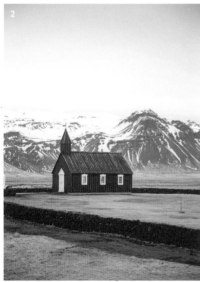

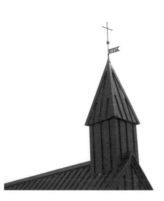

### 1. HOTEL BÚÐIR

The hotel lounge offers a view all along the southern coast of the Snæfellsnes peninsula.

### 2. AND 3. BÚÐARKIRKJA

At the edge of the Búðahraun lava field, the small black timber church adds to the already magical surroundings.

### 4. AROUND THE CHURCH

The location is considered romantic, as couples arrive from all around the globe to exchange vows here.

**ABOVE**

*The south coast of the Snæfellsnes peninsula is a long beach of light-colored sand.*

**RIGHT**

*The basalt coast is carved by erosion from the wind and surf. This is the*
*kingdom of the kittiwakes.*

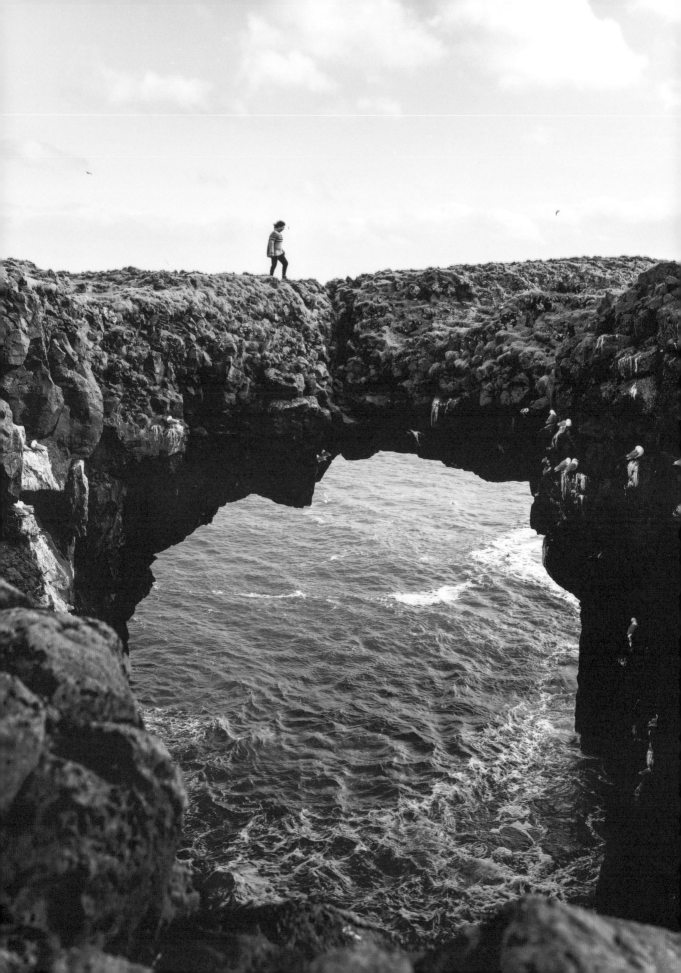

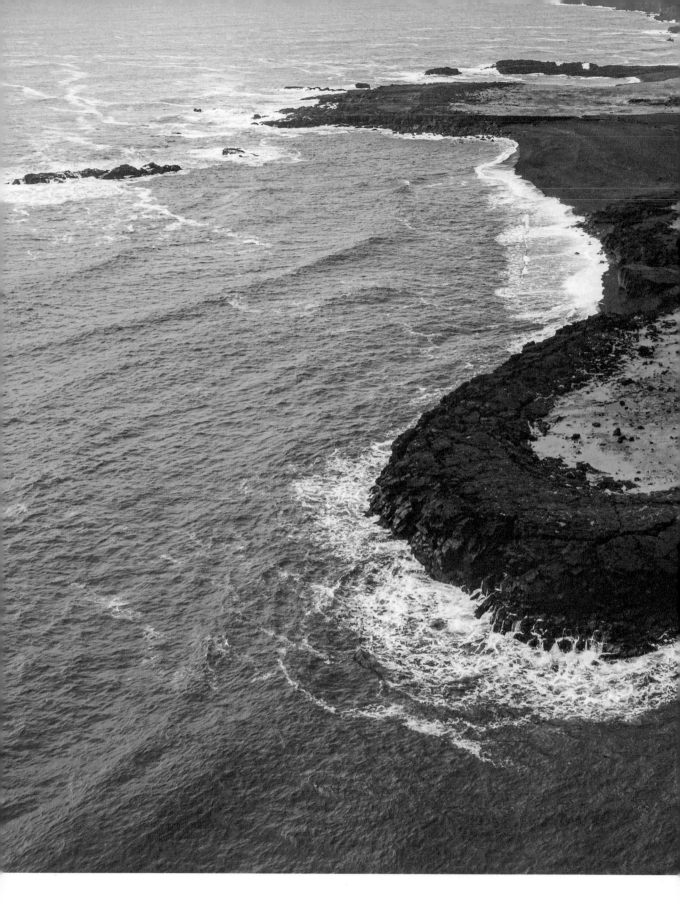

*The Malarrif lighthouse stands at the end of a black lava field jutting out of the Snæfellsnes peninsula.*

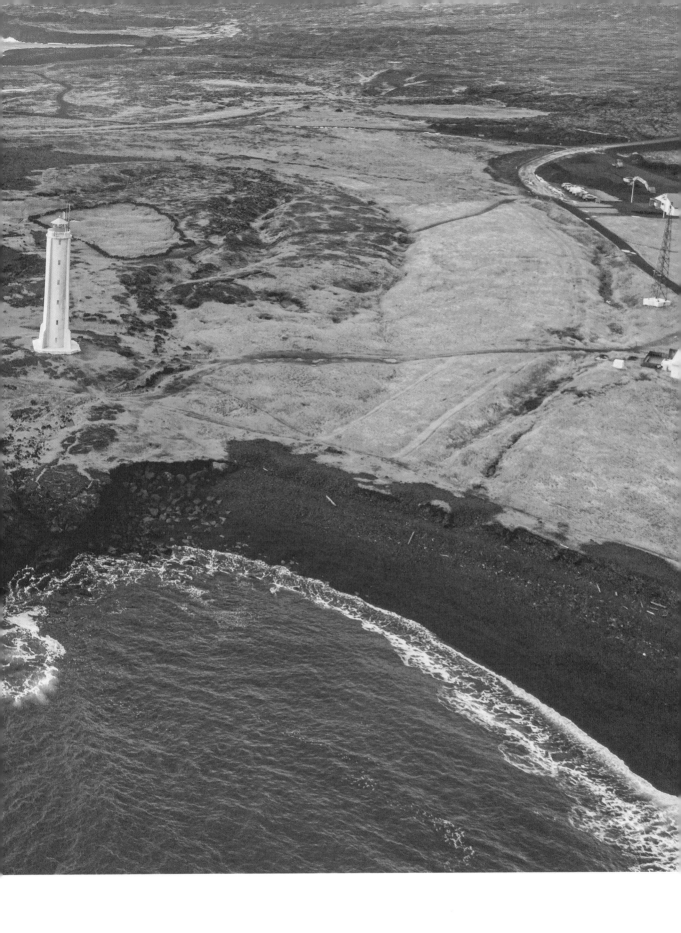

**ABOVE**

*In Djúpalónssandur, the foreshore of the bay is constantly beaten
by ocean waves.*

**RIGHT**

*Near the port of Grundarfjörður, on the north coast, Kirkjufell is considered
the most beautiful mountain on the Snæfellsnes peninsula.*

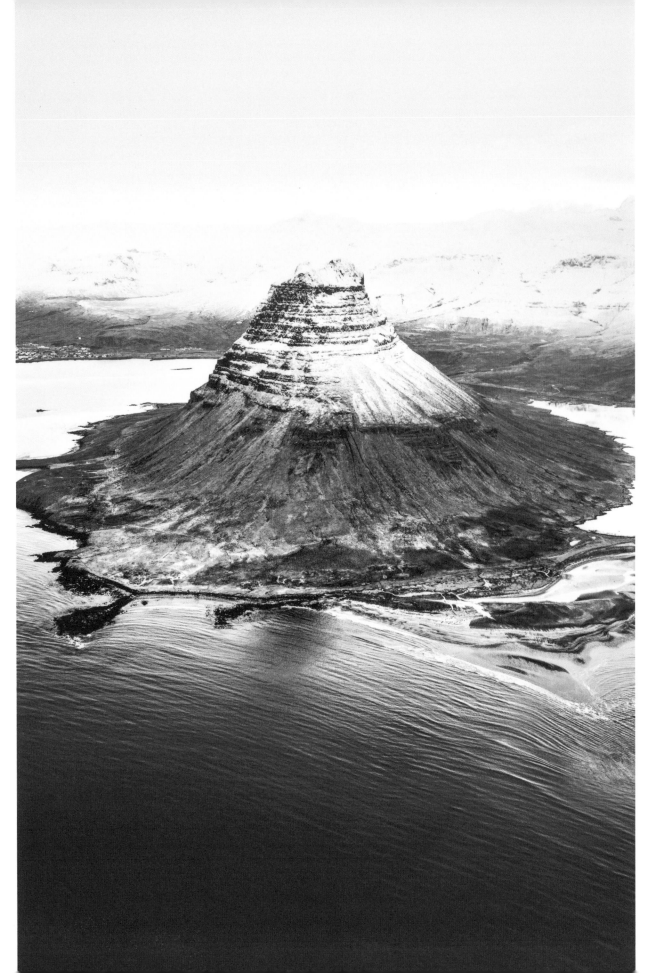

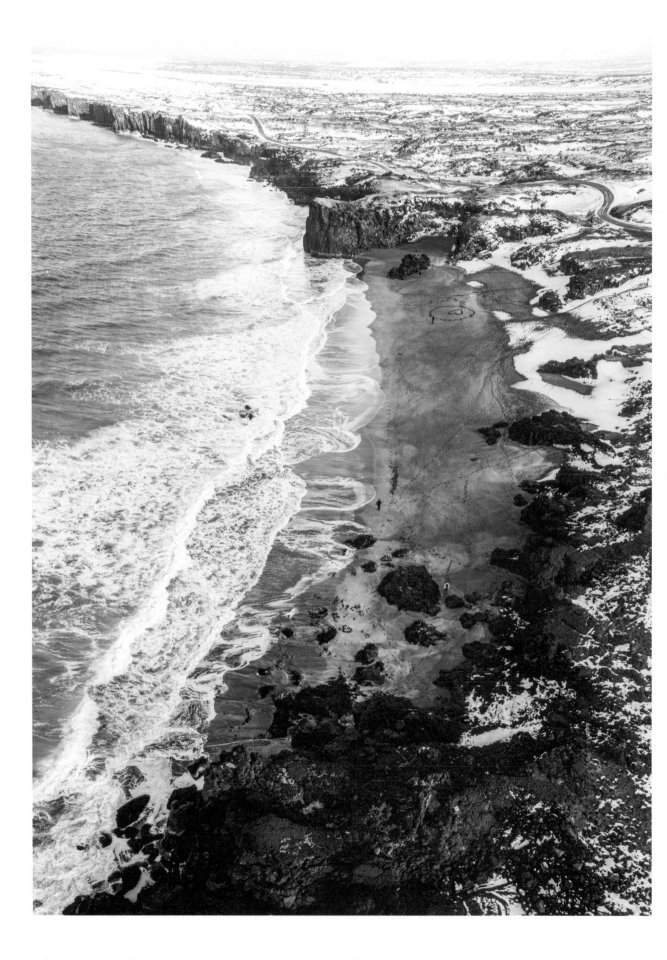

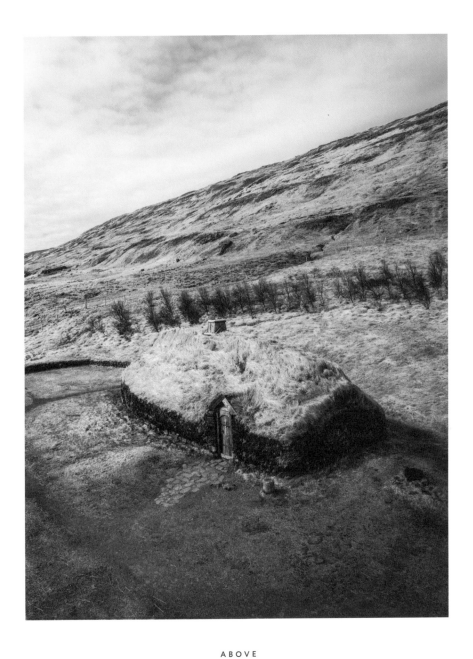

**ABOVE**

*In Eiríksstaðir, this building is a reconstruction of the farm
of Eiríkr Rauði (Erik the Red).*

**LEFT**

*On the western slopes of the Snæfellsjökull, lava flowed down its
steep slopes and was eventually eroded by the sea.*

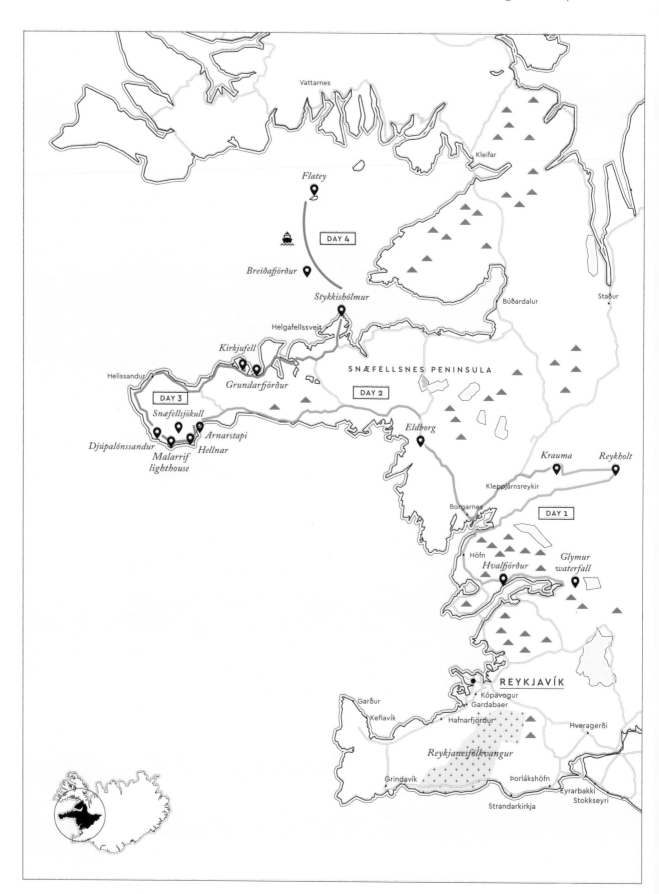

# 4 DAYS ON THE WEST COAST

Leaving Reykjavík to head west feels like leaving the city through the back door.
You must go through the Hvalfjörður, where the road gracefully winds from
time to time, tracing the relief of the landscape.

### DAY 1: FROM GLYMUR TO KRAUMA

Once you reach the end of Hvalfjörður, a detour by Glymur, Iceland's highest waterfall at just above six hundred fifty feet (one hundred ninety-eight meters), will offer you a bird's-eye view of the narrow canyon it carved out. Next, head for the valley at Reykholt, where you'll come upon the woodlands of arctic birches in Húsafell with expanses of lava that announce the Highlands in the direction of Eiríksjökull glacier. Here are hidden some of the most beautiful lava caves on the island, including Viðgelmir. The waterfalls of Hraunfossar, a long resurgence of clear water dozens of yards wide, spills into the tumultuous glacial river Hvítá, which forms a lava barrier that created Barnafoss. As the end of the day approaches, you can quickly warm up at the Deildartunguhver hot springs, followed by a restorative dip at the Krauma thermal baths.

### DAY 2: FROM ELDBORG TO HELLNAR

Now begins the tour of the Snæfellsnes peninsula: Start at the Eldborg crater or by the small coast of basalt columns in Gerðuberg. It's okay to decide to stop at both—enjoy the south coast with its long beach of golden sand, its ponds, and its slopes whose peaks sometimes get lost in the fog. The Búðahraun lava field, with its enchanting atmosphere, and a stroll along the cliffs between Arnarstapi and Hellnar under the silhouette of the majestic Snæfellsjökull glacier-capped volcano, are a must in this corner of Iceland. In summer, the sound of birds together with the sounds of the ocean fill the air in these peaceful places.

### DAY 3: FROM DJÚPALÓNSSANDUR TO BREIÐAFJÖRÐUR

On the black-sand beach of Djúpalónssandur, an arabesque of lava descends from the slopes of the glacier-volcano. The bravest will stroll along the reefs. Otherwise, you will have to cross austere and mesmerizing landscapes of lava to discover that the north coast is dotted with fishing villages.

The popular Kirkjufell mountain peak has become an Instagram star. The towns of Grundarfjörður and Stykkishólmur offer the charm of isolated harbors on the edge of the "wide fjord," the Breiðafjörður. In winter, an outing at sea for whale watching will require you to brave the chill of the ocean, but the beauty of the whales makes it so worth it!

### DAY 4: FROM STYKKISHÓLMUR TO FLATEY

Traveling by boat is a great way to change the rhythm of your trip, slowing it down to a more peaceful pace. From Stykkishólmur, a ferry crosses Breiðafjörður, studded with islands and islets, and offers the opportunity to stop on Flatey, the country's only still-inhabited island . . . and by just two families. In the not-so-distant past, the island was much more populated, and many of its old houses have been tastefully restored. A small hotel with incredible charm even allows you to spend the night here. The ferry continues to the Westfjords, where you can spend part of the day before turning back or continuing on with your journey.

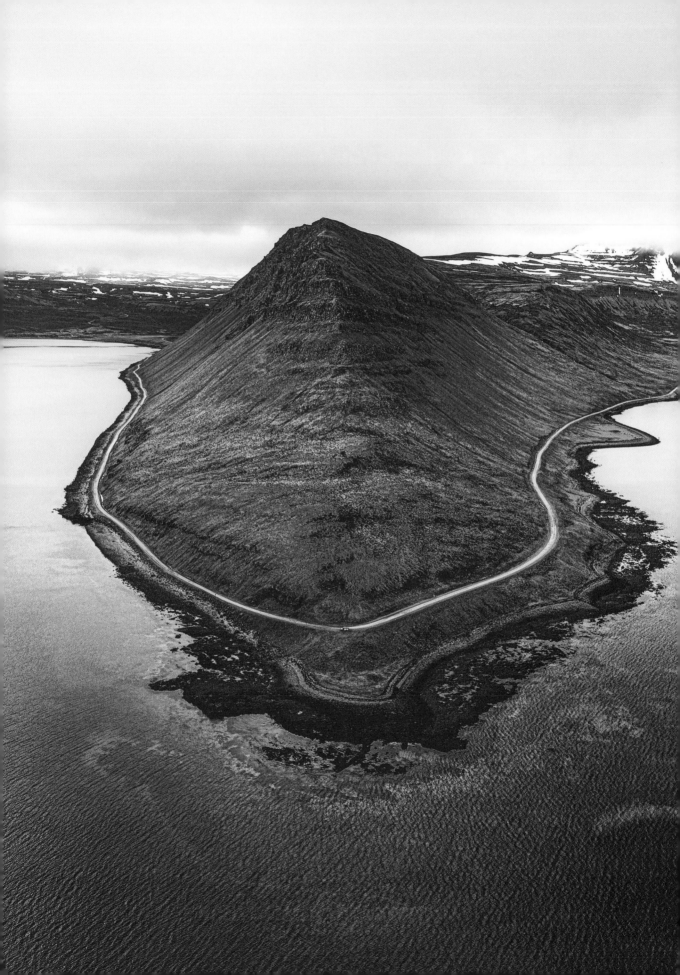

# THE WESTFJORDS

Although much of this land lies far away from everything,
the area is welcoming during the brief boreal summers.
The Westfjords are one part of the island that experiences
some of the most difficult winters, with significant snowfall.

**P. 46**

*Between Álftafjörður and Seyðisfjörður, as almost everywhere on
the peninsula, the road curves to accommodate the shape of the fjords.*

**RIGHT**

*On this typical slope you can see the stacking of different lava flows,
separated from one another by a thin layer of sediment.*

**P. 52–53**

*This coastal road grants a new way to discover Gilsfjörður.*

The residents of the Westfjords cling to a few acres of land dominated by steep slopes where living space is reduced to its simplest expression. This region is at the end of a vast plateau once covered by glaciers that dug an abundance of deep fjords. Just as with many places on the island, people settled here, even going so far as to colonize Hornstrandir, the peninsula of the peninsula—the Cape Horn of Iceland, if you will. Eventually these areas were abandoned during the 1940s, as they were decidedly too inhospitable.

The departure of the last inhabitants favored the return of wildlife. As a nature reserve with sumptuous landscapes, this end of the island offers exceptional biodiversity of flora. It is also the kingdom of the arctic fox, which can be easily observed, as well as storm petrels, which love to come up the ascending corridors during the summer, surprising the hikers as it sits along the cliffs, which look like lace thanks to erosion as they rise toward the heavens. And while hikers face these rising landscapes, kayakers may come across a gazing seal along some secluded bay.

Further south, fishing villages still cling to narrow strips of land where fishermen used all methods of fishing through the ages, from the perilous small boat to the large trawlers equipped with the latest technology, used for shark fishing to whaling. This is the land of exile. Many Icelanders considered it not worth living here, but the region has experienced a revival thanks to an immigrant population arriving mainly from Poland to work in the fisheries. A few Syrian families, welcomed on the island, have recently settled here to find a little peace and a more serene future. It is a peculiar community, one of peoples from diverse backgrounds who have revived these villages that seemed lost forever, where even the Icelanders from the city have left the old colorful wooden houses untouched. As rough and austere as they are, the Westfjords have an undeniable force of attraction.

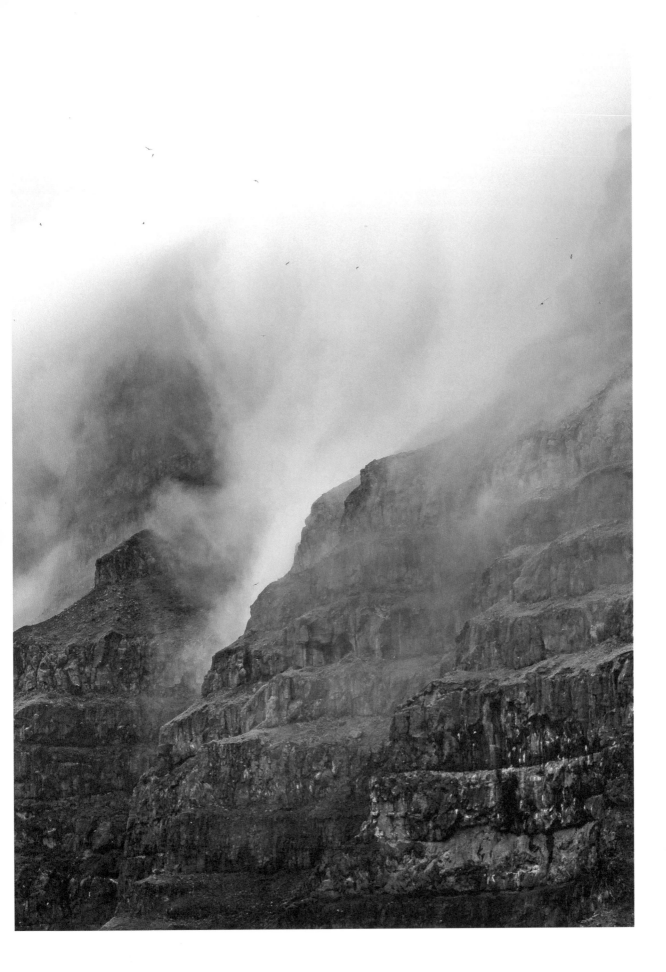

# THE ESSENTIALS

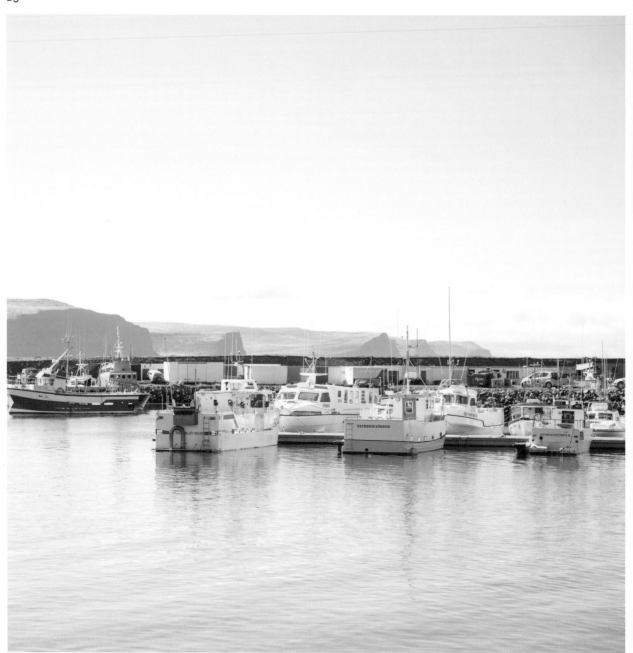

### PATREKSFJÖRÐUR HARBOR

A classic scene of a fjord harbor with its multitude of
small boats that embark out to sea for the day.

**14**

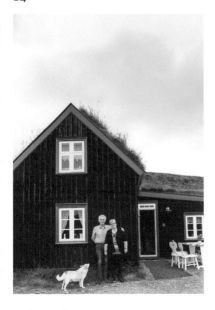

### SKÖTUFJÖRÐUR

Litlibær, literally "the little farmhouse," with its typical turf roof, is one of the few cafés in this out-of-the-way region.

**15**

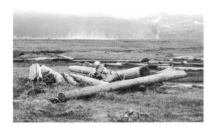

### STRANDIR

Pieces of driftwood wash up on small pebble beaches. They arrive most often from the taiga at the mouths of the great Siberian rivers.

**16**

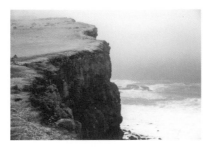

### HORNSTRANDIR

The highest and steepest cliffs are found on the Hornstrandir peninsula in the Westfjords.

**17**

### ÍSAFJÖRÐUR

In this former trading post, black timber houses are called *pakkhús*.

**18**

### ÓSVÖR

Take a fascinating leap through time while visiting this exciting small museum dedicated to fishing methods of the past.

**19**

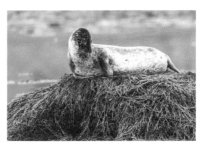

### MJÓIFJÖRÐUR

Here it is not uncommon to come upon a seal resting on algae-covered rocks at low tide.

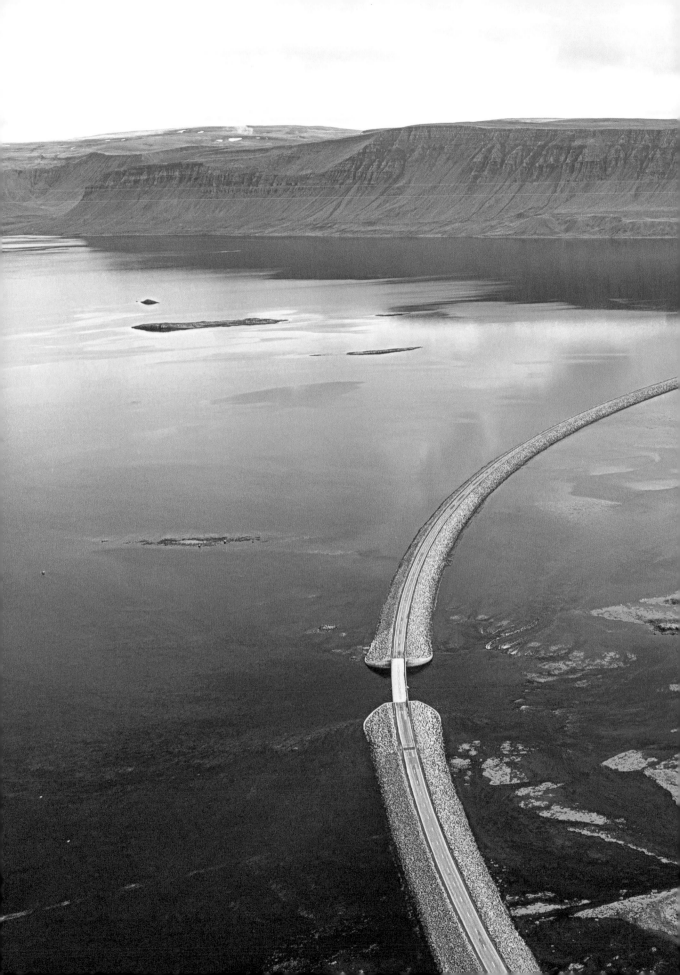

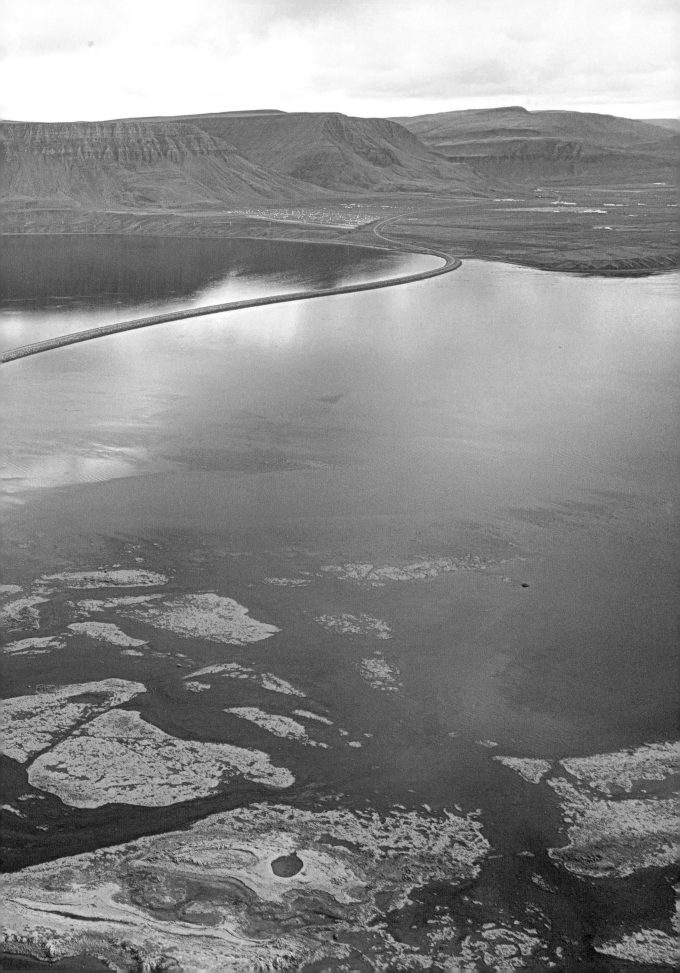

UNDERSTANDING

# FISHING IN ICELAND

Since the arrival of the first Vikings and through the first thousand years of the island's history, little changed for Iceland in terms of technological progress. However, the year 1904 was a pivotal year, as the country achieved its autonomy and motorized boats arrived on the island for the first time, changing the island forever.

Iceland was, at first, principally a land of sheep breeders. But fishing eventually became an activity of great importance, practiced once the brief summers ended and the long winter months made relying on the land difficult. Equipped with rudimentary means, Icelanders embarked on frail rowing skiffs to venture, without hesitation, into the frigid north Atlantic to fish as a means of survival. A visit to the small museum in Ósvör, between Ísafjörður and Bolungarvík, provides a clear idea of how seafarers fished cod for centuries to supply ports of the Hanseatic League.

Salt cod was transported across Europe to Catholic lands to feed populations that strictly respected a calendar abundant with lean days. Basques, Germans, English, Dutch, and even French came to fish on the Icelandic coast, where shoals favored the gathering of many fish species, including cod, haddock, hake, halibut, redfish, and shrimp.

Danes and Norwegians were interested in Iceland for shark liver oil and whale oil, extracted from the animals' fat, which they used as fuel for lighting streets. They also developed the herring fisheries, a great adventure that ended as abruptly as it had begun, and initiated the construction of the first herring ports at the turn of the twentieth century.

The Icelanders, caught up in their struggle for independence, soon realized that they held the key to their future. In the 1950s, they extended the boundaries of their fishing zone, even if it meant provoking clashes with foreign fishermen, especially the British. This conflict, which lasted for twenty years, has been remembered as the "cod wars." The Icelanders modernized their fishing fleet, which is now one of the most efficient in the world. They were also among the first to introduce a quota system to regulate catches and stock turnover and are now, only recently, taking an interest in fish farming.

## PRINCIPAL FISHING ZONES

In Iceland, fishing is the country's second largest industry after tourism.
Fishing accounts for sixty percent of exports.

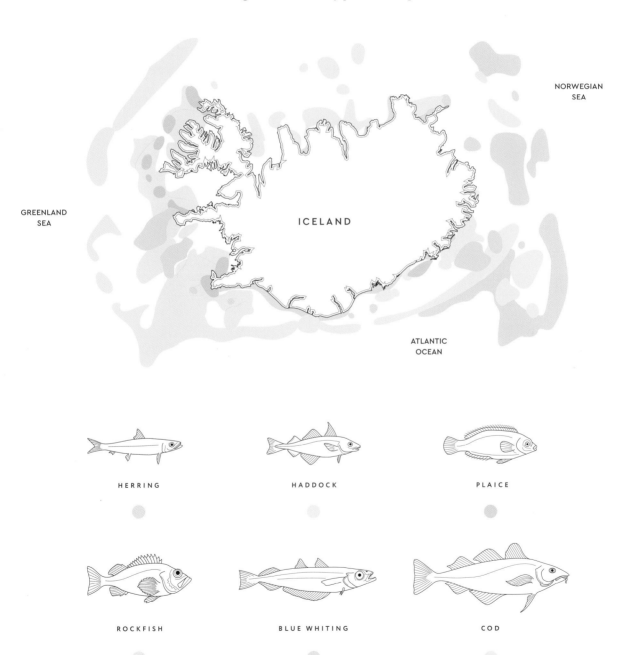

NORWEGIAN
SEA

GREENLAND
SEA

ICELAND

ATLANTIC
OCEAN

HERRING

HADDOCK

PLAICE

ROCKFISH

BLUE WHITING

COD

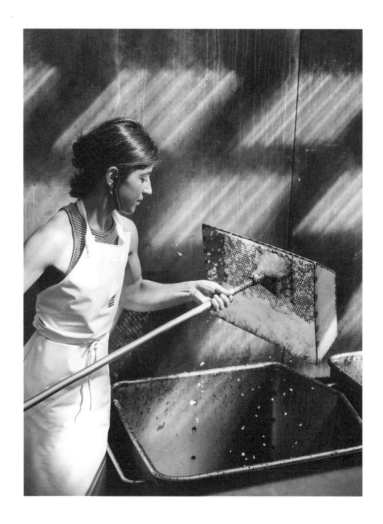

**ABOVE**

*Near Reykhólar, geothermal energy is used not only to heat houses
but also to produce sea salt.*

**RIGHT**

*Icelanders raise salmon in these pods scattered throughout the fjords.*

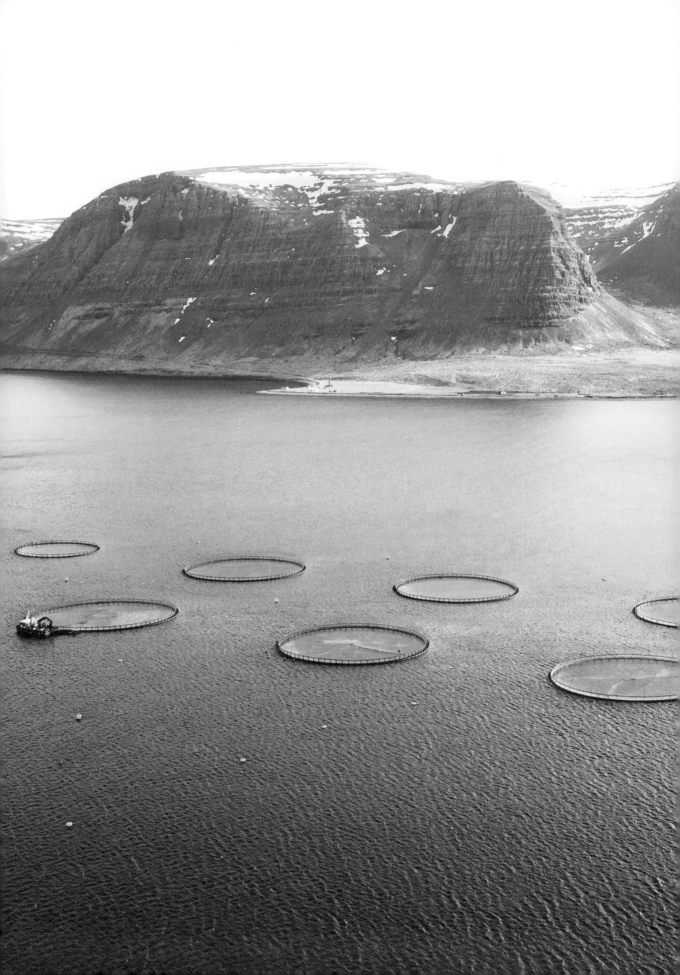

FISHING

# FISHING IN ICELAND

### TRAPS AND NETS

It's a common postcard photograph of all Icelandic ports:
traps and nets leaning against the wall of a fishery.

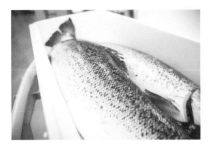

## FLOURISHING FISH

Fishing is the second largest industry after tourism.

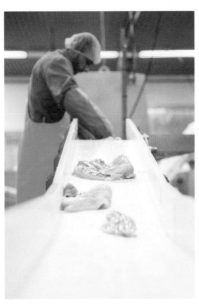

## AT THE END OF THE WORLD

Processed immediately after landing, unless already frozen on board the ship, fish is exported right away by plane.

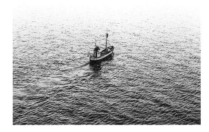

## QUOTAS

When quotas were introduced in 1984, wooden fishing boats were relegated to smaller catches.

## A LONG HISTORY

As early as the fifteenth century, the Basques came to fish for cod in Icelandic waters.

## TAKING TO THE SEA

Fishing is important no matter the time or season.

## ICELANDIC FLEET

Along with heavily equipped trawlers, the Icelandic fishing fleet consists of many small boats that leave during the day to journey not far from the coast.

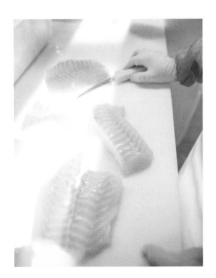

## ADHERING TO TRADITION

Despite modern progress, fish continues to be cleaned with a knife.

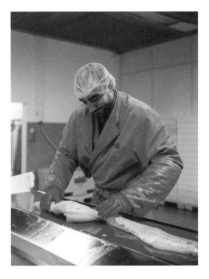

## REQUIRED CLEANLINESS

A fresh product demands irreproachable sanitary conditions.

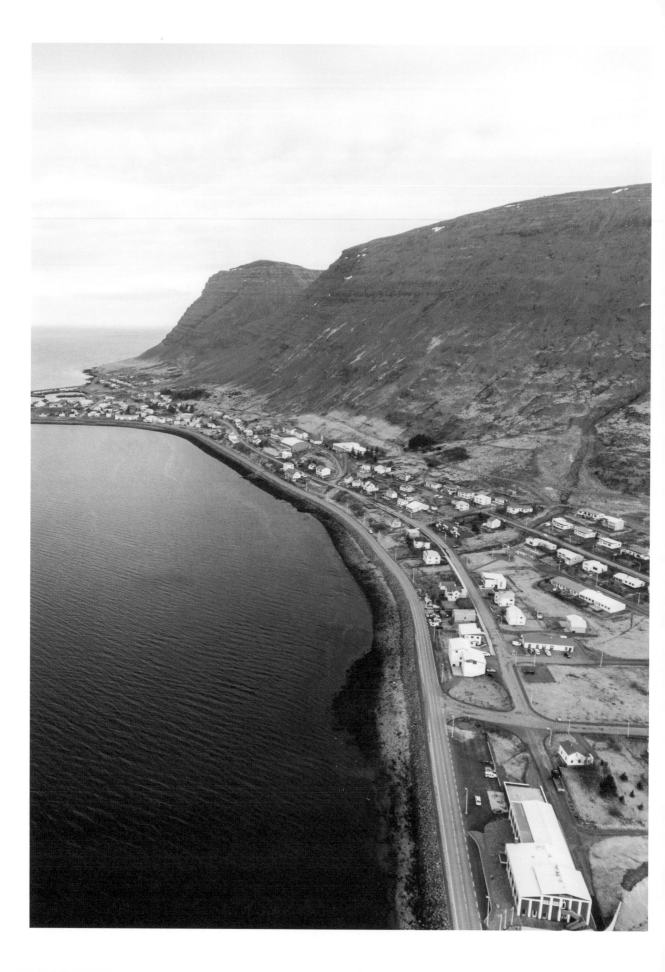

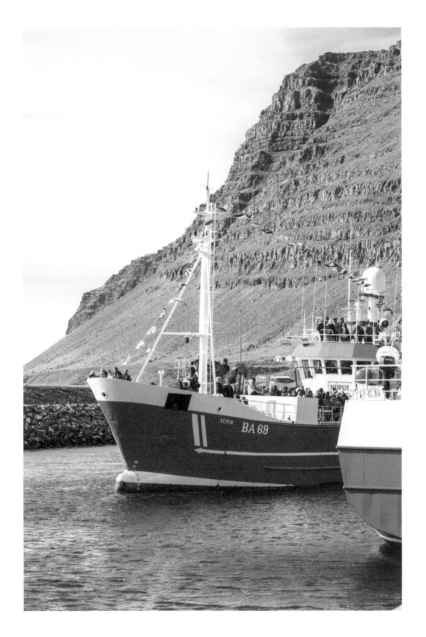

**ABOVE**

*Since 1941 at the beginning of each June, the village of Patró has celebrated
the four-day Festival of the Sea.*

**LEFT**

*Like other villages in the region, Patreksfjörður developed on a narrow strip
of land between steep slopes and the ocean.*

**ABOVE**

*The first villages were established in the second half of the nineteenth century,*
*accompanying the rise of the fishing industry.*

**RIGHT**

*In the Þingeyri region, tunnels now make it possible to avoid narrow roads*
*that can become impassable during long Icelandic winters.*

VISITING

# FLATEY

## ISLAND OF BIRDS

Some natural phenomena in Iceland, such as the many islands around its coast, are so numerous that exact numbers cannot be known. This is the case in Breiðafjörður Bay. Among the approximately three thousand islands that make up Iceland, Flatey marks the gateway to the Westfjords.

Despite its tiny size (one hundred twenty-four acres/fifty hectares), Flatey boasts a rich past, as it has been inhabited since the arrival of the first humans in Iceland. As the location of a monastery built in the twelfth century, the island played a leading cultural and religious role in Iceland until the nineteenth century. It also owes its fame to the *Flateyjarbók* (literally "Book of the Flat Island"), a collection of five royal sagas written at the end of the fourteenth century and one of the richest manuscripts of medieval Icelandic literature. Handed over to the King of Denmark in the seventeenth century, this precious work was formally returned to Iceland in 1971.

All things considered, Flatey has always been an active hub within the country. For centuries, the waters of its bay, rich with fish, and the availability of seabirds allowed the islanders to avoid starvation. At the beginning of the eighteenth century, there were about one hundred inhabitants, then four hundred at the turn of the twentieth century, most of them living mainly off fishing. The island then gradually experienced a decline in population to the point that, today, only two families officially reside here.

Flatey still offers many attractions, including its small size, which makes it easy to move around on foot to explore it and its some thirty colorful houses. It also has a library, the smallest in Iceland, built in 1844, and a church that houses beautiful frescoes. The bird population is particularly large. The ideal time to visit is in May and June, when migratory birds have returned to join the colony and to breed. On a clear night, when the wind has died down to silence, nothing is more exhilarating than staying awake to listen to the orchestra of arctic terns, kittiwakes, and snipes. Black guillemots splash around in the tiny bay, which was formed by the remains of a now-extinct volcano, the view of which is imbued with a strong light unique to these regions. The ensemble fills you with an amazing energy in a place where time seems suspended and provides a sense of being in a new world. The arrival on the island by pontoon approaching an old, abandoned fishery was enough to inspire Arnaldur Indriðason, the king of the Icelandic detective novel, with an idea for one of his novels.

Visitors are surprised to discover a small village here comprised of beautifully renovated old wooden houses that are occupied in the summer. The houses' vibrant colors embellish the summer nights. When either young or old find themselves unable to fall asleep well into the night, many within this little world find themselves gathering on what looks like a square in front of the island's only hotel, a small establishment with excessive charm that takes visitors a century back in time. The noise of the birds will prevent anyone from drifting into a deep sleep, but no matter, the hotel offers a great excuse to stay for a few more hours in Flatey. This is pure joy!

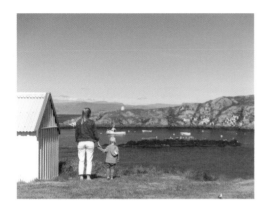

## LONG AWAKENINGS

In Flatey during spring, encouraging children to go to bed early is a wasted effort!

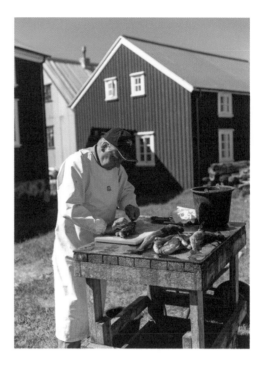

## SIMPLE PLEASURES

In Flatey, far from the stringent rules of any factory, a simple wooden table is enough to clean the catch of the day.

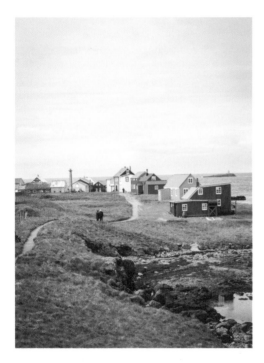

## VACATION HOMES

The island's brightly colored small wooden houses have been renovated as holiday residences.

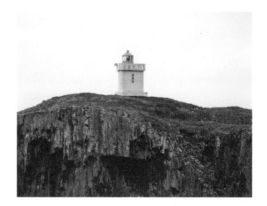

## STYKKISHÓLMUR LIGHTHOUSE

The lighthouse located at the end of Stykkishólmur harbor points the way to Flatey and the Westfjords.

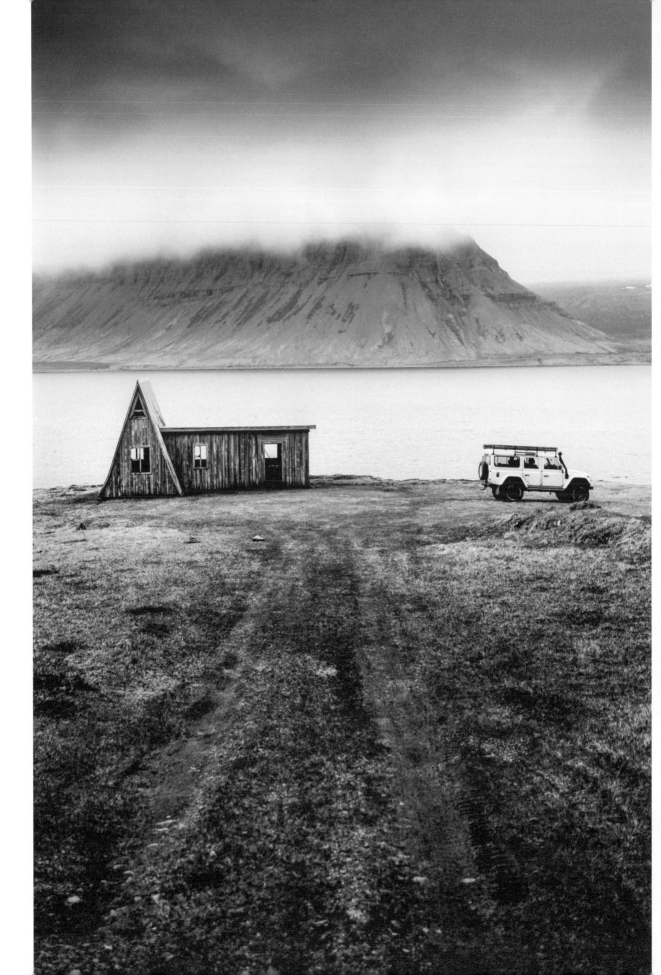

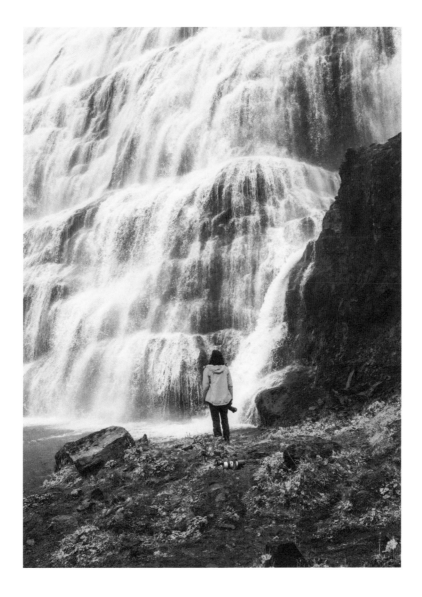

**ABOVE**

*The cascading Dynjandi waterfall descends
a slope 330 feet (100 m) high.*

**LEFT**

*The most remote places on the island are now deserted,
sometimes leaving behind empty houses and cabins.*

VISITING

# ÓSVÖR

## A PLACE OF MEMORIES

When touring the Ósvör Maritime Museum, visitors get a clear sense of the source of inspiration for Jón Kalman Stefánsson's trilogy, *Himnaríki og helvíti (Heaven and Hell).*

Visitors to this small open-air museum tucked along the shore between Ísafjörður and the village of Bolungarvík will understand why, for nearly ten centuries, men took enormous risks to fish, just as a tightrope walker balances on a wire without any protection below; the survival of their communities depended on it.

While learning about ancient fishing techniques—which were practiced until the latter part of the twentieth century—visitors will realize the fervor, coupled with resignation, with which men repeated their prayers before going out to sea, placing their lives into the hands of a higher being who could decide their passage from life to death: With just a single gust of wind, boats could capsize and send both men and boats to be lost in abyssal darkness.

Moreover, since fishing excursions most often took place in winter or spring, it was not easy, if not sometimes impossible, once on the water to distinguish the sky from the sea, making the distinction between heaven and hell even more precarious. While preparing to embark, every detail mattered: from the clothes and equipment on board to the condition of the boat and the weather. The slightest oversight could prove to be a fatal mistake. Bárður, the unfortunate hero of Stefánsson's novel, who went fishing for cod without his sailor's jacket, makes such a tragic mistake. Equipped with four, six, eight, or ten oars, sometimes also sails, the boats led the men to the *mið*, the fishing areas known for their abundance. But without a compass and with only rudimentary equipment, setting out on such frail skiffs, like the one exhibited at the museum, was like sailing the high seas, becoming even more unpredictable when the sea acted in concert with the icy, violent, and intense wind.

In Ósvör, the visitor is made aware of the heroic courage of these fisherman risking their lives while leaving behind women and children. These days it is easy to get there by car, but if you aren't paying attention, you will pass the short, grass-roof houses without noticing. Even before touring them, the small size of the houses built along the shore, nearly invisible against the vastness of the fjord, offers us a precise idea of the suffering endured by generations of fishermen and evokes the memory of the countless anonymous men who disappeared at sea. This small museum is a gold mine: Through a collection of tools, clothes, boats, and utensils of all kinds, you can discover the daily life of Icelandic fishermen spanning a thousand years. And to extend the tour, just dive into Jón Kalman Stefánsson's masterful descriptions of Iceland's weather for a sense of both the heavens and the earth, indeed heaven and hell.

# IN ÓSVÖR, MORE THAN ANYWHERE ELSE, THE VISITOR BECOMES AWARE OF THE HEROIC COURAGE OF THESE FISHERMAN RISKING THEIR LIVES AT SEA.

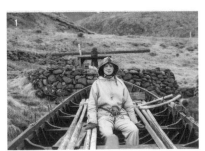

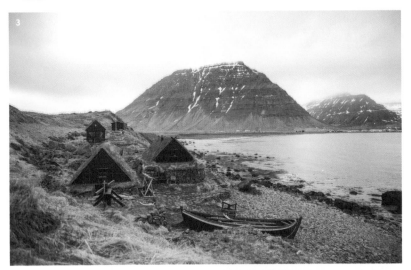

### 1. A SAILOR OF YESTERYEAR

In his period sailor's outfit, a reenactor sits in a *sexæringar*, a traditional boat with six oars.

### 2. VIEW FROM THE SKY

An aerial view of this traditional fishing village, representing many others that existed along the Icelandic coast.

### 3. FISHERMEN'S HUTS

Covered with fresh turf, these very rustic huts together could shelter up to four hundred men during the fishing season.

### 4. CONSERVATOR

The museum's curator, Jóhann Hannibalsson, wears traditional fisherman's clothing to welcome visitors.

### 5. DETAIL

The reconstruction of the period is executed to the smallest detail inside the huts.

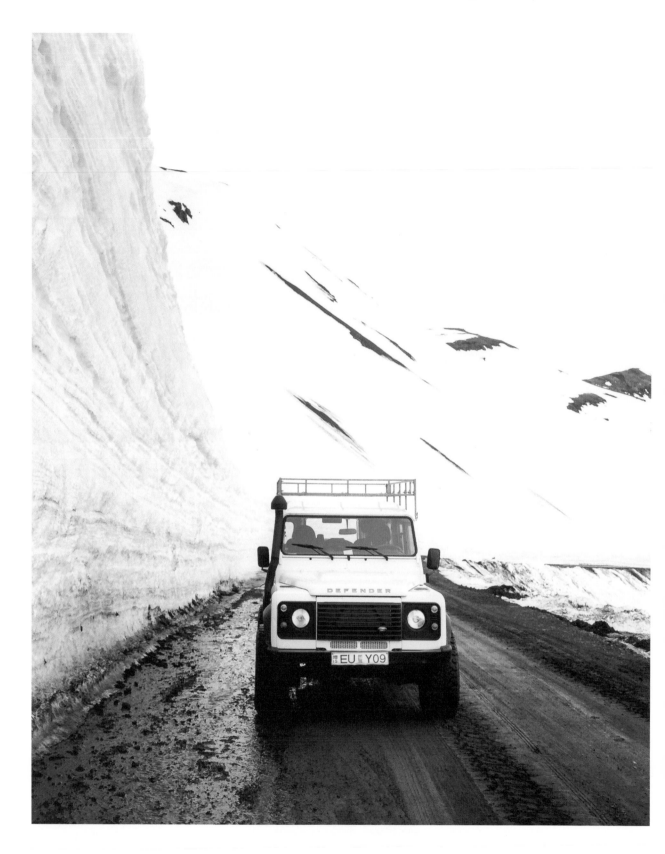

*At the end of May, the only road around the peninsula reopens and the first cars
pass by snowdrifts several feet high.*

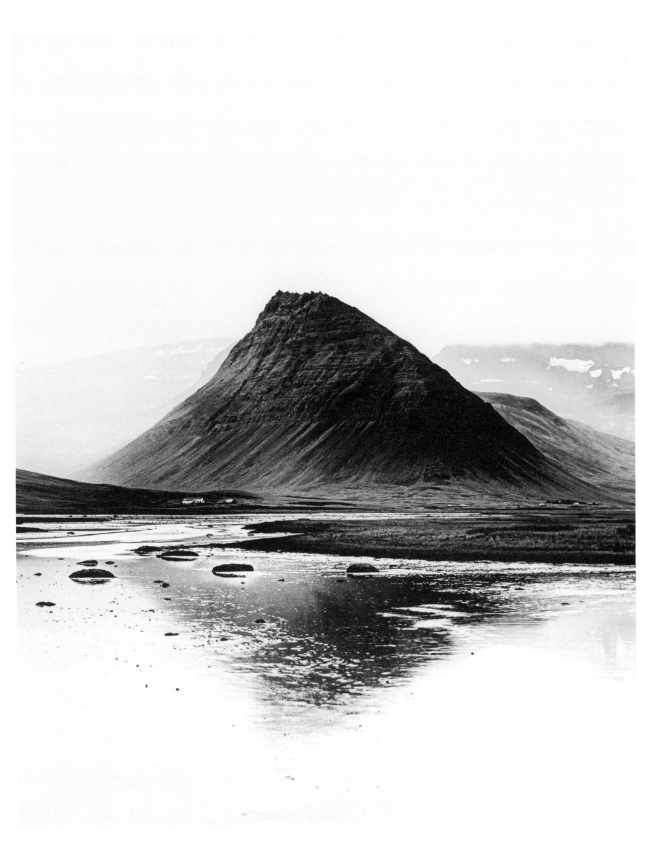

*Many isolated farms remain in operation despite the deserted countryside.*

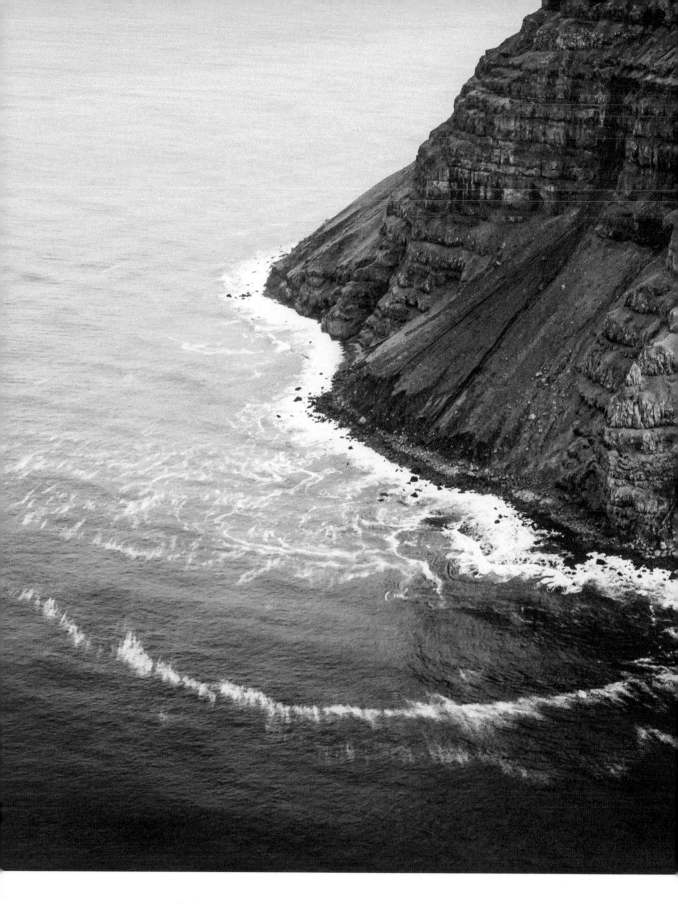

*The landscape of a steep coast shows layers of lava eroded by time, wind, and the sea.*

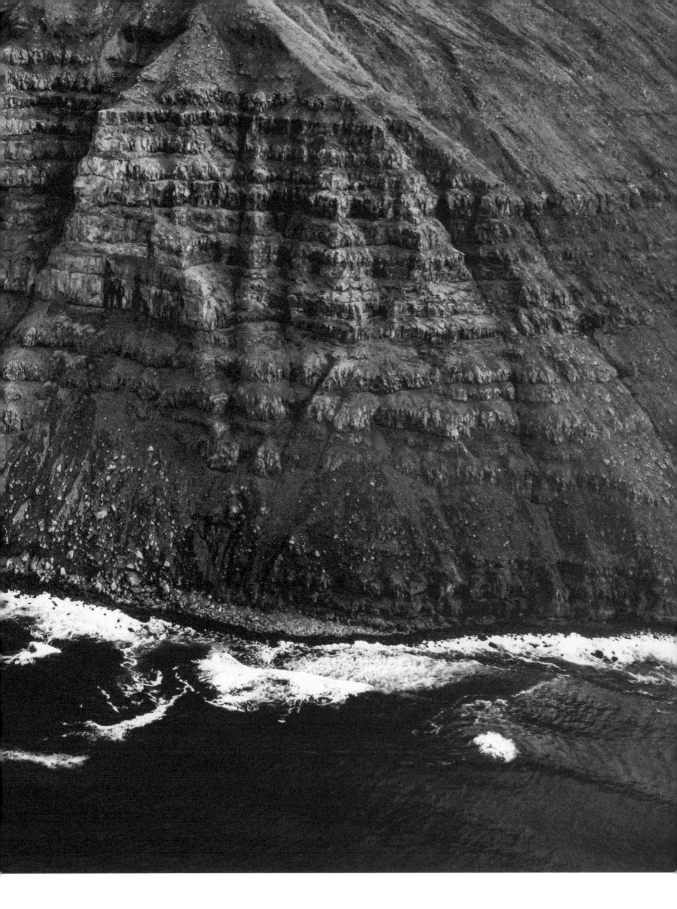

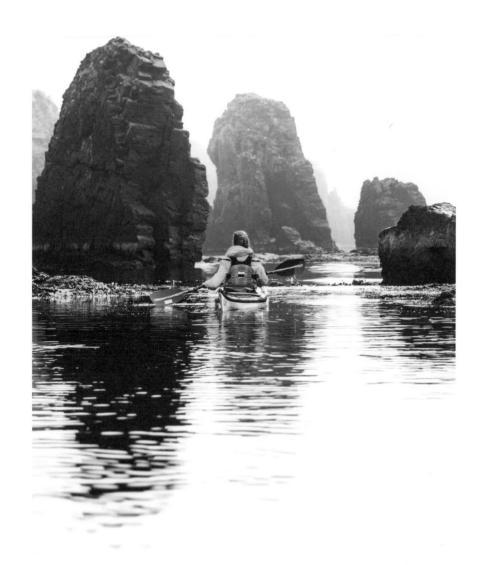

**ABOVE**

*In the south of the Hornstrandir nature reserve, the coast is suitable for
kayaking, often impossible elsewhere on the island.*

**RIGHT**

*Seven small narrow fjords form the southern coast of the Ísafjarðardjúp fjord,
which stretches for about 37 miles (60 km).*

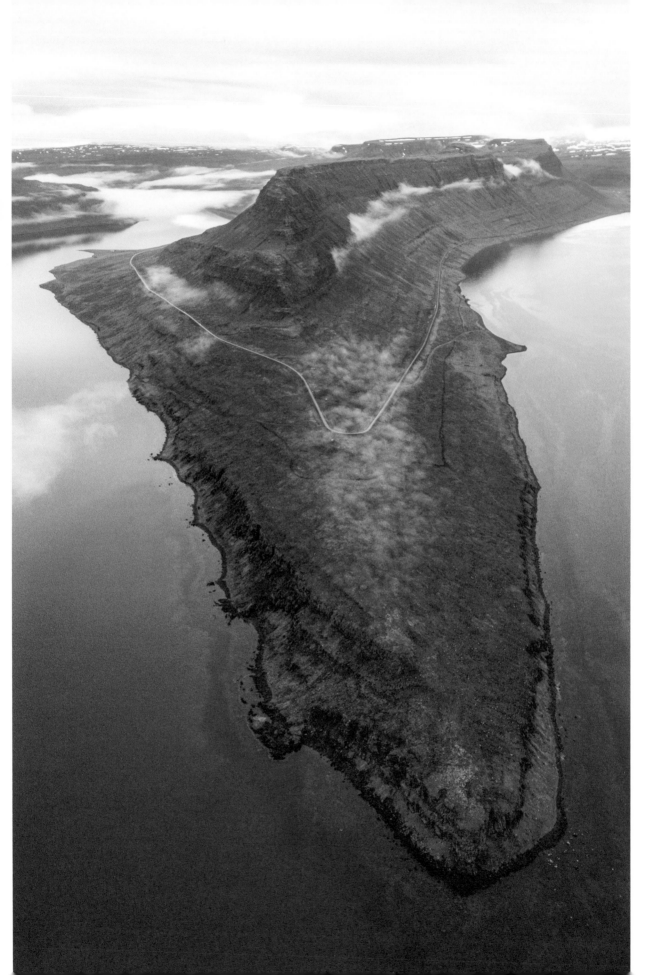

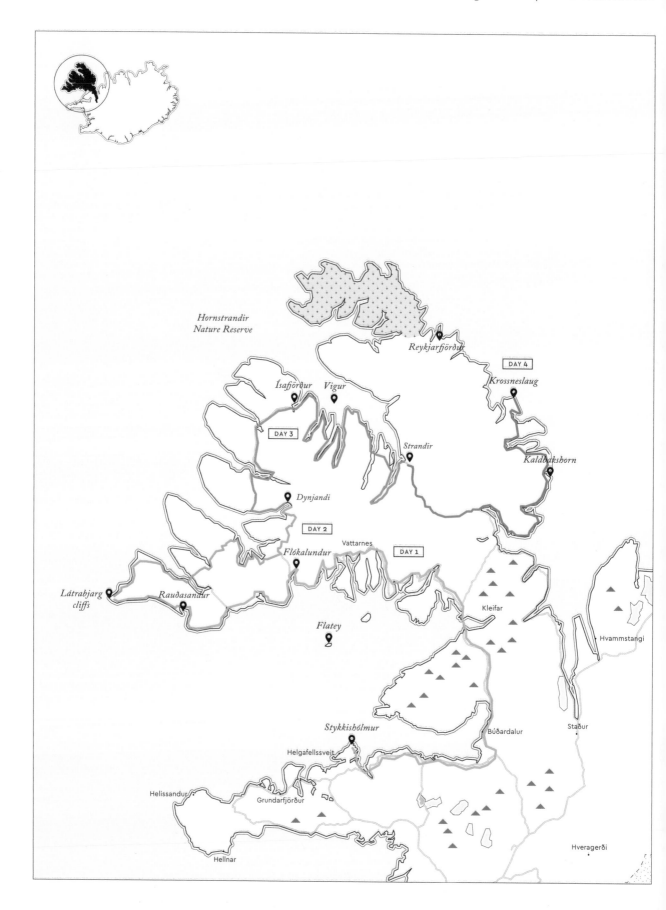

*Hornstrandir
Nature Reserve*

*Reykjarfjörður*

DAY 4

*Ísafjörður*   *Vigur*   *Krossneslaug*

DAY 3

*Strandir*

*Kaldbakshorn*

*Dynjandi*

DAY 2

*Flókalundur*   Vattarnes   DAY 1

Kleifar

*Látrabjarg
cliffs*   *Rauðasandur*

Hvammstangi

*Flatey*

Búðardalur   Staður

*Stykkishólmur*

Helgafellssveit

Helissandur   Grundarfjörður

Hveragerði

Hellnar

# 4 DAYS IN THE WESTFJORDS

There are two ways to approach the Westfjords:
by road and by sea. By road, the arrival by way of the
Gilsfjörður offers an alluring route over its drivable
bridge stretching more than two miles (three kilometers).

## DAY 1: FROM GILSFJÖRÐUR TO PATREKSFJÖRÐUR

The road that serves Gilsfjörður winds over the ocean and then follows the route of a dozen small fjords. By sea, the route via the Baldur ferry moves quickly, crossing the Breiðafjörður Bay. In either case, you will be along the coast of Bárðaströnd. After taking a break in a natural hot spring around Flókalundur, head for Patreksfjörður and make a detour to the wonderful beach of Rauðisandur, literally "red sand." Here you will have a sense of still being in Iceland, yet in a place like nowhere else.

## DAY 2: FROM LÁTRABJARG TO DYNJANDI

Sitting at the tip of the end of the world is Látrabjarg, the longest and highest cliff in Europe, offering breathtaking views of the ocean. Those who love beautiful landscapes will find their special moment here when taking in its stretch of just over nine miles (fifteen kilometers) and its height of thirteen hundred to sixteen hundred feet (four hundred to five hundred meters). Its lighthouse will be a highlight as you discover this land's end, the most western cape of Europe. The road then passes from village to village, from fjord to fjord, and from plateau to plateau. It is a world apart, where habitable spaces are rare, but men have stayed devoted to it. The Dynjandi waterfall, one of the most surprising on the island, will be a stopping point for a break before continuing on toward the "Alps" of this region among the most majestic fjords and lovely small villages.

## DAY 3: FROM ÍSAFJÖRÐUR TO REYKJANES

The road goes around the peninsula and passes through Ísafjörður. A detour by the small maritime museum in Ósvör will take you back to a not-so-distant past when rowboats were used for fishing. On the Ísafjarðardjúp, the island of Vigur offers an enchanting setting with the oldest preserved mill in Iceland as well as its colony of eiders and arctic terns. Further on, you will have to have a keen eye to spot seals lazing away on the rocks. In the mood for an Olympic-size swimming pool? Where there is hot water there is joy, so a stop on the Reykjanes peninsula for a swim is in order. At the end of a plateau the east coast of the peninsula appears suddenly, a little hidden from view, but with many surprises in store.

## DAY 4: FROM STRANDIR TO KROSSNESLAUG

There are still a few inhabitants clinging to this area. The only dead-end road runs the length of the Strandir region coast, its small beaches scattered with driftwood, following the contours of the jagged, turbulent coast. In Djúpavík, a former herring factory, remnants of a bygone era, serves as a space for art exhibitions. And the farther you go toward Norðurfjörður (the northern fjord), the more the feeling of isolation takes over. But what a nice surprise to see, once there, that people live here! The Krossneslaug thermal pool, located in an unlikely place facing the sea, will be the perfect place to take a break.

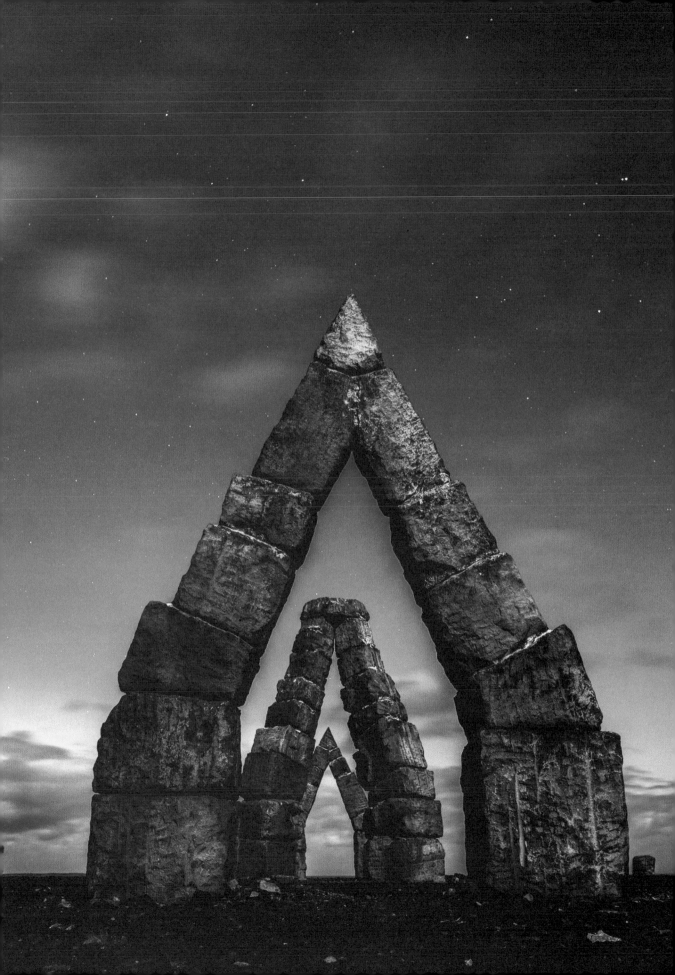

# THE NORTH

North Iceland is the region touched by the Arctic Circle.
Its fjords, the largest on the island, point resolutely in the
direction of the north pole.

P. 78

*Upon completion, the Raufarhöfn Arctic Henge will be 171 feet (52 m) in diameter*
*with a crystal sitting atop a 26-foot (8-m) column that will reflect the midnight sun.*

RIGHT

*When the surroundings of Lake Mývatn are covered with snow,*
*the ice-free road looks like a passage out to sea.*

The wind blows winter's precipitation to the point that houses sometimes disappear under thick layers of snow. Boreal nights are longer, but summer nights are nonexistent, and the temperatures are often higher than in the south of the island. The northern lights, which cover the sky with their exquisite and surreal moving curtains, are followed by a symphony of spectacular colors during the late hours when everyone finally settles into bed.

The north also marks a clear break between early geological Iceland, eroded by glaciers, and the events of the active volcanic rift that regularly transform it. To discover this region is to move from one fjord to another, from Skagafjörður, the domain of sheep and horses, to Eyjafjörður, which is home to Akureyri, the country's largest city outside the capital, with its seventeen thousand inhabitants who will not hesitate to tell you that their city is more beautiful than Reykjavík. The inhabitants of Siglufjörður experienced the era of herring fishing, similar to the gold rush, at a time when Iceland was gradually becoming independent. Unarguably, the island's northern population played an important role in the Icelandic renaissance. A certain friendly rivalry is detectable between the north and the capital, its inhabitants having developed a way of living in harmony with the sumptuous natural setting among the fjords.

The closer you get to the northeast of the island, the more the Iceland of the recent past is revealed. The Leirhnjúkshraun lava field that was formed during the cycle of eruptions between 1975 and 1985 impresses the observer with the terrible force of creative destruction it still expresses today. Here you are at the limit of two worlds, since Lake Mývatn and its surroundings open onto an enormous plateau that marks the entrance to the uninhabited Highlands. Here, lush vegetation (it's all about perspective), enjoyed by large gatherings of wild ducks, brushes up against one of the largest lava deserts.

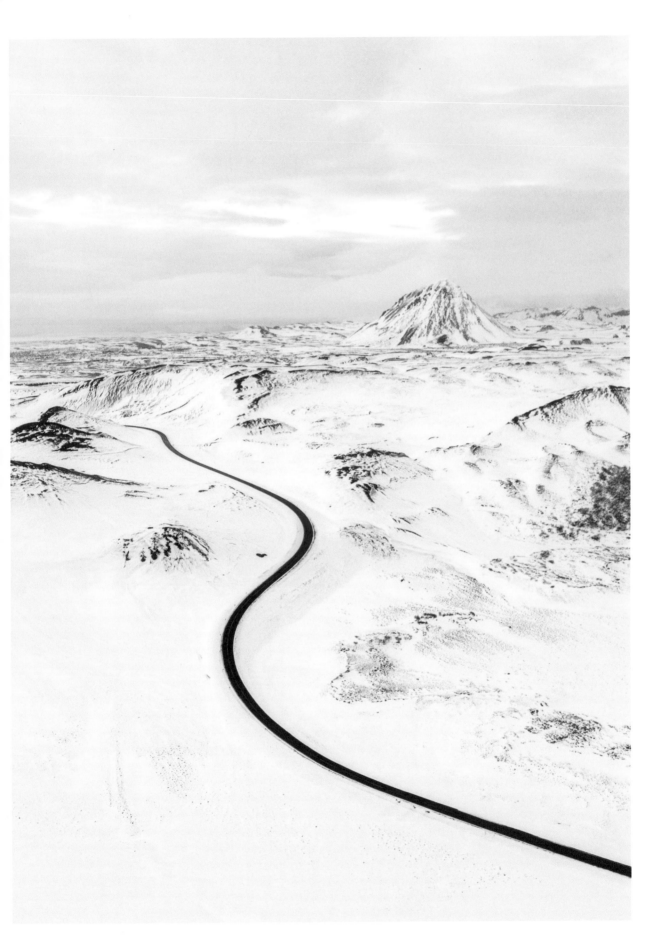

# THE ESSENTIALS

**20**

### SKAGAFJÖRÐUR

This fjord, one of the largest in the country, is a land rich in history and legends. It is home to Drangey and Málmey islands.

**21**

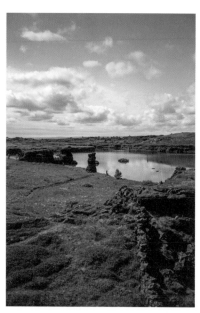

### LAKE MÝVATN

This must-see lake is an important nesting place for several species of wild ducks.

**22**

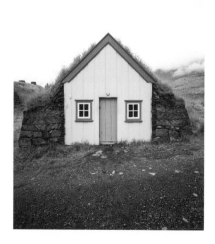

### GLAUMBÆR

Here, the Skagafjörður Folk Museum, housed inside a very old, transformed farmhouse, honors the history of sheep farming in Iceland.

**23**

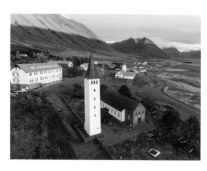

### HÓLAR

One of the dioceses of Iceland, this location also hosts an antenna from the University of Iceland, whose programs include those within the tourism trade.

**24**

### GÁSEYRI POINT

Each year around July 20, the site of Gásir, located at the tip of Gáseyri, becomes a stage for a three-day celebration in which participants reconstruct the life of medieval traders.

**25**

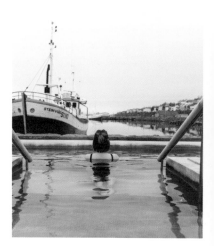

### SIGLUFJÖRÐUR

In Siglufjörður, the Sigló Hótel bath offers a nurturing break in the heart of the city.

**26**

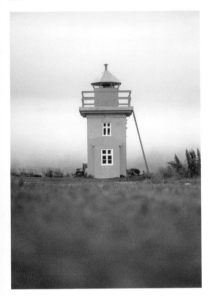

### SVALBARÐSEYRI LIGHTHOUSE

Located on the east coast of Eyjafjörður, this lighthouse surprises with its small size. Although old-fashioned in their navigation equipment, such small lighthouses remain a source of charm.

**27**

### DETTIFOSS

Wider (330 ft/100 m) than it is high (150 ft/45 m), its waters flow to Selfoss and Hafragilsfoss waterfalls.

**28**

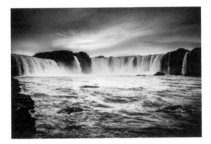

### GOÐAFOSS

Legend says that a local chief threw his pagan statues into these falls to signify his renunciation of the Viking gods and his submission to Christianity.

**29**

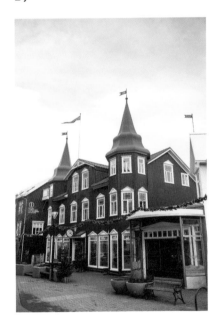

### AKUREYRI

Here, tourists are charmed by the colorful old wooden houses of the country's second largest city.

**30**

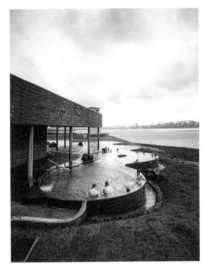

### GEOSEA BATHS

In Húsavík, GeoSea completes an already very rich offering of baths, including those of Jarðböðin, the municipal swimming pool of Hofsós, and the small spring of Grettislaug.

**31**

### NÁMAFJALL

It's one of the most accessible geothermal zones, yet also exotic, taking you back to the origins of the world.

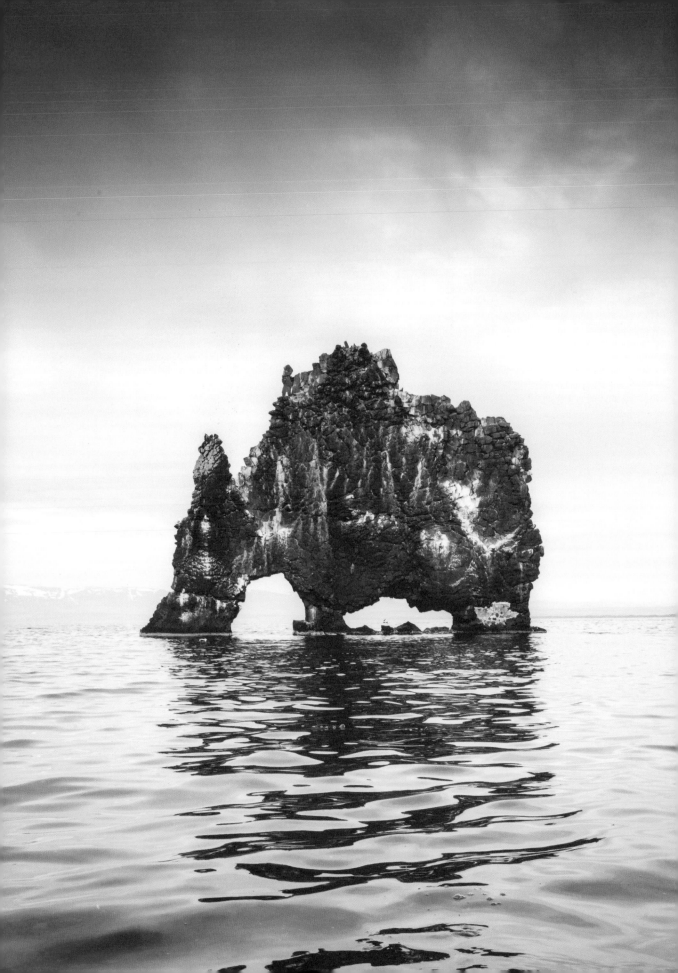

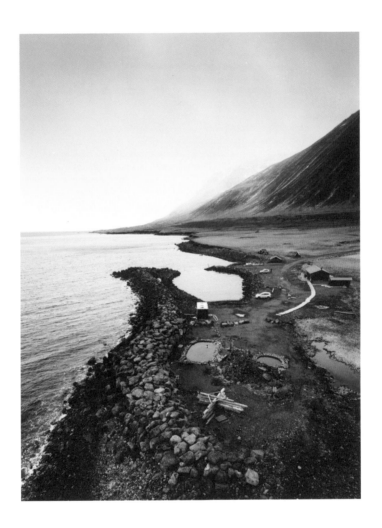

**ABOVE**

*The recently redeveloped Grettislaug spring offers water
at about 104°F (40°C), perfect for relaxing.*

**LEFT**

*The sea stack of Hvítserkur, in the Vatnsnes peninsula,
seems nearly accessible by foot at low tide.*

## THE SECRETS OF GEOTHERMAL ENERGY

### 1. GEOTHERMAL ELECTRICITY PRODUCTION

In 2014, 66 percent of Iceland's electricity generation
was from geothermal sources.

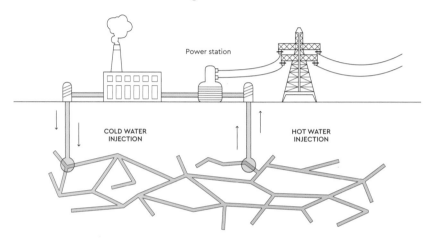

### 2. ALLOCATION OF GEOTHERMAL ENERGY

Geothermal energy is mainly used for urban heating:
Nine out of ten households use it. It also produces electricity,
mainly supplying the aluminum industry.

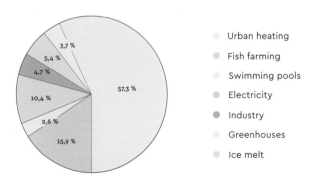

- Urban heating
- Fish farming
- Swimming pools
- Electricity
- Industry
- Greenhouses
- Ice melt

# NATURAL ENERGY

## EARTH'S RICHES

Although, as noted in ancient texts, the use of hot springs by men arriving
by sea dates to the early days of Iceland's occupation, the island had to
wait until the twentieth century and the advent of technological advances
to envisage a systematic exploitation of its geothermal resources.

It eventually became clear that the island's hot springs were not just useful as a pleasant pretext for relaxation. And the presence of much hotter sources, in the form of mud pools, thermal waters, steam vents, and geysers, was evidence that merely drilling into the earth could access the riches of the subsoil to use these sources in a new way. It took some time for the technological means to do so to become available, however.

Although the first house to be heated by geothermal energy was in the 1920s, the large-scale exploitation of thermal energy did not really begin until the oil shortages of 1973 and 1978. To catch up, Iceland developed a major network of geothermal power plants, particularly around Reykjavík and at Krafla near Lake Mývatn. This was not without risks, however, as geothermal sources mean the presence of an active volcanic center generating earthquakes and eruptions. This is evidenced by the eruptive cycle of the Kröflueldar between 1975 and 1985, which threatened to destroy the settlements at

Kröflustöð; the molten lava burst through the wells and erupted several feet high through the fountains.

Today, the best-known application of geothermal energy is the development of the small open-air pools (*heitir pottar*) in which people relax while sitting in the water. But there are many other applications: For example, 90 percent of Icelandic houses are heated by geothermal energy, as are public facilities, schools, hospitals, industrial sites, and greenhouses where flowers, fruits, and vegetables bloom in abundance. The Icelanders have developed such advanced technical know-how in this field that they export it abroad and even claim they are able to drill more than three miles (five kilometers) deep. All that remains is to find the materials that will withstand the heat released by friction during drilling and the extreme temperatures of the subsoil, which gradually becomes hotter deeper into the Earth's crust. Thanks to this gift from nature, Iceland has gained its energy independence and is hailed as one of the "greenest" countries in the world.

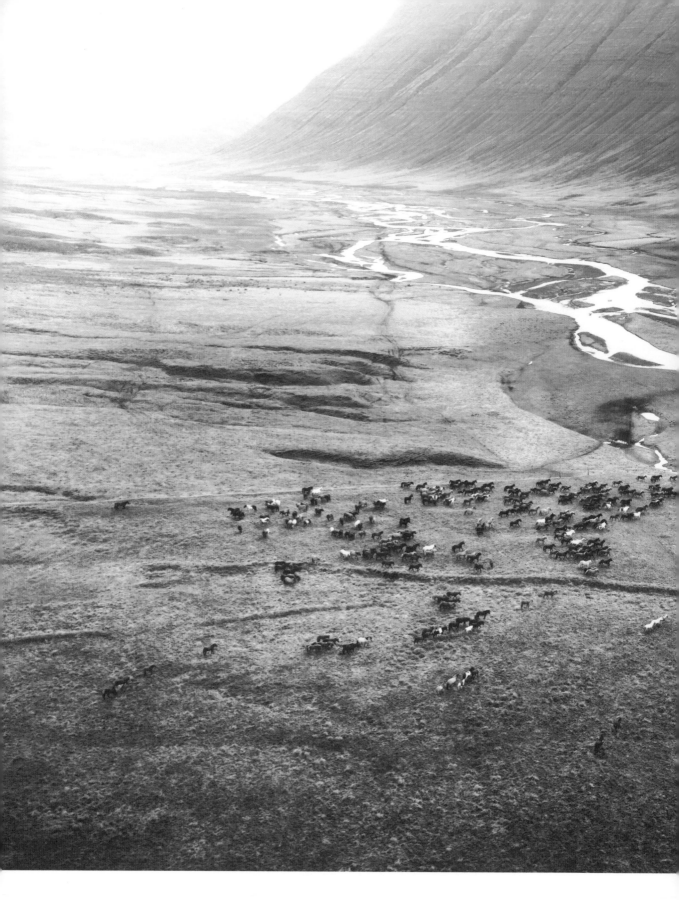

*Every autumn, hundreds of horses are herded in Laufskálaréttur.*
*This unique event is part of the calendar of Icelandic folk festivals.*

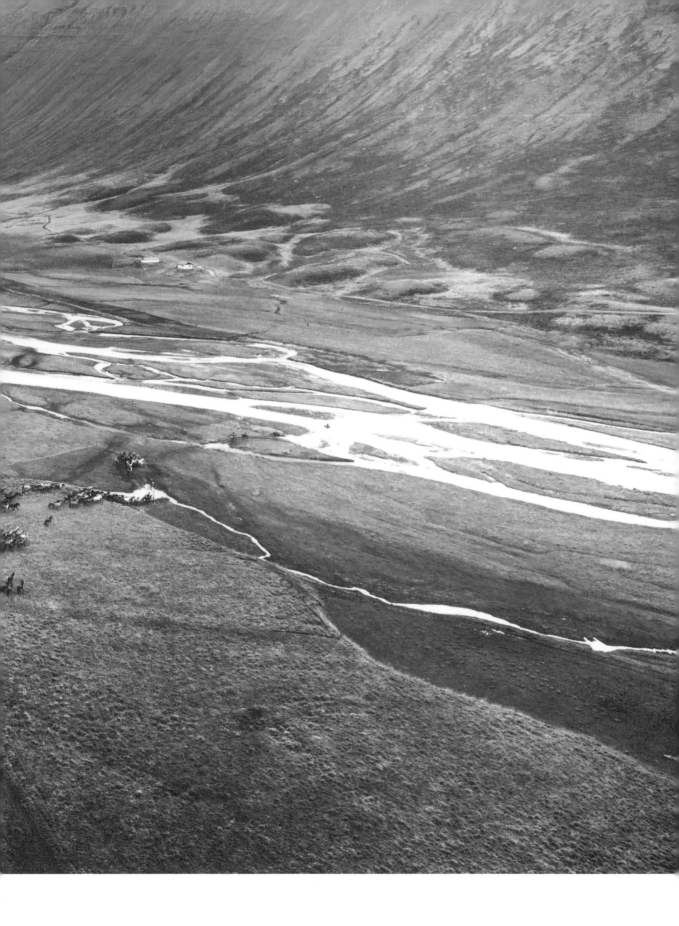

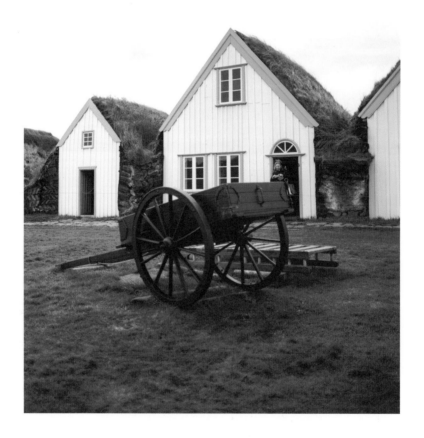

**ABOVE**

*The small museum of Glaumbær includes a traditional farm from the
nineteenth century, with its peat walls and grass-sodded roofs.*

**RIGHT**

*Completely renovated, the tiny Grafarkirkja turf church
dates from the seventeenth century.*

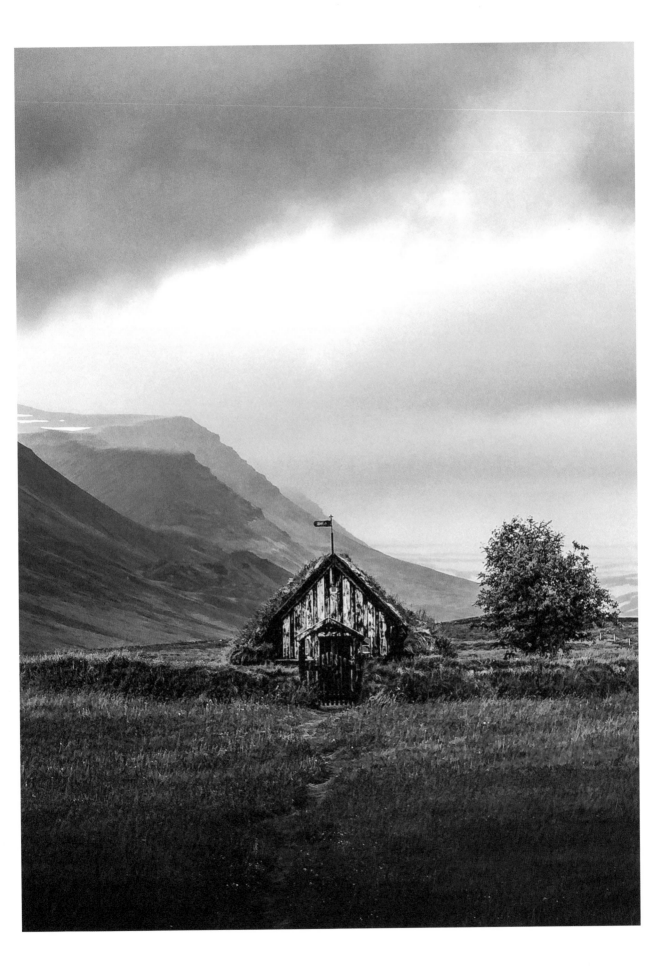

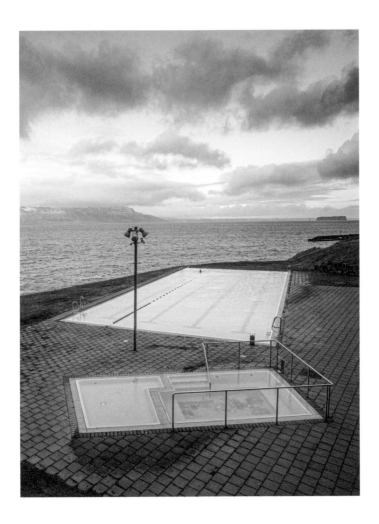

*The municipal swimming pool of Hofsós is uncovered, like all those in Iceland.
However, this one offers a little extra: an unforgettable view of the fjord!*

*Since its Christianization in the eleventh century, Iceland
has been divided into two dioceses, Skálholt in the south and Hólar,
in the Hjaltadalur Valley, in the north.*

LIFESTYLE

# DEPLAR

## LUXURY "AMONG THE TROLLS!"

What could be more satisfying than seeing a project through to its completion without giving in to any compromises? On the Tröllaskagi peninsula, "the troll peninsula," the Deplar Farm ecolodge is the result of just such an incredible project.

Transforming an old sheep farm into a luxury hotel could seem an impossible task, and dreaming it is one thing but achieving it, as was done here, is quite another. At the ecolodge, luxury is nothing ostentatious or flashy: The richness of this hotel lies in the fact that everything is in its place and that every detail has been thought out.

From the outside, visitors first get the impression of entering a simple black timber house with a grass-covered roof just as houses were constructed here for centuries—and in which people lived deprived of all modern comforts in a country covered with lava fields where stone to build more substantial houses was lacking. But such a comparison stops there. In this remote setting, no amenity has been forgotten. Immediately after entering, the visitor quickly realizes that everything has been designed for his well-being and comfort: a relaxation room, massage rooms, an exclusive spa with breathtaking views, a wine cellar, multimedia lounge, karaoke room, billiards, ping-pong table, foosball table, musical instruments, and a bar separated by a lounge offering comfortable sofas and armchairs.

The idea to build this ecolodge in such a remote place would seem a bit crazy, but it was born from

the passion its designer has for skiing and for the mountains dominating over the sea, culminating into his idea to offer his guests the prestigious activity of heli-skiing, which involves placing a skier aboard a helicopter to descend the mountain off-trail after a flyover of the valleys and snow-capped mountains.

The Deplar Farm ecolodge fits perfectly, and with calculated discretion, into the glacial valley where it was built on a road leading to the ocean, invisible from the hotel, but whose lake subtly suggests its presence. This is another one of Iceland's many incredible end-of-the-earth locations. Its large bay windows fit harmoniously with the exterior of the building. The restaurant has been designed as a meeting place for sharing meals and exchanging stories about the day's activities, particularly, of course, heli-skiing, but also, depending on the season, sea excursions, snowshoe hikes, mountain biking, snowmobiles, and many others—all supervised by qualified guides, attentive and discreet, and available at all times.

In the evening, the visitor can retire in the cozy and elegant comfort of one of thirteen rooms where absolutely everything has been provided to ensure an unforgettable stay.

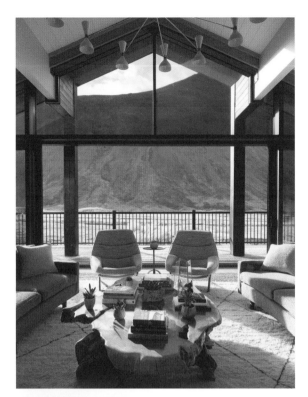

## A COZY NEST

Charm and authenticity make each room a cozy nest in perfect harmony with the energy emanating from the fjord.

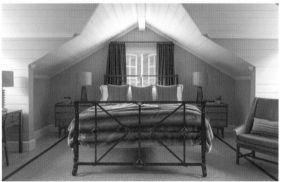

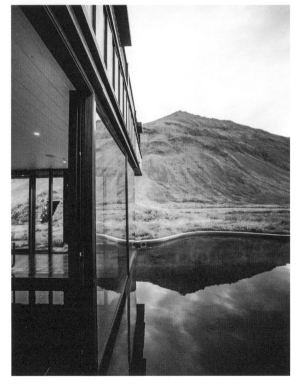

## ABSOLUTE WELL-BEING

The large lounge is bathed in natural light. The spa, meanwhile, offers a pool overflowing into the outside as part of its many relaxing amenities.

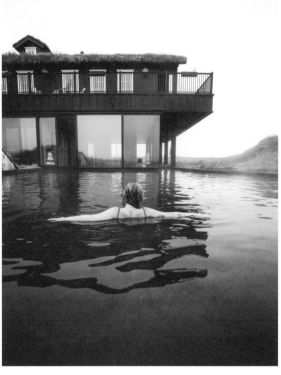

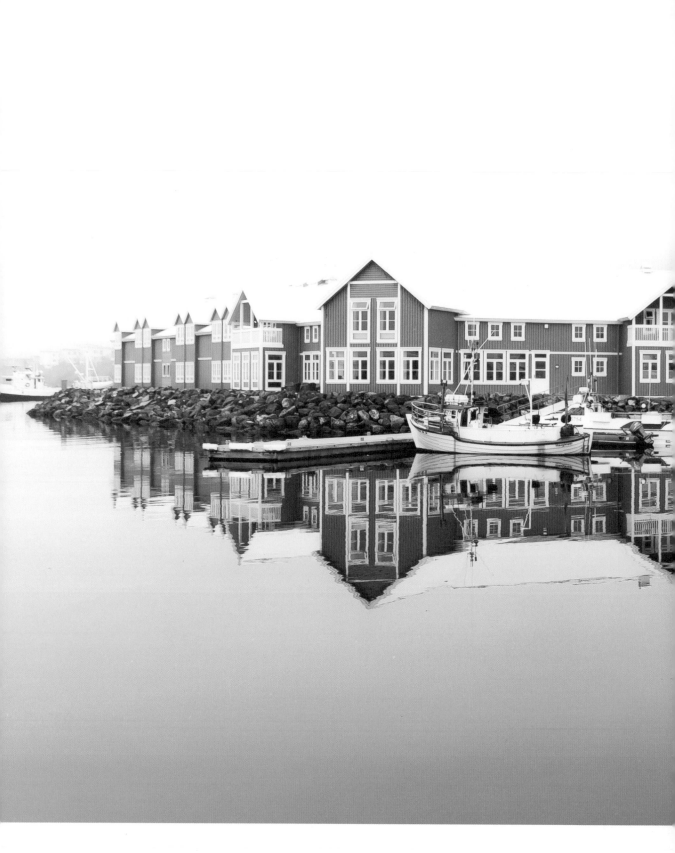

*Situated between steep mountains, Siglufjörður (called Sigló by Icelanders) is an amazing village.*
*Norwegian-style Sigló Hótel is a haunt of heli-skiing enthusiasts.*

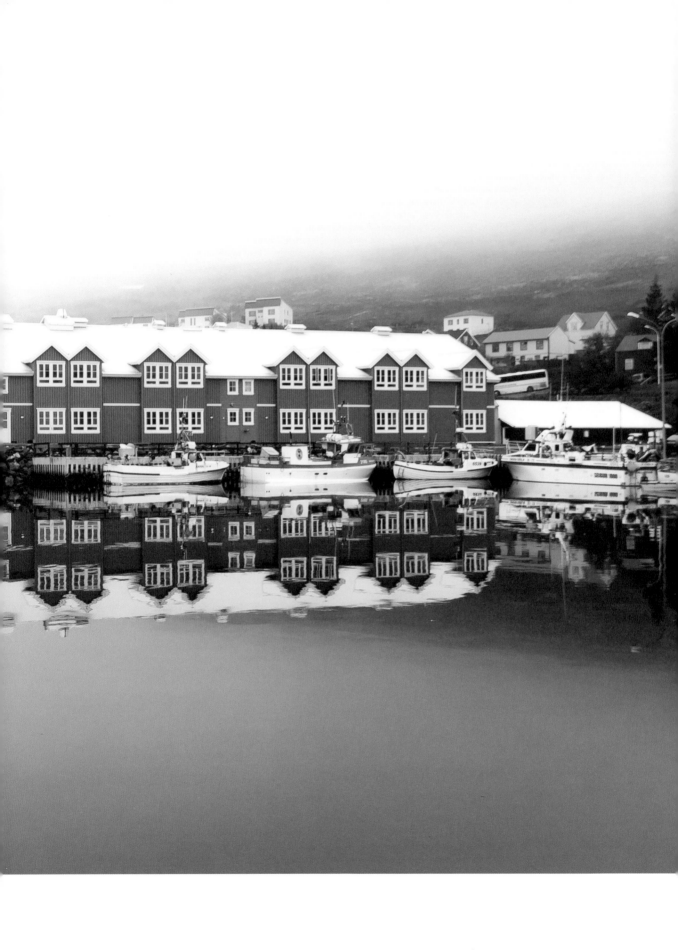

NATURE

# SHEEP AND HORSE BREEDERS

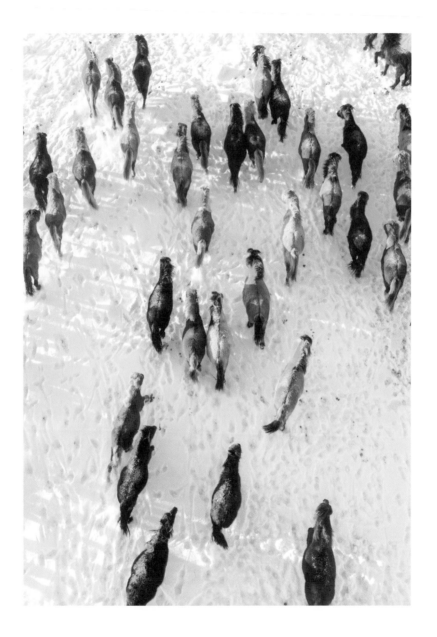

### SMALL ICELANDIC HORSE

Originally from Norway, this purebred arrived with the first settlers and
has never been crossbred with another species for more than a thousand years.
Today, there is about one horse for every four inhabitants.

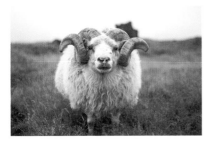

**RAM HORNS**

Rams' horns take on numerous shapes.

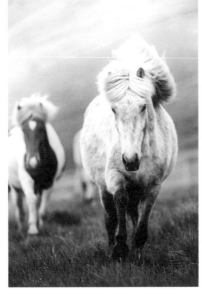

**PLENTIFUL DESCRIPTIONS**

The Icelandic language has many words to describe a horse's coat.

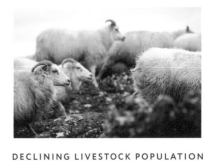

**DECLINING LIVESTOCK POPULATION**

With less than five hundred thousand head, livestock has decreased by half over the last thirty years.

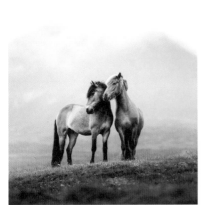

**ICELANDIC HORSES**

Despite their size close to that of a pony, these are horses in their own right.

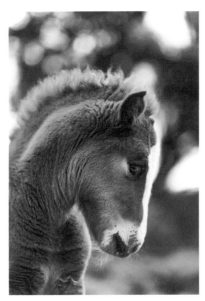

**BEAUTIFUL MANE**

Born in spring, the foal's mane will lengthen as he grows.

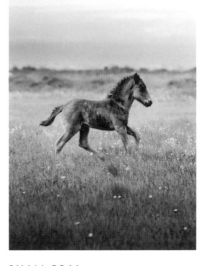

**SMALL FOAL**

Foals enjoy a life of running freely before many are then trained.

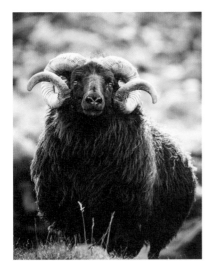

**BLACK AND WHITE RAMS**

The wool industry favors white sheep, but there are other colors!

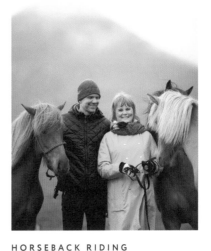

**HORSEBACK RIDING**

Thousands of Icelanders enjoy horseback riding no matter the weather.

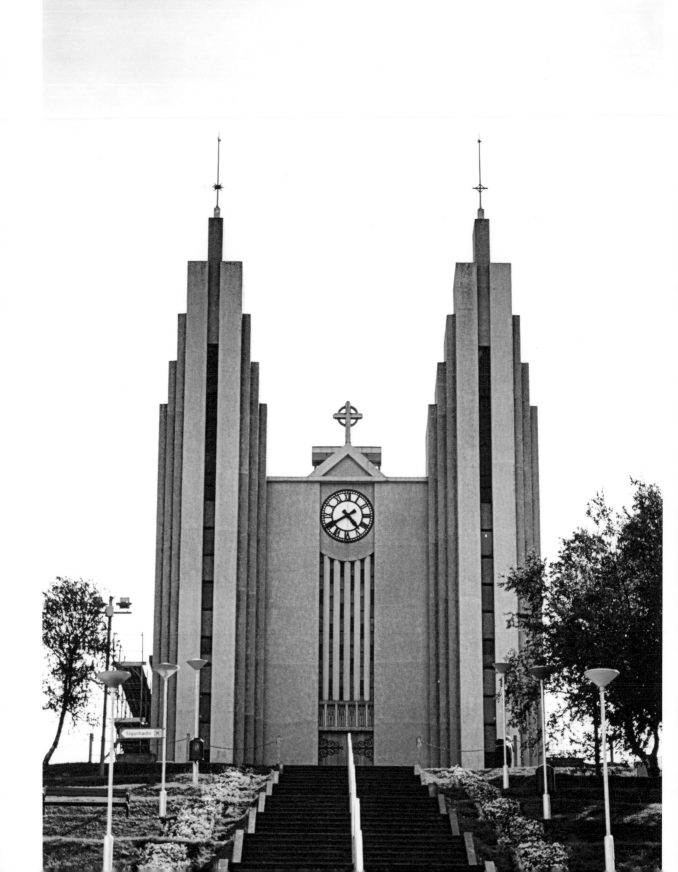

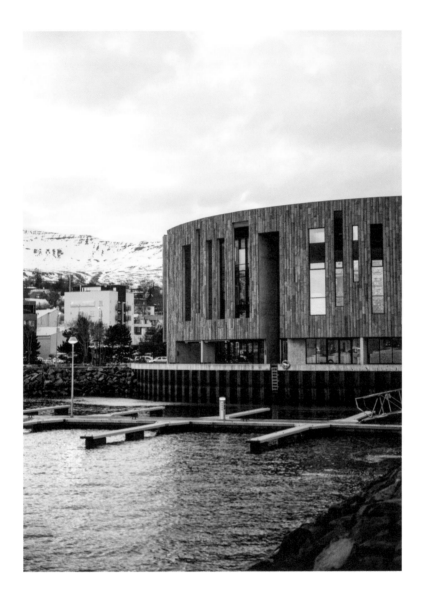

**ABOVE**

*The Hof Cultural Center in Akureyri reconnects with*
*traditional wooden architecture.*

**LEFT**

*Built in 1940, the church of Akureyri breaks with the local tradition*
*with its concrete facade rather than one made of wood.*

HISTORY

# THE SAGA OF THE SURFER

Every era needs its heroes. Iceland's heros of yesteryear are represented in the "family sagas." Today's island heroes face, with courage, the bad weather of the north fjords while balancing on their boards.

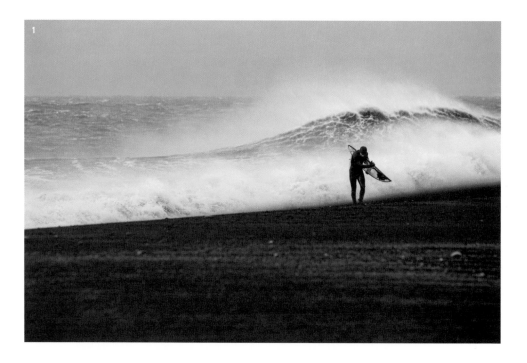

The heroes of Iceland's early days were Burnt Njáll, Gunnar of Hlíðarendi, Gísli Súrsson, and Egill Skallagrímsson. The sagas also included women of great courage. The common thread running through all these stories are characters who triumph over seemingly insurmountable odds that fate has bestowed upon them. In some ways, to be a hero is to be born under an unlucky star, to carry within oneself something dark, irredeemable, and tragic. We can witness in the qualities of such a hero the beginnings of his fall from grace. In short, the saga is a genre of stories far from a typical happy Hollywood ending.

The *Saga of Grettir* tells the story of one such hero who lived in the north of Iceland in the wide fjord of Skagafjörður during the first half of the eleventh century. Grettir was endowed with an unusual physical strength, hence his name, Grettir Sterkur (Grettir the Strong). Banished, he wandered for

## THE HARSHER THE CONDITIONS, THE MORE INTENSE THE EXPERIENCE. IT'S THEIR WAY OF FACING AN EXTREME . . .

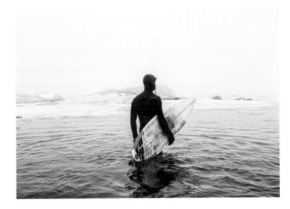

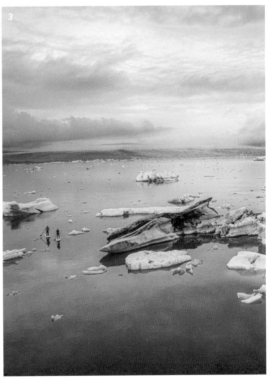

nearly twenty years over inhospitable lands, was hunted down like a wild beast, and ended his life on a rocky island where he died a violent death after a betrayal. This mighty soul, a true rebel, could not have known any other end; this was his fate. Some believe that the men who had the courage to leave Norway and the tyranny of a monarch were the most spirited and enterprising, though perhaps not the wisest. Their ancestral characteristics, passed down to new generations, might explain the impulsiveness attributed to some Icelanders today, as if to illustrate the adage that the apple doesn't fall far from the tree.

Who are examples of men and women of modern times who represent audacious character and strength? You can discover some of them on the waters, but to do so, you will have to be curious enough to brave the bad winter of Iceland's north fjords. Equipped with boards and suits, surfers revel in the cold, violent, biting north wind of the breaking waves that invade the hollows of snow-capped fjords, pushed in from the Arctic Ocean by glacial sea currents. The harsher the conditions, the more intense the experience for those who love sensational adventures. This is their way of facing extremes and adversity, and of affirming their thirst for adventure—but this time with a happy ending.

1. A surfer fights against the wind on a stretch of one of Iceland's black-sand beaches.

2. The icy seas don't stop the most experienced surfers.

3. The paddleboard is an amazing way to discover Icelandic glaciers.

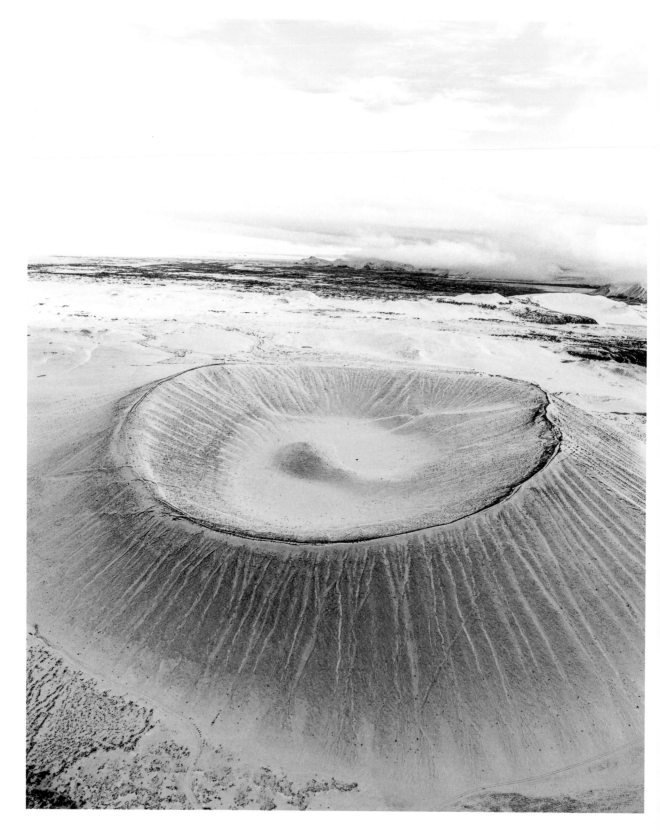

*The Hverfjall crater evokes the surface of the moon. It formed 2,500 years ago from a short but powerful eruption.*

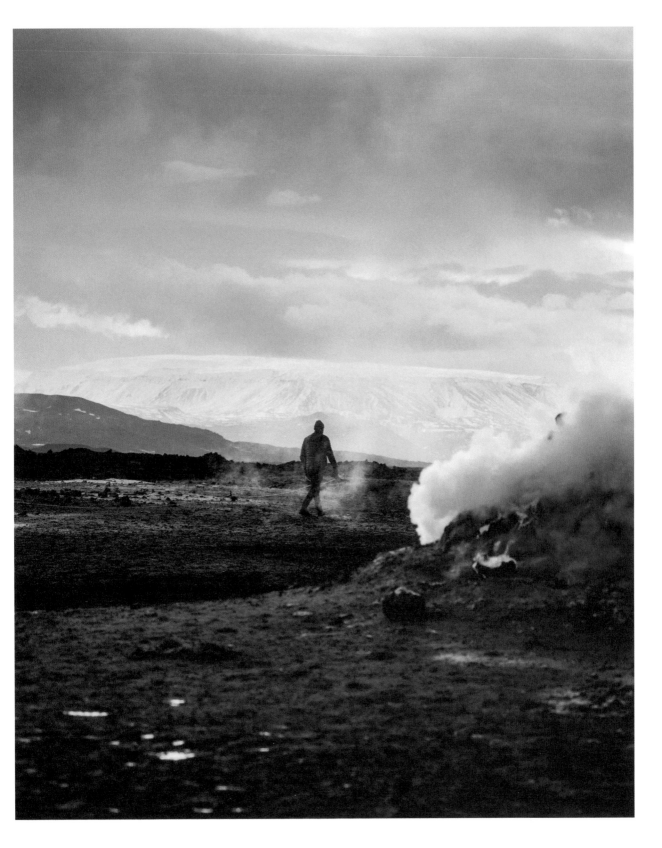

*From the Middle Ages to the nineteenth century, sulfur from the Námafjall geothermal field
was collected to manufacture gunpowder used by the Royal Danish Army.*

*In Húsavík, the new GeoSea baths offer a breathtaking view of Skjálfandi Bay,*
*where you can observe the ballet of various marine mammals.*

*In Húsavík, the Gamli Baukur restaurant is built entirely of driftwood*
*originating from the mouths of the great Siberian rivers.*

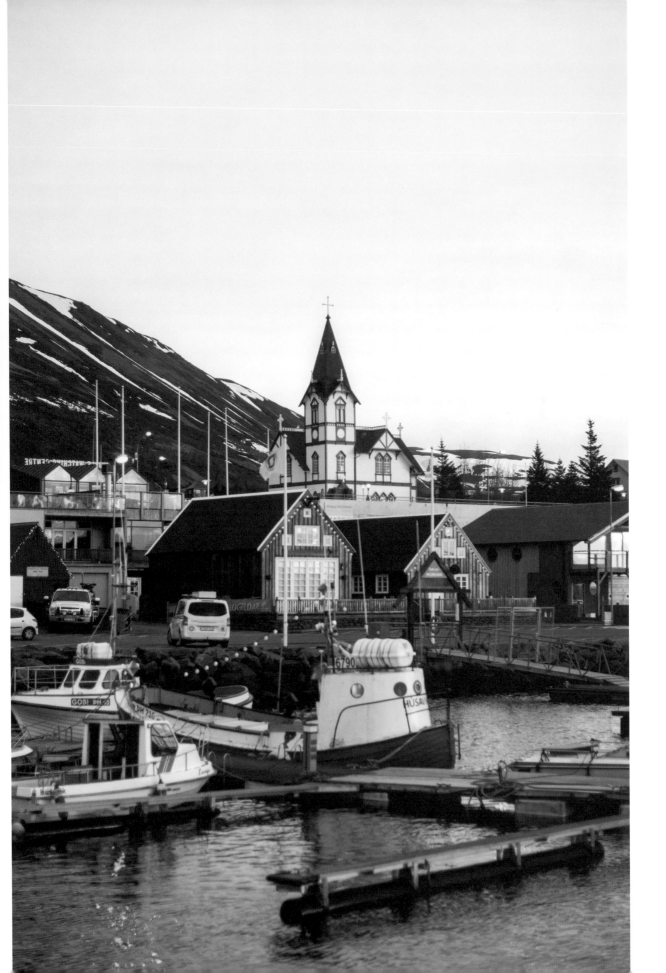

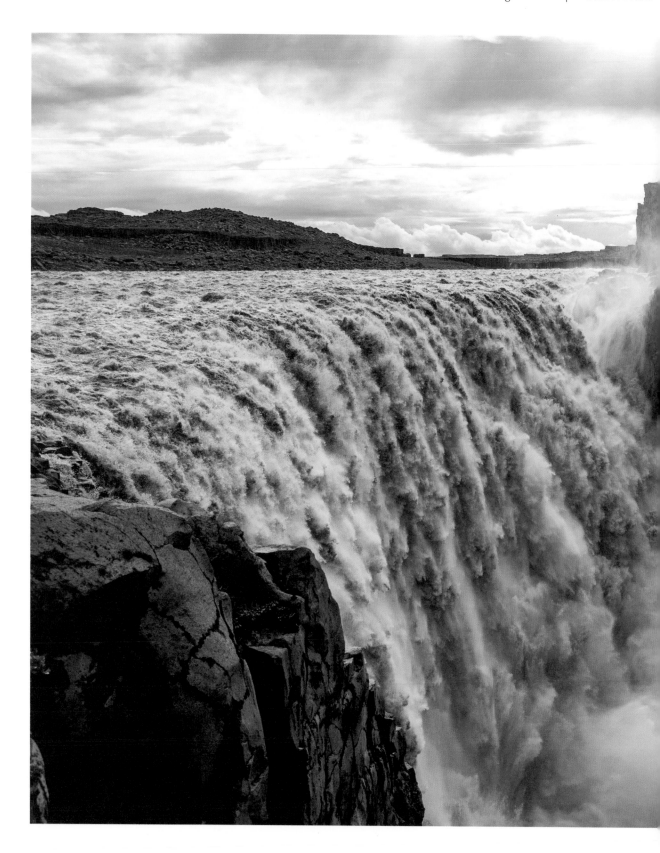

*With its exceptional output, Dettifoss marks the beginning of the Jökulsárgljúfur,*
*literally the "gorge of the Jökulsá in Fjöllum."*

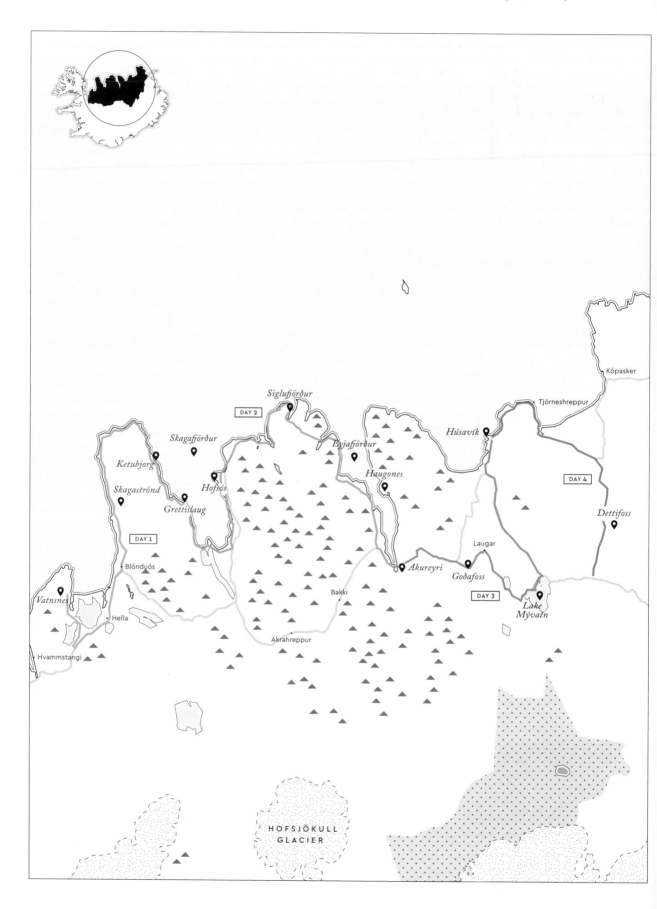

# 4 DAYS IN THE NORTH

The north marks a clear break between Iceland's early geological beginnings, eroded by glaciers, and the events of the active volcanic rift that regularly transform it. Fasten your seatbelts . . .

### DAY 1: FROM THE VATNSNES PENINSULA TO GRETTISLAUG

North Iceland touches the Arctic Circle. Its beauty is undeniable but quite understated, as in the Hvítserkur sea stack in the Vatnsnes peninsula, best known for its seal colonies. A detour through the Skagaströnd peninsula allows you to discover several basalt columns, as in the unlikely place of the Kálfshamarsvíti lighthouse. On the east side of the peninsula, the Ketubjörg cliff offers stunning views of Skagafjörður. And for lovers of hot water, a small detour by the beautifully converted Grettislaug spring is a must.

### DAY 2: FROM SKAGAFJÖRÐUR TO AKUREYRI

This is an opportunity to go from Skagafjörður, a territory of sheep and horses with a rich history, to Eyjafjörður, home to Akureyri, the country's second largest city with a population of seventeen thousand. In between is the Tröllaskagi peninsula. In Hofsós, the Emigration Center tells the story of the thousands of Icelanders who set out to conquer the New World. In Siglufjörður, the museum devoted to the era of herring fishing has no equal. In winter, heli-skiing enthusiasts descend the slopes above the ocean. In summer, there is not a beach nor watery area that is not accommodating colonies of migratory birds. Whether you are in Dalvík, Hauganes, or Hjalteyri, a trip out to sea is a must for whale watching in a unique setting. Finally, nestled at the very end of the Eyjafjörður, Akureyri, despite its small size, offers up its old timber houses, restaurants, and a sense of true well-being.

### DAY 3: FROM AKUREYRI TO LAKE MÝVATN

The "waterfall of the Gods," Goðafoss, marks a transition: It is the gateway to the sumptuous landscapes of Lake Mývatn and its surroundings. In Leirhnjúkshraun, the lava field created by the cycle of eruptions between 1975 and 1985 impresses the observer with the terrible force of creative destruction it still expresses today. This is the end of these two worlds, as Lake Mývatn and its surroundings open onto an enormous plateau that announces the uninhabited Highlands. The bubbling mud pits of Námaskarð, the caldera of Krafla, the Hverfjall crater, the ruiniform formations of Dimmuborgir—to name just a few—follow one after the other. The best way to discover them is to stop and go for a walk.

### DAY 4: FROM HÚSAVIK TO DETTIFOSS

This is still the northeast, but already the interior Highlands are looming, devoid of all human presence. The colorful village of Húsavík offers outings at sea to whale watch and thermal baths above the ocean, the GeoSea. Next follows a succession of places vastly different from each other: serving as a connecting point, the glacial river Jökulsá á Fjöllum and its canyon Ásbyrgi, with its horseshoe-shaped cliff; the valley of Vesturdalur and its basalt column formations of Hljóðaklettar; the enchanting streams of Hólmatungur; and finally, at the origin of the canyon, the Dettifoss waterfall, the most powerful on the island. Now head east.

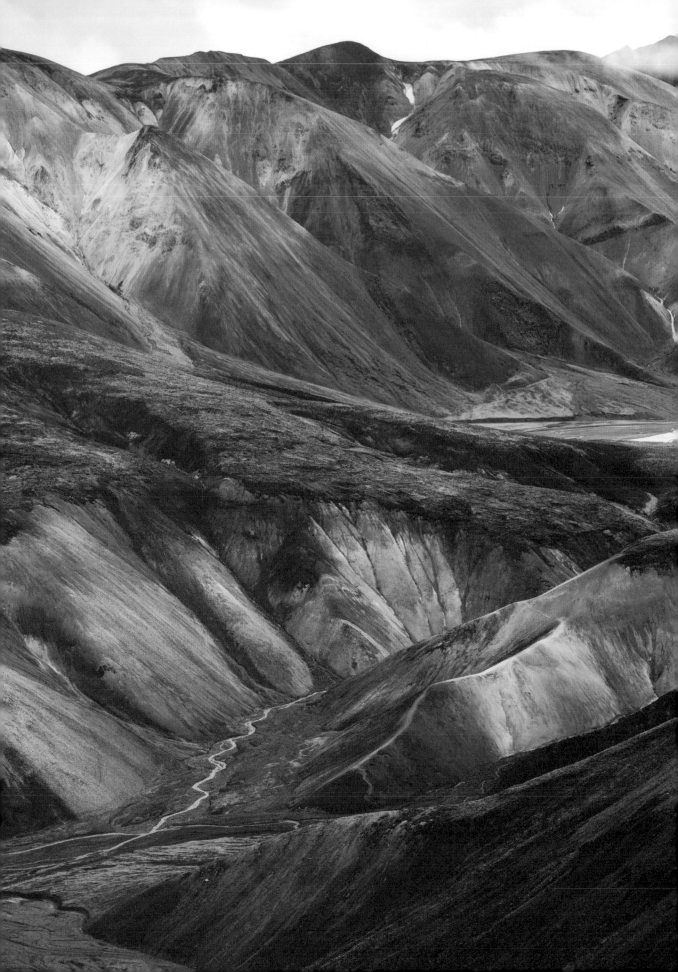

THE UNTAMED HEART

# THE HIGHLANDS

In Icelandic, the word *Hálendidae* refers to the vast
wilderness that covers eighty percent of the territory:
the uninhabited Highlands.

P. 112

*The Torfajökull caldera is a reminder that six percent of the country
is composed of acidic volcanic rocks in pastel hues.*

RIGHT

*The Kerlingarfjöll rhyolite massif is a combination of reliefs resulting
from subglacial eruptions and geothermal energy.*

For some, the Highlands offer nothing interesting, consisting only of vast eroded plateaus devoid of vegetation, covered with glaciers, stones, sand, and lava beaten by strong winds, sometimes so strong that a person can barely stand against them. Here there are no inhabitants. Nothing. At best, the water resources here have enabled Icelanders to produce cheap electricity to light up their increasingly spacious and modern homes. But for others, this area is the promise of a new horizon, of a unique exoticism. This area represents a conflict of interests between those in favor of increased exploitation of glaciers and rivers and those who are fighting for the extension of Vatnajökull National Park, the largest natural park in Europe, to include all these lands.

The supernatural creatures of Scandinavian legends, elves and trolls, are still thought to inhabit these untamed territories, and sheep arrive here to graze in the brief summers. But it is for the grandiose landscapes that so many people come to explore this area. During winter, the Highlands take advantage of the darkness to be left in solitude, yet as soon as the light announces the return of spring, adventure seekers arrive to measure themselves against all it has to offer, although, at this time of year, the land presents no more than a snow-topped vastness. Perched on snowmobiles or on 4x4s, or perhaps while skiing for the bravest among them, snow lovers eager for the great outdoors enjoy a short period before the breakup of ice begins, giving them a feeling of being on top of the world.

The arrival of summer offers the most adventurous traveler the opportunity to discover the titanic battle still being waged today by the active volcanic rift, propelled by the drifting tectonic plates and central volcanoes, such as the majestic Askja or Hekla. This great confrontation has shaped some of the most unexpected landscapes on the surface of our planet, making visiting Iceland a bit like flipping through a geology book that incites emotion. Here you discover the battle between fire and ice, although in some cases these two inseparable elements work together. This is an area made for walking without a precise purpose, except to take in the spectacular landscape. The Highlands are the untamed heart of Iceland.

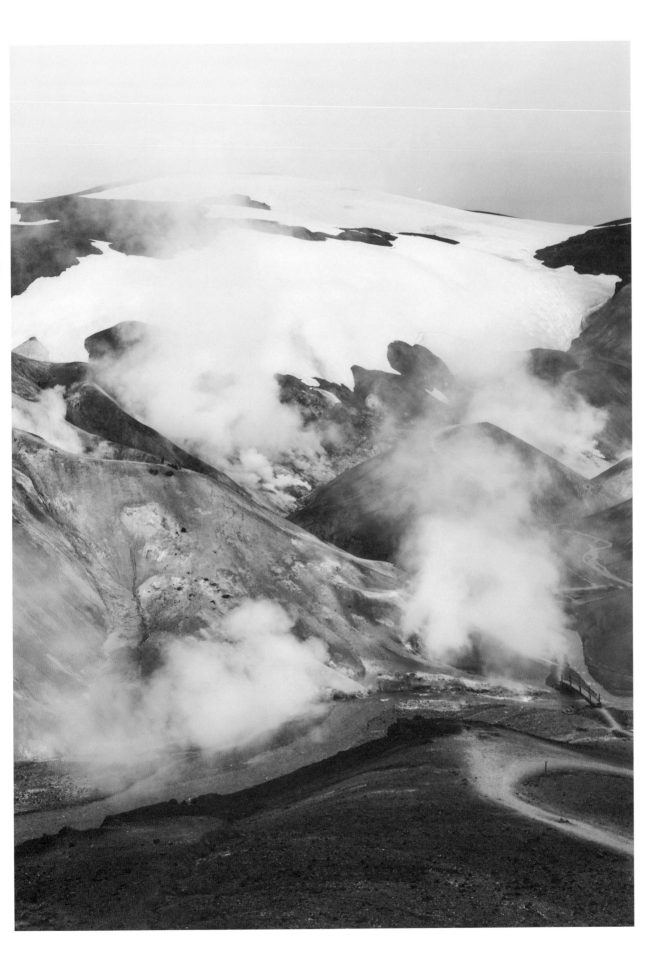

# THE ESSENTIALS

**32**

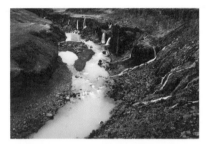

### SIGÖLDUGLJÚFUR CANYON

Because lava, which formed this canyon, is a porous rock, it is not uncommon to discover clear-water springs on desert plateaus.

**33**

### HRAFNTINNUSKER

Is it a coincidence that the word *hrafn* ("raven") is part of the name of this all-black caldera?

**34**

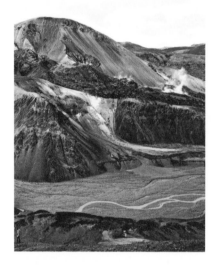

### LANDMANNALAUGAR

This hiking paradise is an invitation to explore ravines of eroded slopes overhanging the bottoms of glacial valleys.

**35**

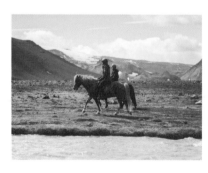

### NORTH OF MÝRDALSJÖKULL

These regions of the Highlands are accessible only on 4x4s, horses, on foot, or by bike. Going off path is strictly forbidden

**36**

### FJALLABAK REGION

Icelanders have traditionally crossed this area on horseback. To explore these wide-open spaces today, 4x4s are most often used.

**37**

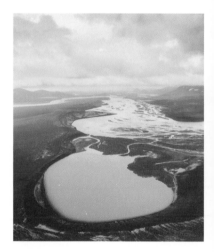

### TUNGNAÁ

This river begins west of Vatnajökull and flows into the Þjórsá river, the largest Icelandic river, passing through three reservoirs.

**38**

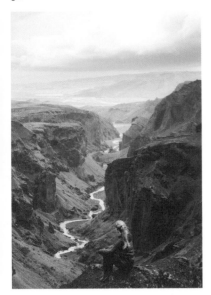

### HVANNÁRGIL CANYON

In the glacial valley of Þórsmörk, the canyons are numerous. This area can be accessed on foot or by bus.

**39**

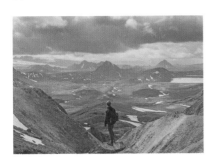

### LAUGAVEGUR TRAIL

This is one of the few marked trails. This trek goes from the geothermal springs of Landmannalaugar to the Þórsmörk nature reserve.

**40**

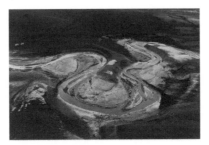

### AROUND HATTFELL

A winding stream, fluorescent green mosses, and very black ash: A traveler is captivated passing from a macro-landscape to a micro-landscape.

**41**

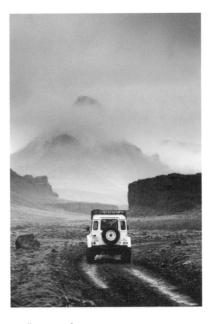

### TRÖLLAGJÁ FAULT

Located at the foot of the Einhyrningur mountain, this is an example of one of Iceland's fissure vents.

**42**

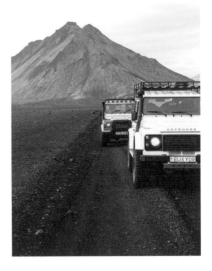

### MÆLIFELLSSANDUR DESERT

This desert of black ash lends itself to unforgettable crossings in a 4x4.

**43**

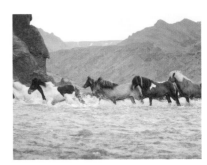

### ÞÓRSMÖRK VALLEY

When crossing these lunar landscapes, the most beautiful reward is to come across a herd of wild horses.

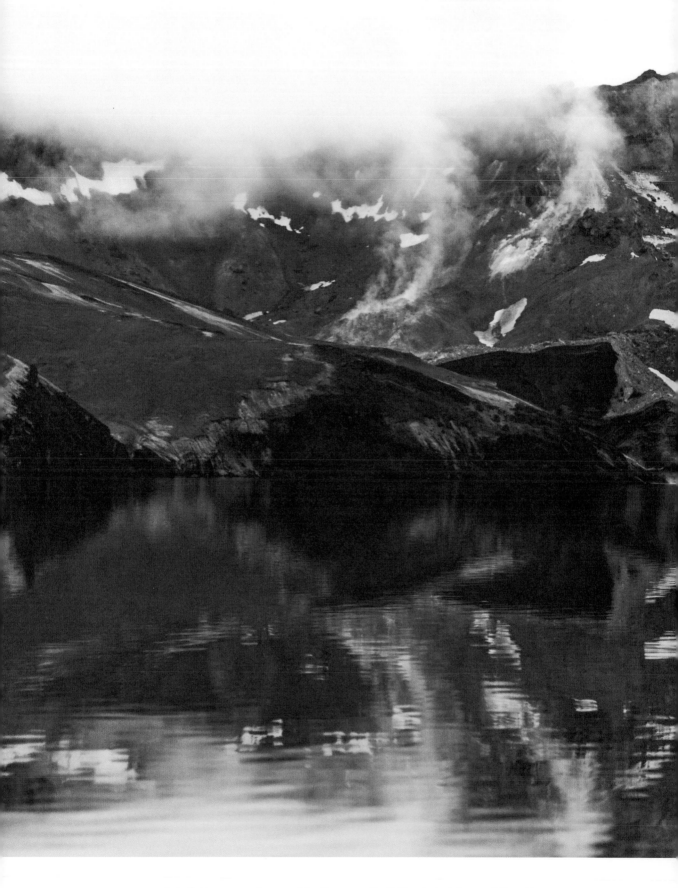

*Lake Öskjuvatn occupies part of the 40 square miles (100 sq km) of the vast Askja caldera, created by a huge volcanic eruption in 1875.*

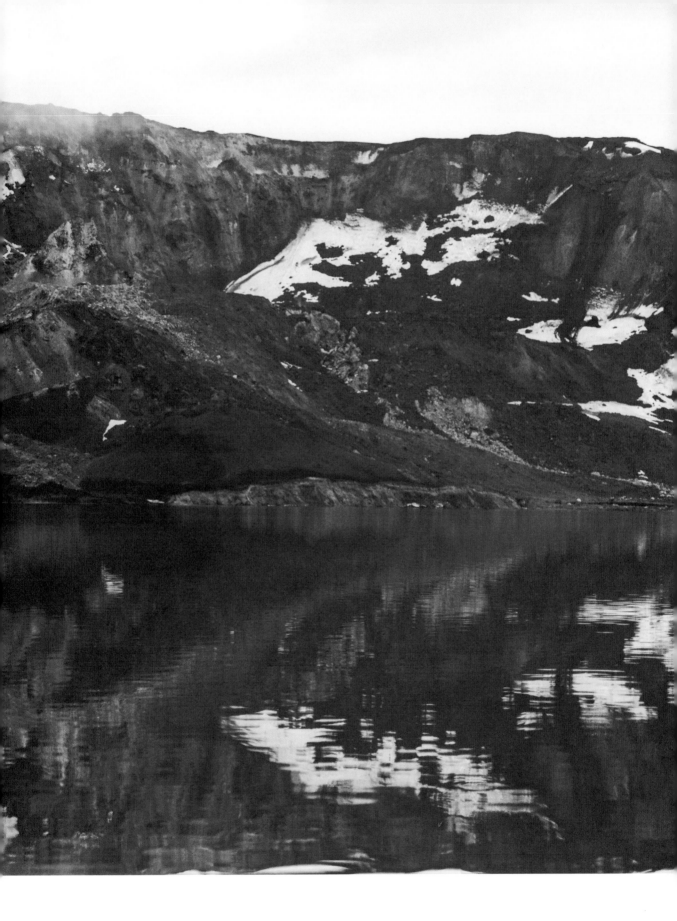

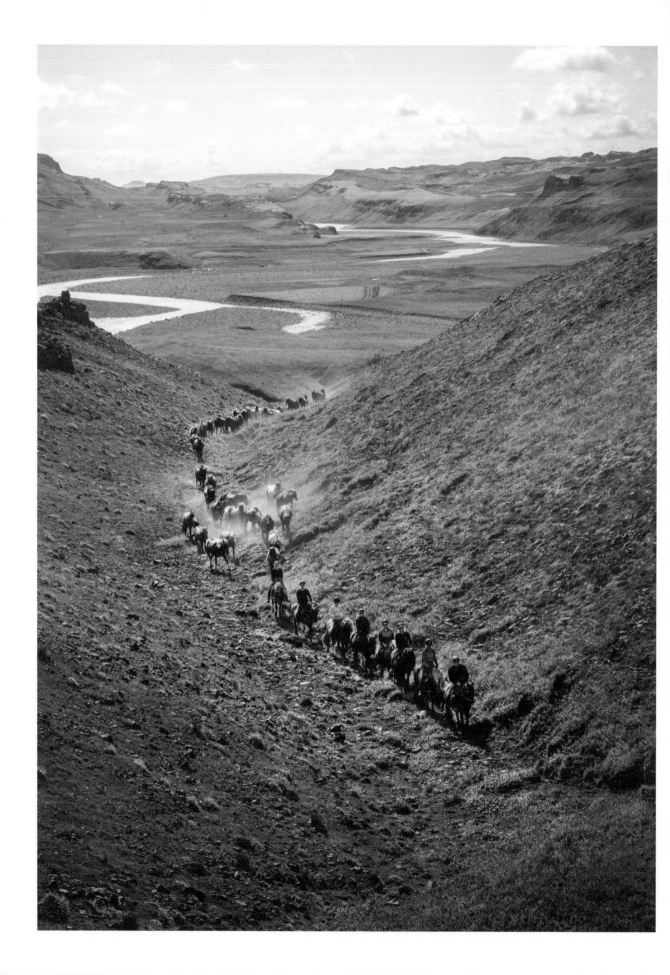

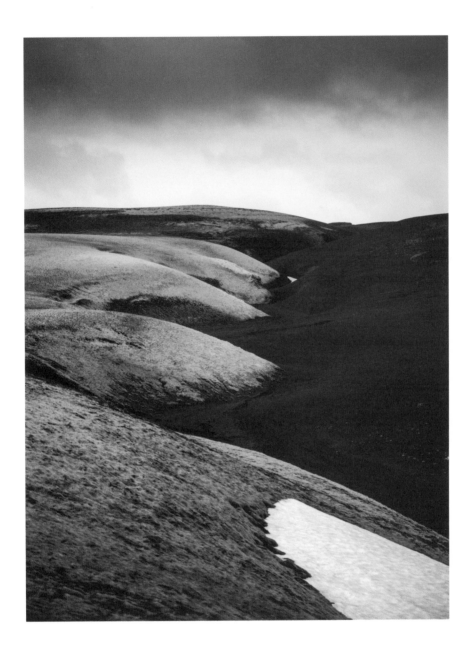

*With its black sand and green mosses, this landscape is typical of the
south central part of the island near the Fjallabak nature reserve.*

*Riding enthusiasts enjoy crossing the island over several days on horseback.*

UNDERSTANDING

# VOLCANIC ACTIVITY

Venturing into the Highlands is not just about exploring uninhabited—
and uninhabitable—high plateaus. It's about a personal experience with the
most untamed and seemingly impenetrable part of the island whose lands
are at least eight hundred thousand years old.

Exploring this territory is an opportunity to disco-ver the Iceland born from craters and fiery faults starting from the last ice age to about ten to twelve thousand years ago. This is the forgotten Iceland of an earlier era that places you in contact with the culminating conflict between the central volcanoes, such as Askja or Hekla, which take on the appea-rance of an oasis within the vastness of this territory, and the active volcanic rift created from the central mid-Atlantic ridge. The land here is streaked with long cracks, which materialize along the rift on a southwest-northeast axis in its southern region, then bending just north of the Vatnajökull glacier to form a semicircle that runs distinctly to the north. The Eldgjá fault, the "fire canyon," which can be followed for tens of miles, is an example.

Another characteristic of these lands, which are among the youngest on the planet, is that they bear the mark of subglacial volcanic activity everywhere, to which we owe the island's suitable description of "the land of fire and ice." Many eruptions have occurred under the glaciers, and some volcanoes, whose activity is still closely monitored, are located under hundreds of feet of thick ice.

Some mountains, such as Herðubreið, often referred to as Iceland's "queen of the mountains," bear traces of this activity, with a flat summit on which rests a small cone, evidence of its extinct phase.

One of the island's latest eruption—within the Holuhraun lava field, linked to the Bárðarbunga subglacial volcanic system which is about one hundred twenty miles (two hundred kilometers) long—originated beneath the Vatnajökull glacier. Lava ejections began in August 2015 and ended in March 2016.

### 1. AN ISLAND ON A HOT SPOT . . .

Iceland is located on a hot spot, namely an area of Earth's mantle where magma is formed, rising in a plume to the earth's surface.

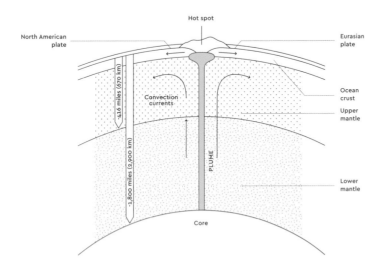

### 2. . . . AND BETWEEN TWO TECTONIC PLATES

The island is crossed from north to south by a collapsed fault in the Earth's crust—the rift, an emerging part of the mid-Atlantic ridge.

This relief, essentially located underwater, results from the meeting of the North American and Eurasian plates.

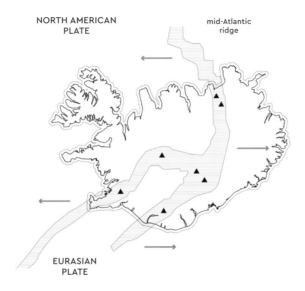

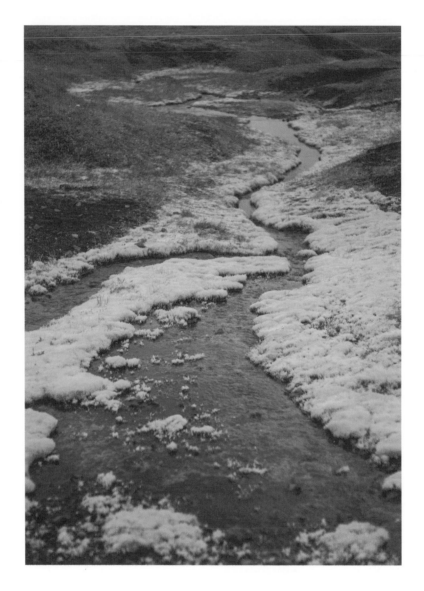

**ABOVE**

*In the Fjallabak nature reserve, a stream with saturated green mosses
appears almost fluorescent in foggy weather.*

**RIGHT**

*Depending on its flow, the Tungnaá becomes either a single
wide glacial river or several rivers*

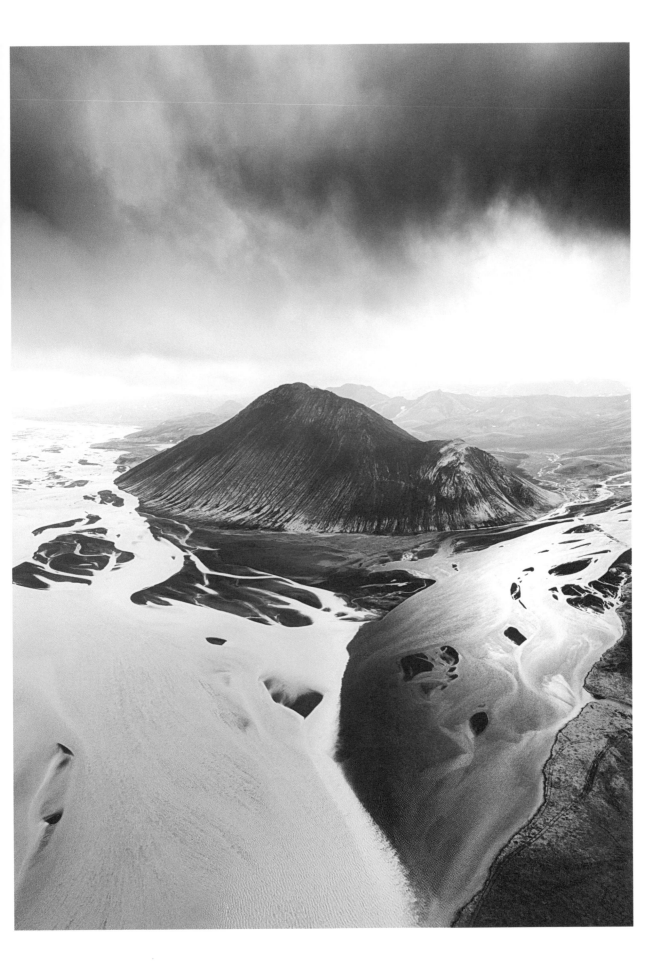

# BATHING

## IN SPRINGS

**In summer, sheep are not the only ones to disperse into the Highlands. Travelers eager for wide-open spaces rush into the territory to take to the trails during this brief seasonal window.**

Just as sheep are spotted gathered in small groups among the green meadows or around rocks in the arid desert, travelers also gather here in groups of all kinds—hikers, among the most rugged; those traveling aboard a bus, for those who prefer a more idle approach; family or friends driving a 4x4 on the countless miles of crisscrossing routes; or solo adventurers, perched on a mountain bike or on foot with a backpack. There is not just one way to discover the Highlands, but *many*. To visit here is to visit the island's most untamed locations at the edge of heaven and earth among landscapes impossible to find elsewhere.

Once perched on these heights, a person feels small, perhaps infinitely small, underneath massive, constantly changing skies of blue or storms and fog sometimes so dense you'll wonder if you'll ever find the clearing. The epicureans among the group will not forget to take along provisions for a picnic, which of course would be unthinkable without a good beer, while the more ascetic

adventurer will be satisfied with a swig of clear water taken from the first stream that comes along. But if there is one pleasure everyone will enjoy without hesitation, it is a dip in a hot spring that crops up in the middle of nowhere.

Here again, there are springs to suit everyone's tastes: big, small, some easy to access, while others require more effort. Each has a feature that makes it unique: those of moderate temperatures as well as others that require rearranging a few stones to act as a thermostat controlling the flow of water. Some open onto the surrounding landscape, allowing you to gaze out as far as possible across a lava field or vast plain, while others may be well hidden around the bend of a small gorge. One thing is certain, however: The springs provide a place for every type of adventurer to come together and share their day's unique experiences, with the hope that the dancing curtains of the northern lights will appear as a final performance to a satisfying day.

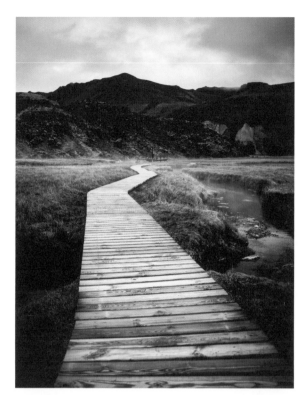

This hot spring is only accessible to hikers.
Rearranging a few stones is all it takes to lower
the temperature of the water.

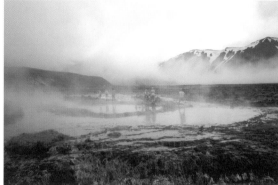

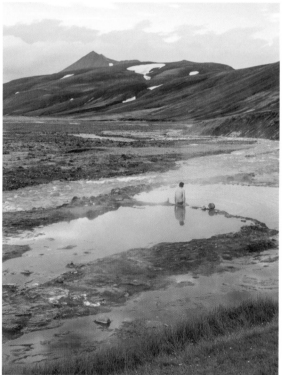

## LANDMANNALAUGAR

Iceland is full of hot springs. Some have basic amenities
to accommodate visitors. The very well known "people's
pool" serves as a departure point for hikes.

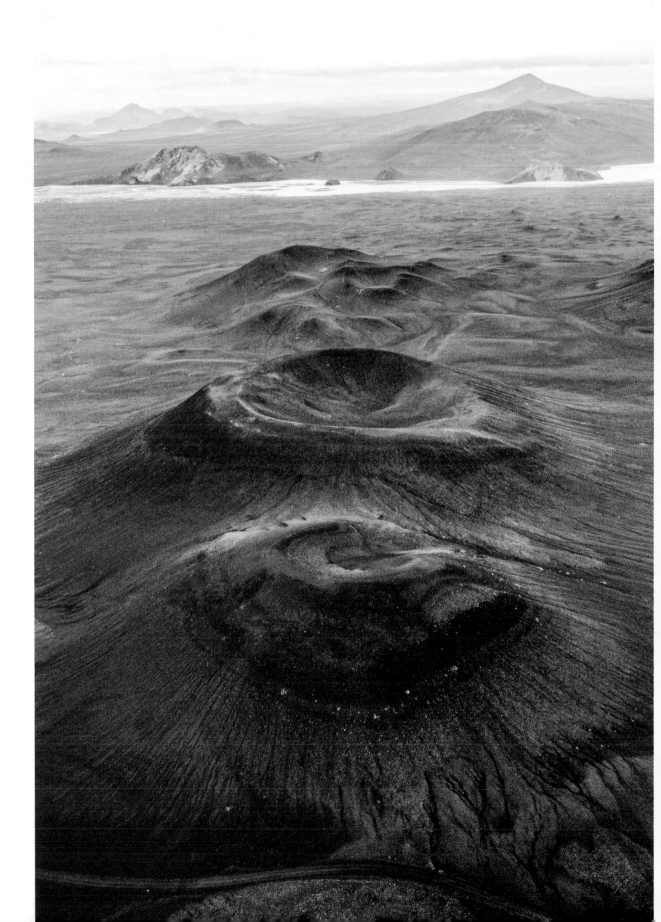

129

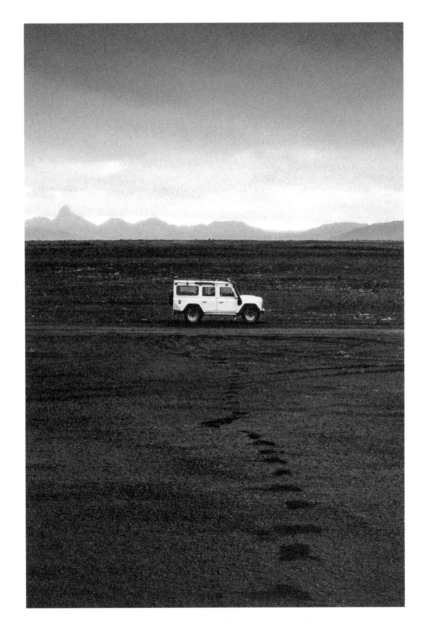

**ABOVE**

*At the back of the black-sand desert, characteristic of Fjallabak,
emerge the Þóristindur peaks.*

**LEFT**

*In the Fjallabak nature reserve, it is not uncommon to come
across craters that have yet to be named.*

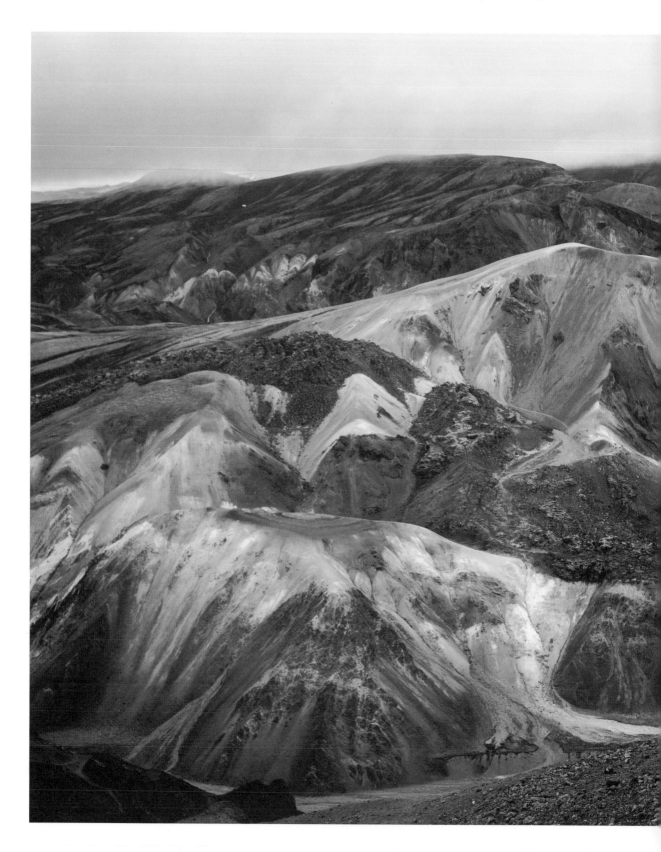

*View of the Brennisteinsalda volcano from Bláhnúkur. The famous Laugavegur hiking trail,*
*between Landmannalaugar and Þórsmörk, passes by its base.*

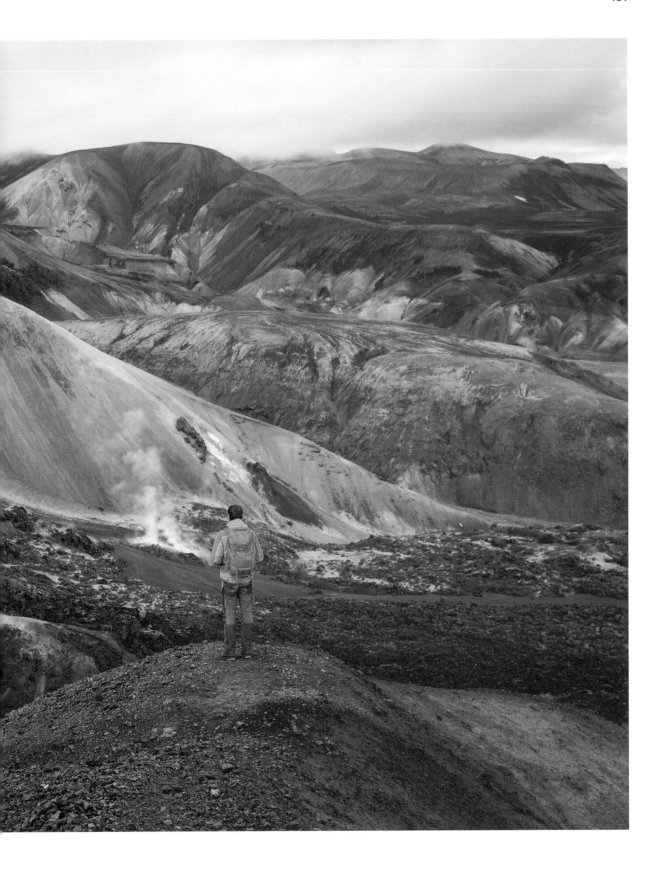

NATURE

# ICELANDIC FLORA

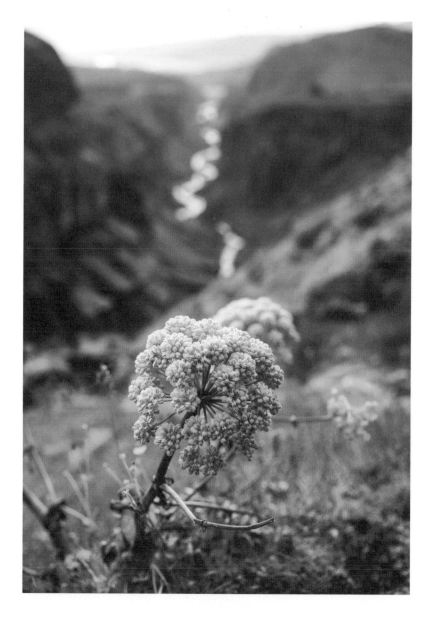

ANGELICA

*In Iceland, the size of this medicinal plant exceeds all others on the island.*

**ARCTIC THYME**

This fragrant plant covers vast expanses once summer begins.

**MOUNTAIN FLORA**

Icelandic flora is similar to that found in the Alps.

**GRASS OF PARNASSUS**

It can be found at an altitude of about 3,000 feet (930 m) near Eiríksjökull glacier.

**BOUQUET OF COLORS**

The flowers of Iceland color the landscape during summer days.

**ALPINE BARTSIA**

A flower characteristic of the Highlands.

**AUTUMN HAWKBIT**

This plant blooms at the end of summer. Present around the perimeter of the island, it can be found up to an altitude of about 1,900 feet (600 m).

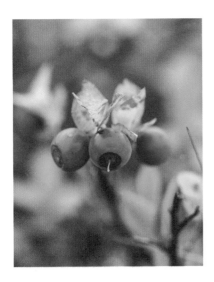

**BILBERRIES**

Rich in vitamin E, these berries are ready to be picked at the end of summer.

**COMMON YARROW**

Found on semiarid plateaus located north of Vatnajökull glacier.

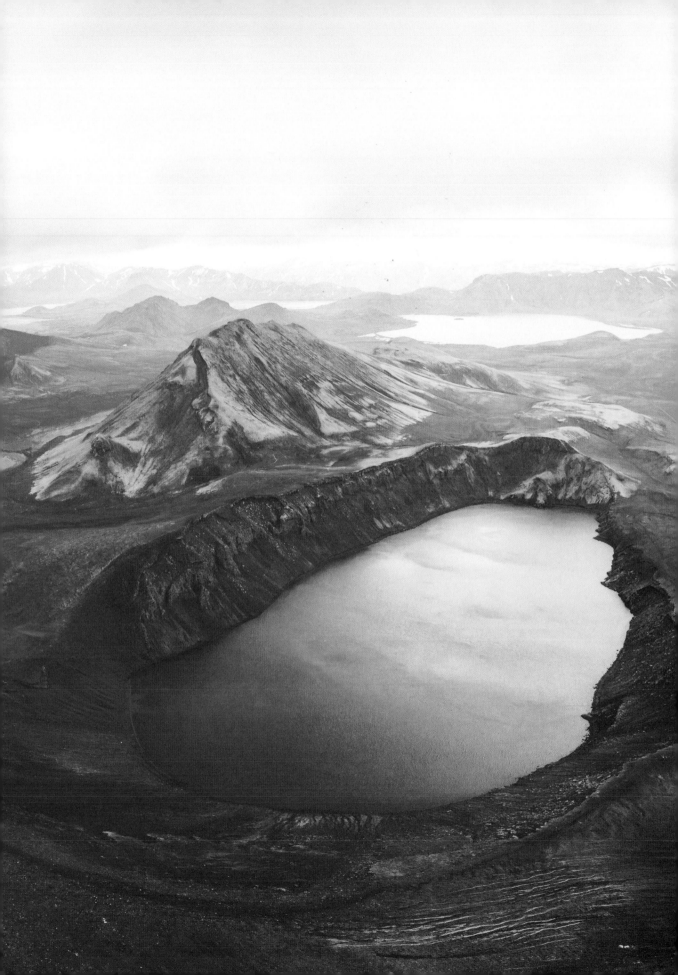

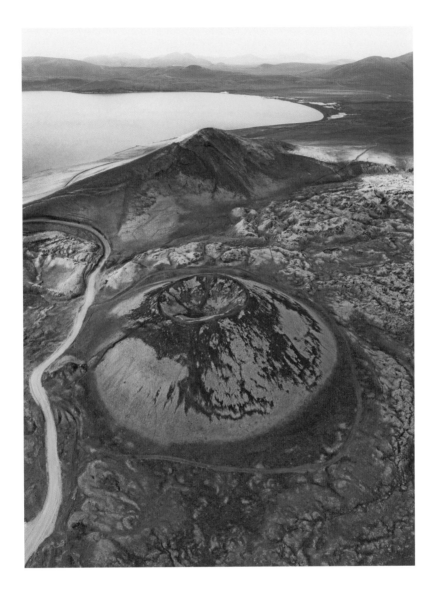

*This small crater located on the trail leading to Landmannalaugar
has a very typical shape.*

*The Ljótipollur crater and its lake are a maar. It results from
the meeting of molten lava with a groundwater table.*

NATURE

# FLYING OVER A UNIQUE WORLD

Flying over a city, the countryside, or a mountain range
is always a source of rare pleasure, offering a perspective from
the sky that can only otherwise be imagined.

In Iceland, this experience takes on another dimension. The unique aspects of the island's landscapes, its extreme contrasts, the virtual absence—or even the total absence—of vegetation, the variety of its terrains that follow one after the other—converging, opposing each other without competing for space—lend a dimension to a flyover that can only be described as extraordinary, perhaps even extraterrestrial.

From above can be witnessed a crater or an erupting fissure spewing its lava like rivers of glowing stones that, rather than flow into the sea, die along a slope atop another lava flow scorching a green meadow, adding even more disorder to this stunning conglomeration of landscapes. These are flows that follow no logical path, covering the ground with hazardous convolutions; flows originating from tectonic events, finishing by carving out a gorge or a cluster of streams or waterfalls. These are rings of smoke emerging from gaping wells

that nature dug out from a setting of pastel rock lined with fissures of ice dirtied with the black moraine from volcanic origins.

Here Mother Nature laboriously, yet artistically, creates her geologic canvas. As part of her tools, she uses the light from the north to enhance the different greens of the mosses: green bronze, bottle green, gray. They appear as splotches among this vast desert of black sand topped with cone-shaped mountains. In places, ribbons of snow, which survived the winter, are highlights along reliefs, striping them in a zebra pattern. Occasional emerald-colored lakes are bordered by a neon-green evanescence contrasting against fine-grained black sand.

Flying over Iceland means entering a poetic world or imagining, for a moment, oneself projected into space to observe another planet within the solar system, yet one that invites us to land and explore.

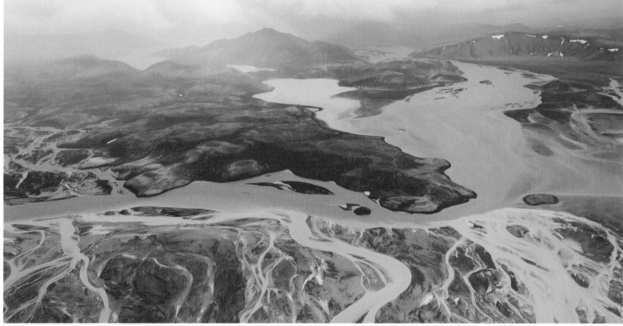

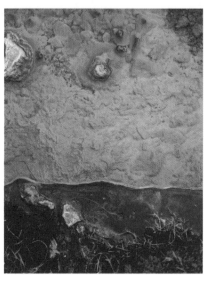

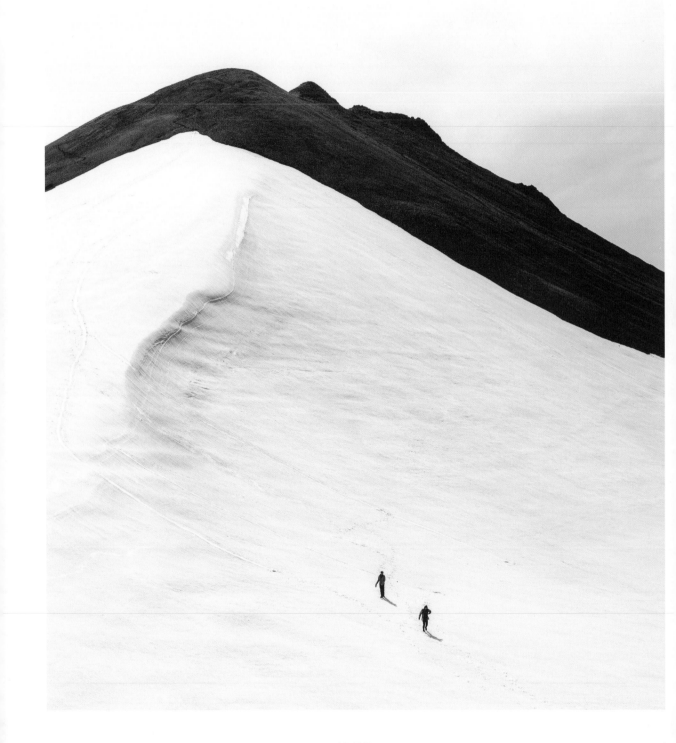

**ABOVE**

*During very snowy winters, the snows last late into the year.*

**RIGHT**

*At the beginning of summer, floodwaters leave behind traces of mud,*
*appearing like clay, after passing through the Mælifellssandur desert.*

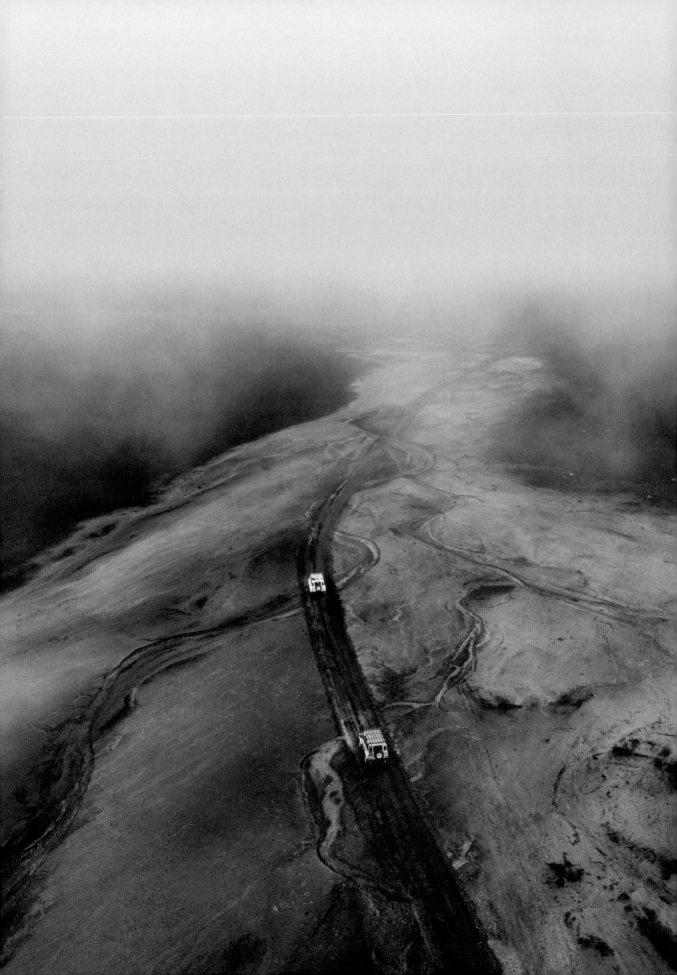

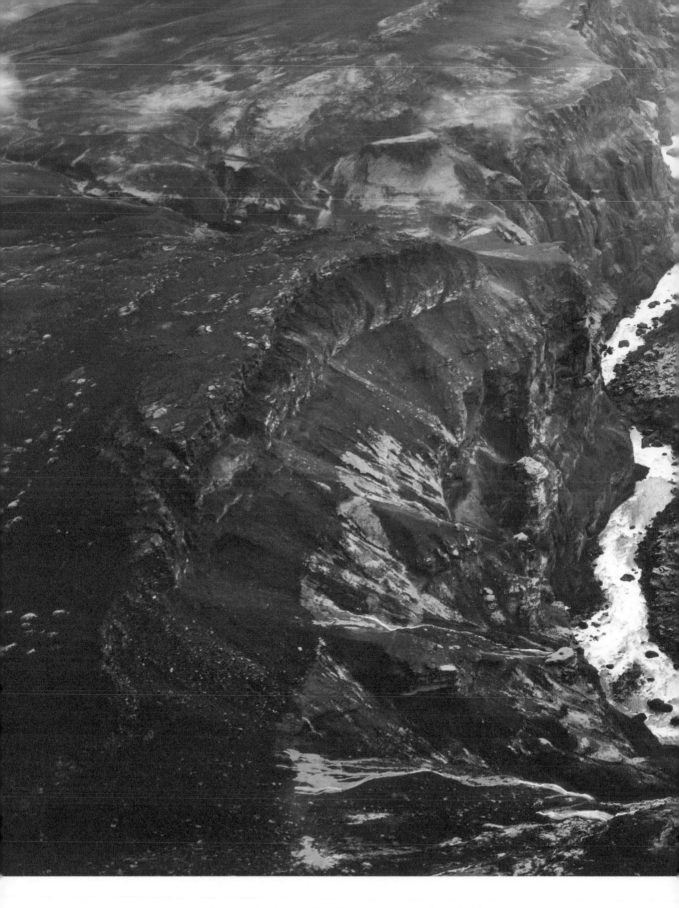

*About 400 feet (130 m) deep, these gorges are carved out of soft layers of rock by the Markarfljót river.*

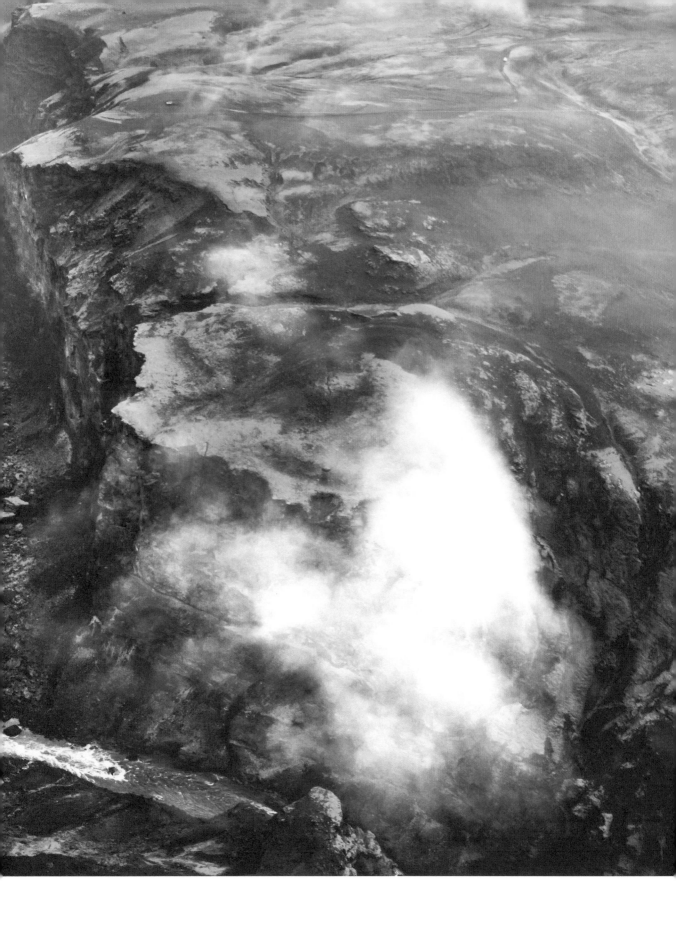

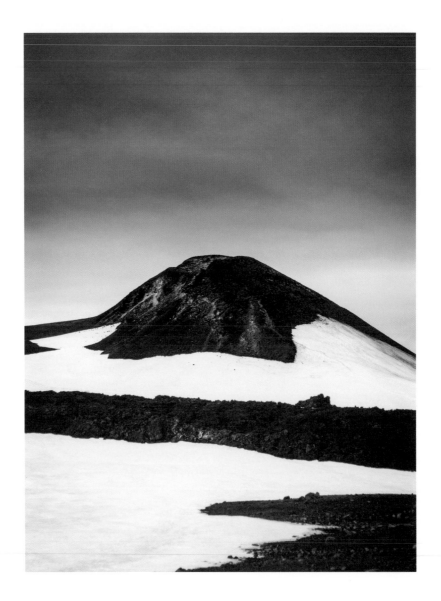

**ABOVE**

*Iceland, the land of fire and ice, is also a land of snow and cooled lava.*

**RIGHT**

*The Brennisteinsalda ("sulphur wave") volcano owes its name
to the sulfur formations found at its base.*

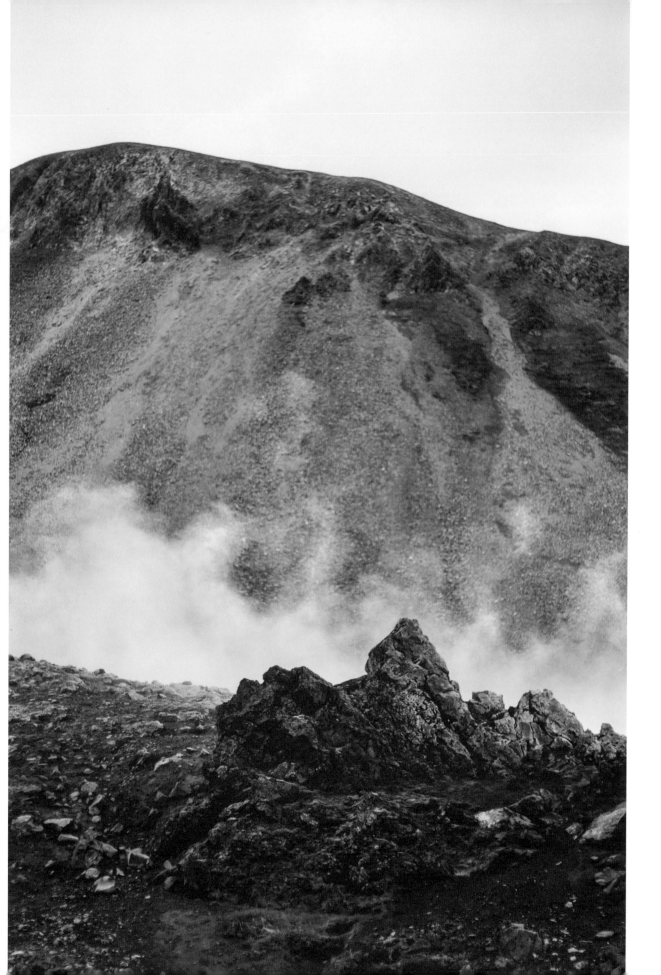

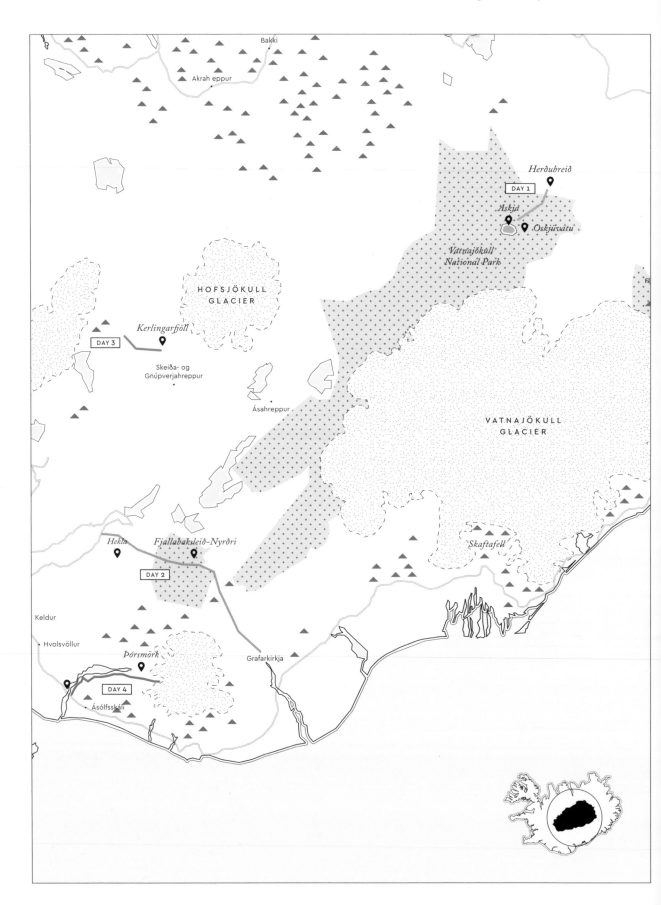

Bakki

Akrah eppur

*Herðubreið*

DAY 1

*Askja*
*Oskjuvatu*

*Vatnajökull*
*National Park*

Fl

HOFSJÖKULL
GLACIER

*Kerlingarfjöll*

DAY 3

Skeiða- og
Gnúpverjahreppur

Ásahreppur

VATNAJÖKULL
GLACIER

*Skaftafell*

*Hekla*    *Fjallabaksleið–Nyrðri*

DAY 2

Keldur

Hvolsvöllur

*Þórsmörk*

Grafarkirkja

DAY 4

Ásólfsskáli

# 4 DAYS IN THE HIGHLANDS

In Icelandic, the word *Hálendidae* refers to the vast wilderness
that covers eighty percent of the territory, the central Highlands.
For some, they are devoid of anything interesting. For others,
they are a promise of exotic adventures.

### DAY 1: FROM HERÐUBREIÐ TO ASKJA

Generations of Icelanders believe firmly that Herðubreið is the "queen of the mountains." Accessible by what seems like an improbable path, this huge subglacial volcano dominates over open spaces that are among the most desertlike, including the Ódáðahraun lava field, the largest on the island. The oasis of greenery and clear water at the mountain's base induces the same enchantment as when discovering an oasis in the deserts of Africa. Approaching from the north, Herðubreið masks the Dyngjufjöll massif, announced by a trail covered with pumice stones. Within this massif hides the Askja caldera, a vast volcano whose center has collapsed. The landscapes are resolutely lunar, but Lake Öskjuvatn adds a touch of brightness, and the small lake of the Víti ("hell") crater looks like a saucepan filled with popcorn left too long on the fire, not to mention the small lake here with warm mint-colored waters. Once in Askja, it's easy to imagine that you have landed on another planet.

### DAY 2: THE FJALLABAKSLEIÐ-NYRÐRI ROAD

This is an opportunity to discover the epic battle that is still being waged today by the volcanic rift and the majestic central volcanoes, such as Hekla, a kind of sentinel that marks the starting point. This is a battle that has created some of the most unexpected landscapes on the surface of the planet. A walk around here is a must, wandering without a specific goal except to take in the amazing horizons surrounding you. The multicolored massifs of the Landmannalaugar and the Hrafntinnusker caldera are matched only by the explosive Eldgjá fault, a long gaping scar with glowing edges. Hekla, Landmannalaugar, Eldgjá—these are a breathtaking trilogy.

### DAY 3: THE KERLINGARFJÖLL

Located slightly away from the Kjölur hiking trail, which allows you to cross the island from north to south, between the Hofsjökull and Langjökull glaciers, the Kerlingarfjöll massif arouses the curiosity of the explorer. The concentration of snowy peaks on these high plateaus of stone and sand adds to the captivating views. Be sure to survey the pastel tones of these massifs where erosion has carved narrow gorges and where entire slopes smoke and simmer. The spectacle of the surrounding glaciers and deserts mixes with views of the bottom of an infernal chasm, as if one has discovered the entrance to hell itself.

### DAY 4: THE GLACIAL VALLEY OF ÞÓRSMÖRK

Embedded in between three glaciers, this glacial valley is accessible by a trail where it becomes essential to trade your 4x4 for passage on a bus driven by a driver who knows the rivers and their trappings well. Wide at its entrance, the valley narrows gradually. Everywhere erosion has resized, cut, sculpted, and upset the soft rocks that form these palagonite tuffs. The result is many gorges, nooks, and crannies; groups of arctic birches; and steep slopes where glaciers rest peacefully above.

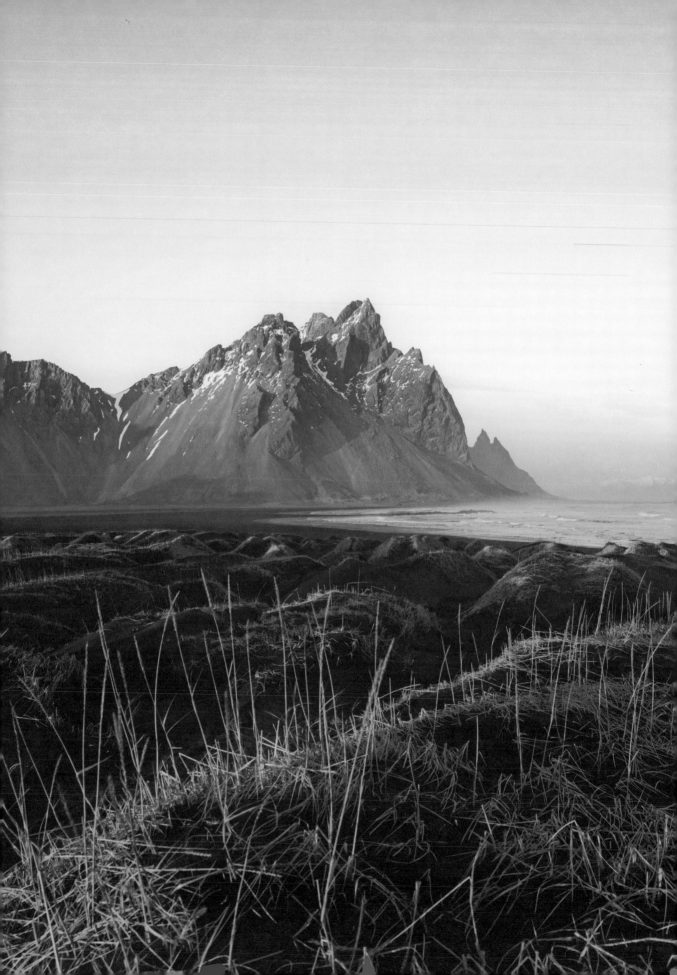

# THE EASTFJORDS

Regions in Iceland are not defined necessarily for administrative purposes but instead geographically, named after compass points or after a natural feature, such as fjords.

P. 146

*Gabbro and granophyre, two types of plutonic magmatic rocks,*
*give Vestrahorn mountain a powerfully rocky appearance.*

RIGHT

*In Iceland, stone houses stand out because of their rarity*

Visitors consider the Eastfjords as starting north of Höfn and ending next to the small village of Bakkagerði. For Icelanders, these fjords are limited to a group of mountains that run from Bakkagerði to Fáskrúðsfjörður. The splendid Seyðisfjörður, at the end of which is one of the most beautiful villages on the island, is the port of arrival of the only weekly ferry arriving from Denmark by way of the Faroe Islands. Orange-toned mountains dip their slopes into the ocean's waves, offering a spectacular view of a bay flanked by a small, discreet refuge where there is a dizzying view of Loðmundarfjörður, whose sharp mountain peaks are often seen emerging from thick clouds. Here begins one of the oldest regions of Iceland, here since the island emerged from the waves about twenty million years ago.

The coast from Seyðisfjörður to Höfn is cut by countless fjords and bays, dotted with small fishing villages and even an aluminum smelter in Reyðarfjörður. The plant's construction during the 2000s was met with strong opposition as many claimed an aluminum plant using a dam and hydroelectric power would cause irreversible damage to the environment. The population was torn between the defenders of nature on one hand, who saw their country as the most untamed area in Europe, and the supporters of the project on the other, eager to bring new energy sources to the region.

The road drops from the high plateaus to meander along the coast. Sometimes reindeer, especially in winter, come to roam in these areas, which are sparse in dwellings. Farmers in the region have become heavily committed to organic farming. Another remarkable feature is that, on this treeless island, in Hallormsstaðir near Egilsstaðir, a kind of administrative seat, the plateau supports the only large woodland in Iceland, made up mainly of native birch trees. From here, the capital seems far away, located on the other side of the island.

The living space here is so limited that the inhabitants had no choice but to cut the road out of the mountainside. A tunnel now makes it possible to reach the southeast via Lónsvík Bay, embedded between the two majestic gabbro mountains, Eystrahorn and Vestrahorn. Finally, in this corner of Iceland, can be found the Eastfjords.

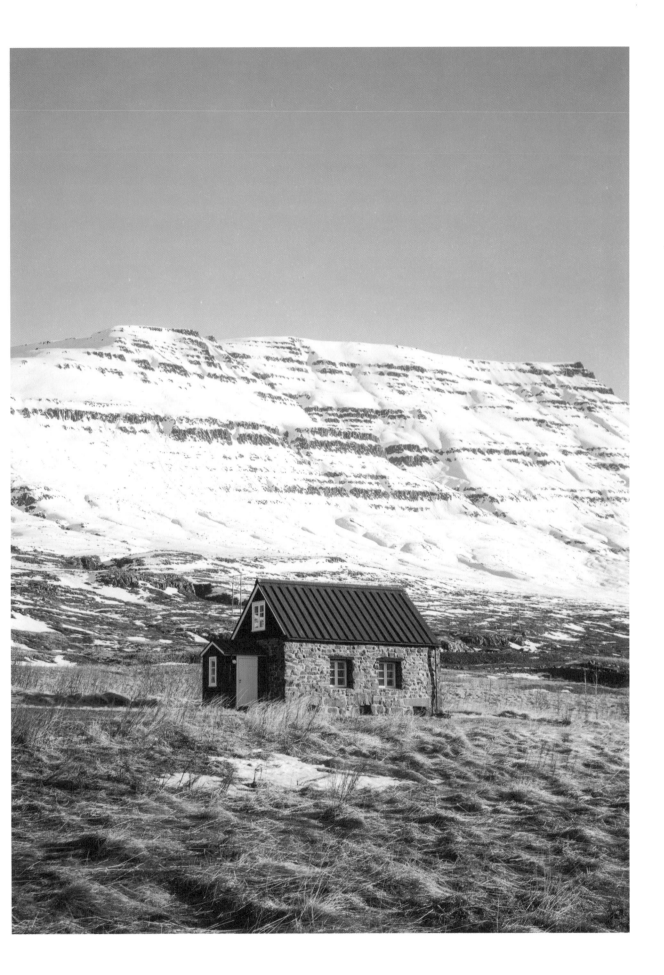

# THE ESSENTIALS

### 44

#### BORGARFJÖRÐUR EYSTRI

In this small and very isolated village, a colony of puffins settles in every summer near the harbor. Some of the most beautiful hikes set out from here for the Víkurnar.

### 45

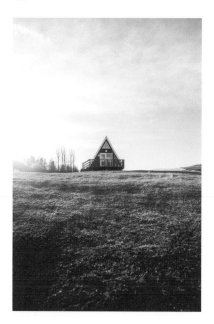

#### SKIPALÆKUR

Many chalets punctuate the country, and their shapes are often a clue to their date of construction.

### 46

#### EGILSSTAÐIR

Built in 1903 away from the village, the Lake Hótel has recently been restored to accommodate a more demanding clientele.

### 47

#### STOKKSNES

Near Höfn í Hornafirði, this café sits near the access to fabulous coastal landscapes around Vestrahorn.

### 48

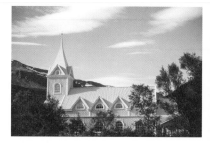

#### SEYÐISFJÖRÐUR

Every Wednesday evening from July to early August, jazz, blues, folk, and classical music concerts take place in this small blue church in Seyðisjörður.

### 49

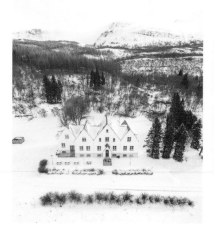

#### HALLORMSSTAÐUR

Isolated by Iceland's largest forest, Hússtjórnarskólinn is a former school for girls, now serving as a think tank for sustainable development in the region.

**50**

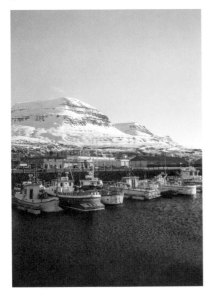

### THE PORT OF SEYÐISFJÖRÐUR

Seyðisjörður, sheltered by spectacular snow-capped mountains, witnesses the arrival every week of the ferry *Norröna* from Denmark.

**51**

### ESKIFJÖRÐUR

Upstairs in this town's restaurant Randúlffshús, an ecomuseum retraces the epic story of the Norwegian herring fishermen in the region up to the 1930s.

**52**

### VATTARNES

Between Reyðarfjörður and Fáskrúðsfjörður, it is still possible to find portions of the road suspended along the slopes of the cliffs.

**53**

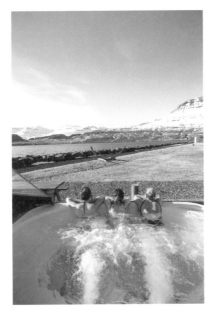

### MJÓEYRI

The eastern part of the island also offers places to relax outdoors in warm waters.

**54**

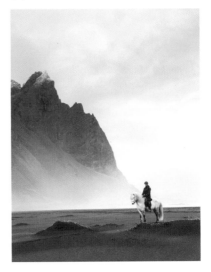

### VESTRAHORN

Houses in Seyðisfjörður are surrounded by the mountains, echoing the appearance of an alpine valley village.

**55**

### SEYÐISFJÖRÐUR

Houses in Seyðisfjörður are surrounded by the mountains, echoing the appearance of an alpine valley village.

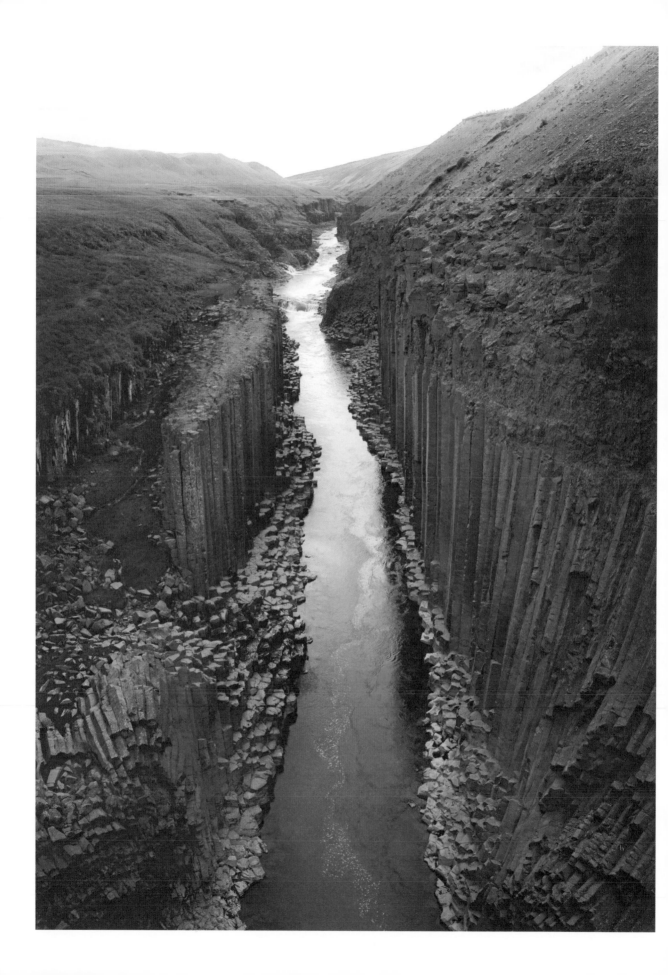

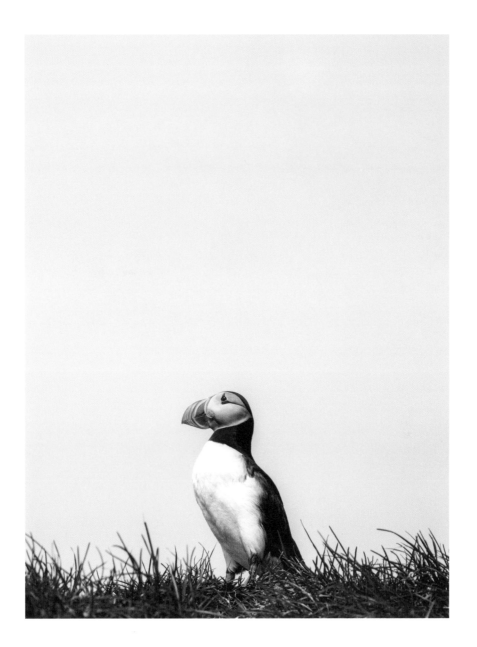

**ABOVE**

*Travelers often consider the puffin to be the symbol of the island, but in fact,
the golden plover is dearer to the heart of Icelanders.*

**LEFT**

*The small canyon of Stuðlagil has vertically aligned basalt columns,
among the most beautiful on the island.*

UNDERSTANDING

# ICELANDIC GEOLOGY

The Atlantic Ocean began forming some two hundred twenty million years ago at the south. The northern part of the ocean began to slowly expand around sixty million years ago. Yes Iceland emerged a mere twenty to sixteen million years ago—only yesterday when measured in geologic time.

Considering its relatively young age, Iceland did not know the age of the dinosaurs and the meteorite that impacted the planet at that time and changed its face forever. When the island began to emerge from the ocean floor, humans had long since populated various lands around the globe, yet the early Icelandic territory remained untouched, detached from any occupied continent.

Lava rose from the depths because of two phenomena: the volcanic rift in the mid-Atlantic ridge at the meeting point of a continental drift, and the existence of a "hot spot," a location under the earth's crust where enormous quantities of magma converge. While the earth's crust is on average one hundred miles thick, at the location where the hot spot and the rift overlap is now just a dozen miles thick! This is far too thin to prevent magma from piercing through. Consequently, huge volumes of magma, mostly basalt, piled up on the ocean floor

and the rock eventually emerged. In other words, Iceland is the emerged portion of the ocean ridge.

The island straddles the ridge where the Eurasian and North American plates separate, moving away from each other at a rate of about 1 inch (2 cm) per year. Its surface has continued to transform due to constant volcanic activity but also from erosion and the action of glaciers, giving rise to the Iceland we know today. This is why the island is a wonderful subject of study for all scientists and enthusiasts of volcanic and tectonic phenomena.

Visiting the fjords throughout the west, north, and east of the island offers the opportunity to contemplate Iceland's beginnings. A walk along the currently active part of the rift allows you to explore portions of land that are among the youngest on the planet. They give a precise idea of what the planet's oldest lands once looked like.

## IN THE LAND OF VOLCANOES

### 1. LOCATION OF THE MAIN VOLCANOES

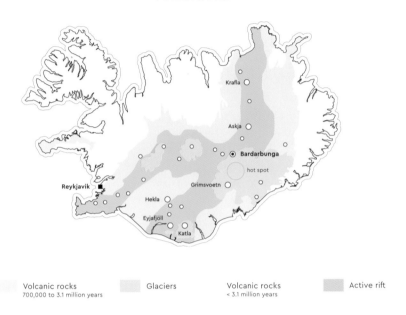

Krafla

Askja

● Bardarbunga

hot spot

Reykjavik ■

Grimsvoetn

Hekla

Eyjafjöll

Katla

Volcanic rocks
700,000 to 3.1 million years

Glaciers

Volcanic rocks
< 3.1 million years

Active rift

### 2. FORMATION OF A SUBGLACIAL VOLCANO

During a volcanic eruption under a glacier, the melting ice (1) forms a lake on the surface (2). The volcano's continual activity eventually causes the glacier to regress (3). Having disappeared, the glacier now reveals a plateau (4).

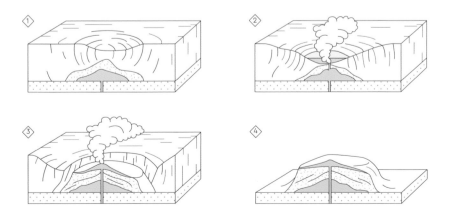

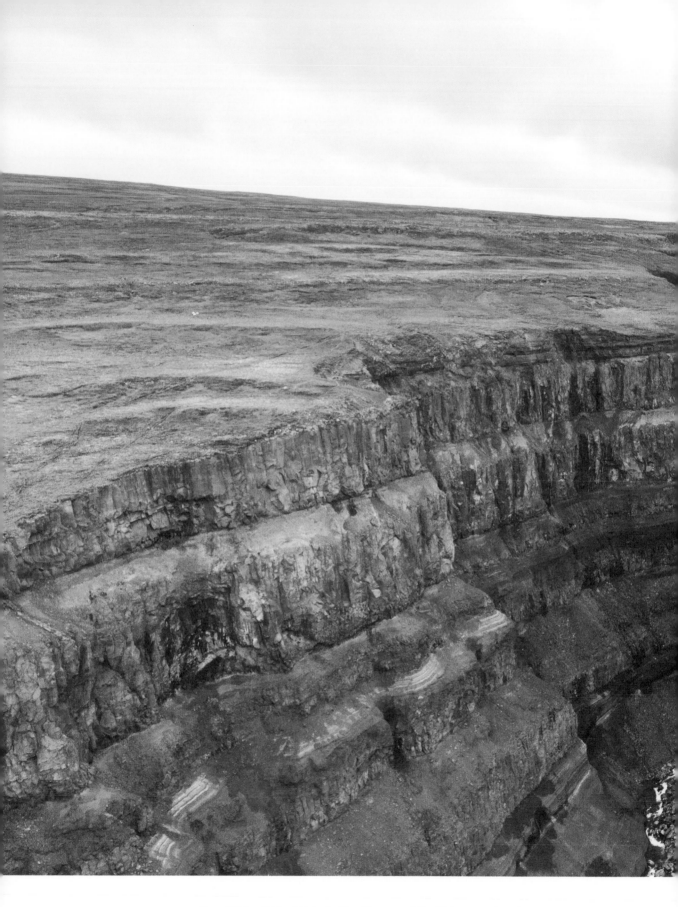

*About 400 feet (128 m) high, the Hengifoss waterfall spills into a setting of
lava layers separated by thin red sedimentary layers including fossils.*

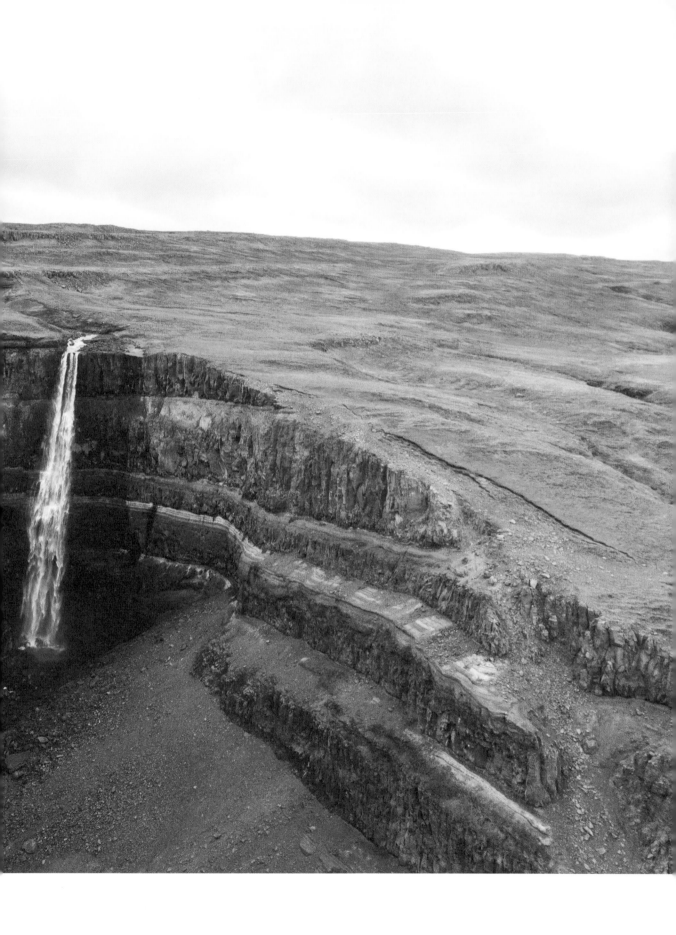

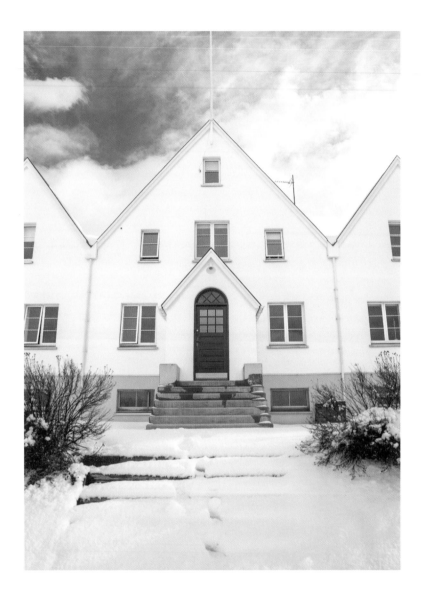

**ABOVE**

*In Hallormsstaður, Húsmæðraskólinn was a school for housewives that
opened in 1930 to educate girls from rural areas.*

**RIGHT**

*With an area spanning nearly 1,900 acres (800 hectares), the woodlands
of Hallormsstaðaskógur are the largest on the island, where the forest
represents less than 1 percent of the territory.*

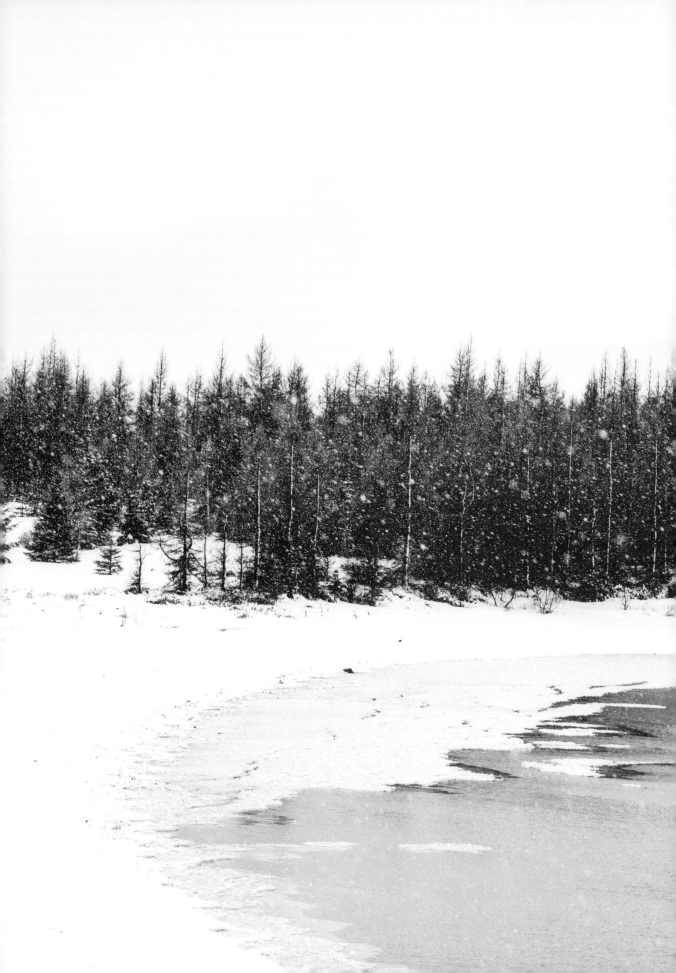

ECOLOGY

# LAKE LAGARFLJÓT
## A NEW ECONOMIC SOURCE

The question always remains how Iceland can continue to derive value from
its regions outside of its bustling capital. Between supporters of industrialization
and ardent defenders of the environment, it's a fervent debate.

In the early 2000s, a proposed dam and hydro-electric complex to supply an aluminum smelter in Reyðarfjörður provoked outcry. Ecologists, worried that natural wonders would disappear under its waters, opposed it, arguing that these wonders play an important part in the development of tourism, an industry that was still in its infancy on the island. With the financial crisis of 2008, however, the industry would become the lifeline for a drifting economy.

Not all local initiatives are directly related to tourism, though they can benefit it. The fertile land that borders Lake Lagarfljót is cultivated along its eastern shore, such as at Vallanes farm. Here, organic farming is not a fashionable phenomenon but a way of life, offering an unusual challenge in a country whose cultivated area represents only one percent of its total area and where the growing season is very short. Several positive initiatives, such as the installation of greenhouses in certain areas despite their lack of geothermal energy sources, combined with common sense marketing, have allowed the cultivation and sale of fresh vegetables, cereals, and their derived products such as jams, linseed oil, and cosmetics. Vallanes farm has partnered with the public authorities to raise awareness of organic fresh produce among a population that is rather addicted to junk food. Success did not come quickly, but finding products in Reykjavík from the Vallanes farm is easier today.

And that's not all. The craze for sushi and other sashimi has spread to Iceland. What could be more natural in a country where fresh fish is abundant? Given this, the cultivation of wasabi was a logical step, along with bragging rights of possessing the plant's northernmost growing area! Modern Nordic cuisine loves this condiment, and since the dam has finally begun service, the inexpensive electricity generated has become a boon for powering its cultivation.

Another example is beer, which has only been allowed for sale in Iceland since 1989. Until that time, Icelanders had to make do with local versions of relatively poor quality or imported beers. But over the last ten years, microbreweries have sprung up, as in Egilsstaðir. Travelers in this region can enjoy one of the dozen beers brewed on site.

The last example is nestled at the very bottom of the valley that extends to the lake, the valley of Fljótsdalur. The Wilderness Center—a farm, museum, and activity center—has true character thanks to its creators who have invested so much into their dream, and a visit here to support them is a must. Owners Arna and Denni take their guests on a journey through the past to an enchanting place where absolutely everything has been thought of to evoke the Iceland of yesteryear. To visit here is to step through a looking glass and find yourself in surroundings as real as nature itself.

Tenacious in their work, the farmers of
Vallanes prove every day that it is possible to grow
crops without resorting to pesticides, even in a
very short growing season.

## A PASSION FOR ORGANIC

At the Vallanes farm, organic farming is not a
fashionable phenomenon but instead a way of life.

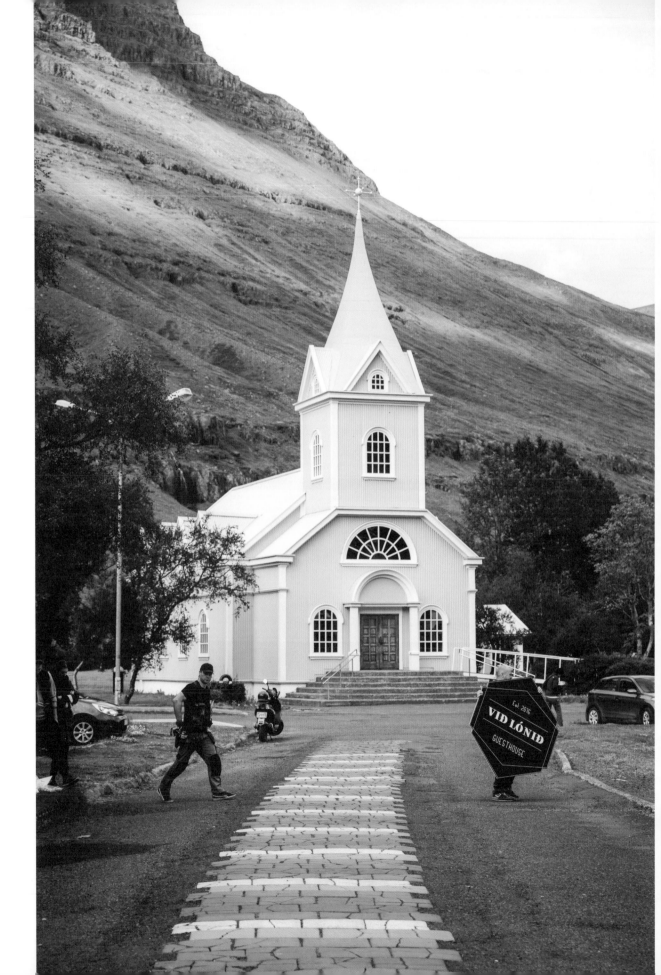

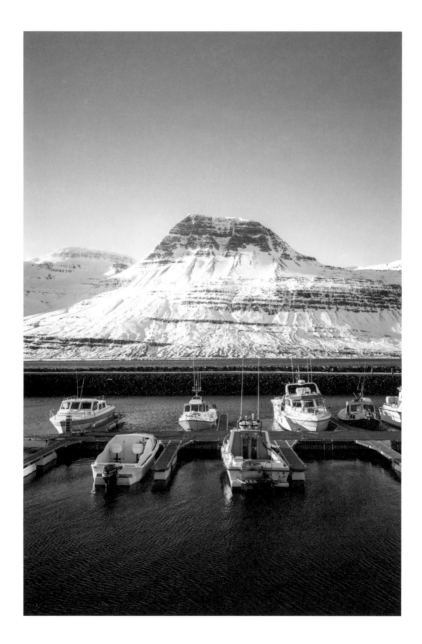

**ABOVE**

*Despite the end of the herring fishing era, the port of Seyðisfjörður
has remained very active.*

**LEFT**

*Nestled at the bottom of a fjord, the village of Seyðisfjörður
is one of the most colorful and picturesque in Iceland*

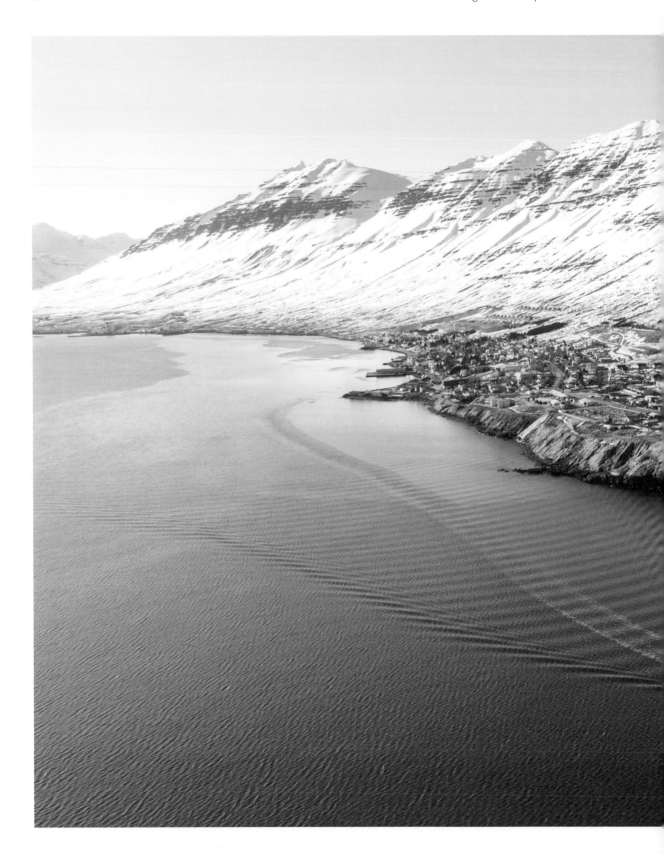

*Located seemingly at the end of the world, the town of Neskaupstaður,*
*long controlled by the local Communist Party, was nicknamed "little Moscow."*

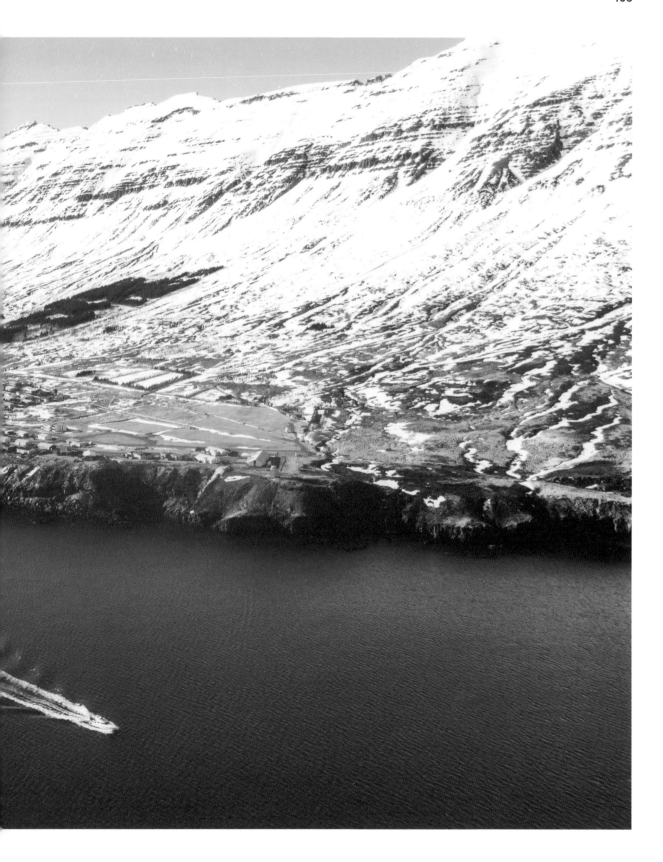

LIFESTYLE

# LIFE IN THE COUNTRYSIDE

**LAGARFLJÓT**

Deciduous and coniferous trees turn the
shores of Lake Lagarfljót green.

**VALLANESKIRKJA**

This church has a typical red roof and a blue vaulted ceiling inside.

**SKRIÐUKLAUSTUR**

Author Gunnar Gunnarsson's house became a writers' residence.

**SMALL BOUTIQUES**

With tourism, boutiques have sprung up here and there inside traditional old houses.

**ESKIFJÖRÐUR**

The upstairs of Randúlffshús restaurant houses an ecomuseum retracing the epic story of Norwegian fishermen in the region.

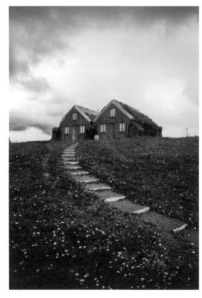

**CHALETS TO RENT**

Small cottages for rent were built on models of old houses with grass-sodded roofs.

**SKRIÐUKLAUSTUR**

This ancient manor estate is a charming detour for a breakfast between stopovers.

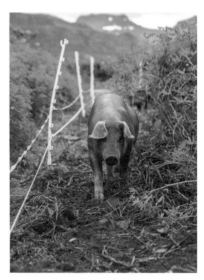

**SEYÐISFJÖRÐUR**

Places in Iceland where pigs are raised roaming freely are rare.

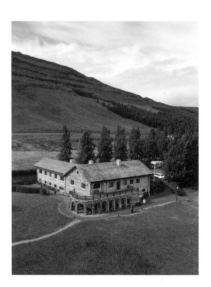

**SKRIÐUKLAUSTUR**

Travelers can stop into the visitors' center near Vatnajökull National Park.

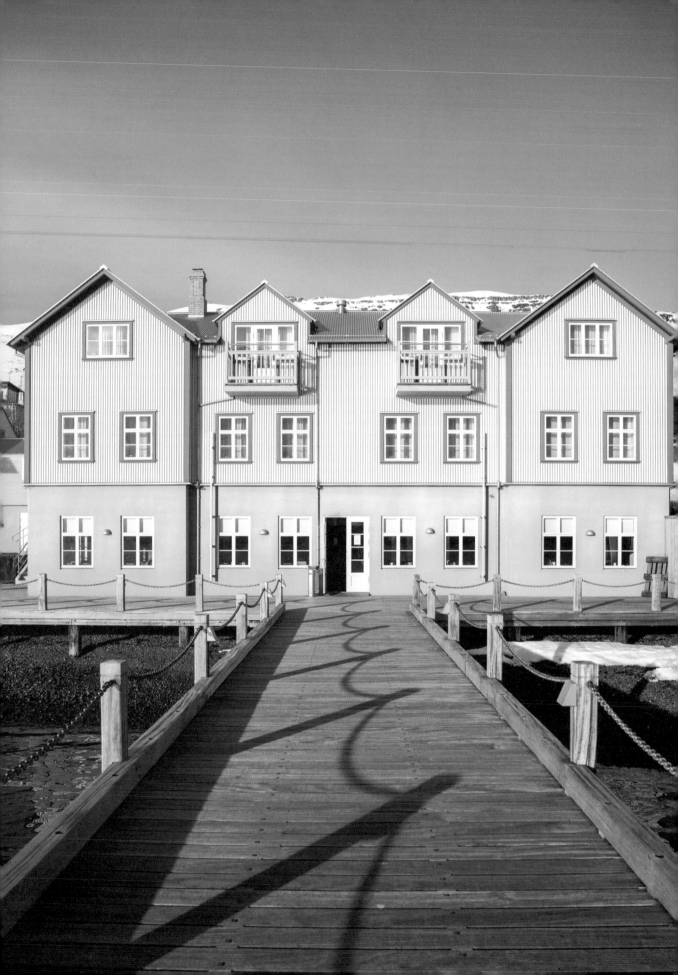

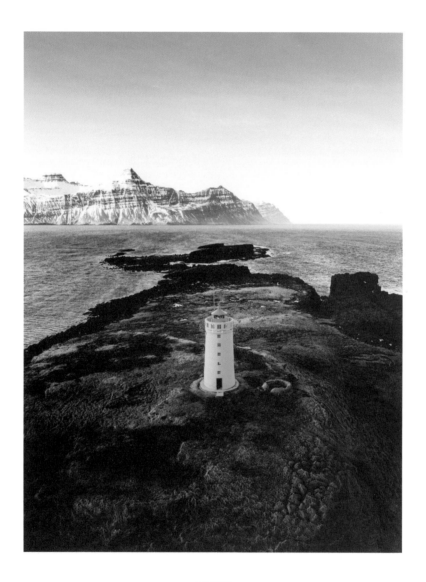

**ABOVE**

*The bright orange Vattarnes lighthouse stands at the entrance
to Fáskrúðsfjörður.*

**LEFT**

*In Fáskrúðsfjörður, the Fosshótel occupies the former French hospital where Icelandic fishermen
were treated. An exhibition retraces the daily lives of these seamen between 1850 and 1914.*

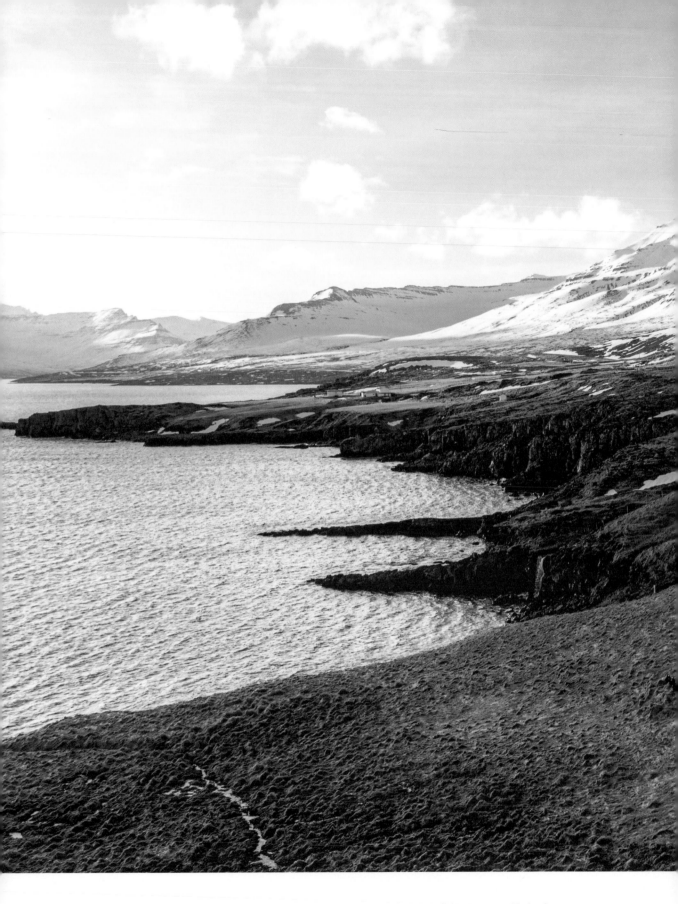

*The Vattarnes fjord peninsula is one of the most beautiful coasts of the east coast of Iceland.*

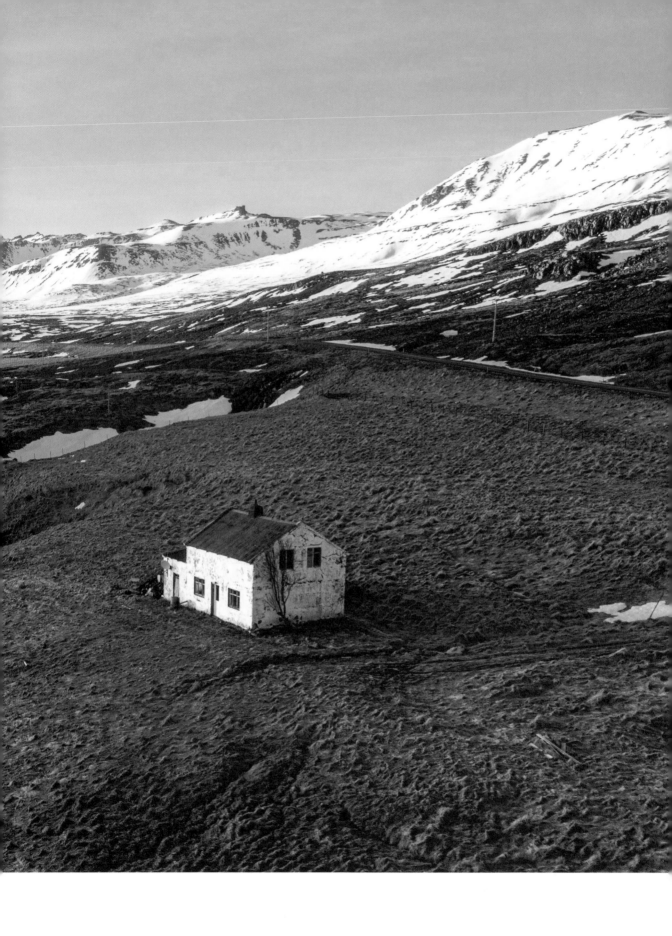

# VESTURFARARNIR

## HISTORY OF MIGRANTS

A fact unknown to many people is that the two countries that
provided America with the largest share of their populations were
Norway and Iceland, with as many as one in four inhabitants
venturing across the Atlantic to seek their fortune.

There are a handful of major immigration events in history that stand out more than others. Most people recall the stories of the pilgrims fleeing England on the *Mayflower* in search of a country where they could freely practice their religion, or the Italians and Spaniards who left to settle in Argentina. There are also a great number of North Americans claiming Irish ancestry due to the numbers who emigrated there from Ireland. But in the second half of the nineteenth century, the Nordic countries, far from the image of prosperity and easy living they convey today, were among the poorest in Europe, resulting in a wave of emigration.

In the nineteenth century, Iceland experienced the same population explosion as the rest of Europe, but it had very little land available for settlement since four-fifths of its territory had not been civilized. Between 1860 and 1914, poverty led many Icelanders to emigrate to Canada (mainly Manitoba) or the United States (Minnesota).

But for a people consisting of sheep farmers and fishermen accustomed to living in a country without trees, terrible hardship awaited them. The concessions granted to them were not located by the sea but instead in the middle of the North American continent, where the territory was largely covered by lakes and forests. Many testimonies provide information about these settlements: Arriving late in the year, many destitute Icelanders barely knew

how to swing an axe to cut down a tree. Consequently, they built poorly insulated houses, unsuitable for the polar temperatures of North American winters. In some areas, however, Native Americans taught them to cut wood effectively, and the Icelanders, in return, taught them fishing techniques.

Time passed, and living conditions improved quickly. The *Vestur-Íslendingar*, literally the Western Icelanders, wrote their loved ones encouraging them to cross the ocean to join them. Departures from the island soon multiplied, amplified by the eruption of the Askja volcano in 1875 whose ashes covered the northeast quarter of the island. The number of Icelanders leaving the island continued to grow, with some even trying their luck as far as Brazil. The First World War would put an end to this exodus, however. Today, the number of descendants of the first emigrants is estimated at near the current population of Iceland today, but few of them know how to speak the language of their ancestors.

An abundance of correspondence about these events remains in the form of books and photos. In Hofsós, north of Skagafjörður, the Emigration Museum brings to life, with emotion, the memory of those who left their homelands to seek better living conditions. Over time, it took a boom in tourism in Iceland for this land of emigrants to become a land of immigration, a phenomenon that was unthinkable until the last century.

*As elsewhere in Europe during the nineteenth century, strong demographic pressure pushed men and women to emigrate from Iceland. The eruption of the Askja volcano in 1875 accelerated these events.*

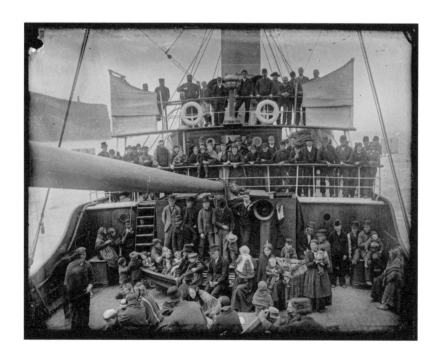

*To reach the New World, emigrants had to first reach Glasgow, then Liverpool, before crossing the Atlantic.*

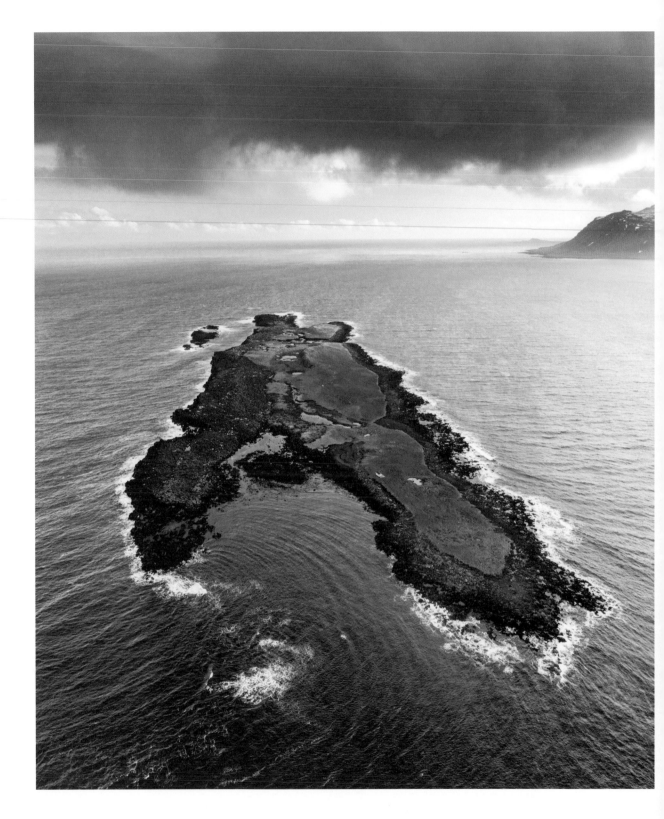

The island of Andey, at the entrance to Fáskrúðsfjörður, is a danger to sailors during bad weather.

Near Lónsvík Bay, acidic volcanoes have shaped a landscape heralding the uninhabited
expanses of the region of Lónsöræfi.

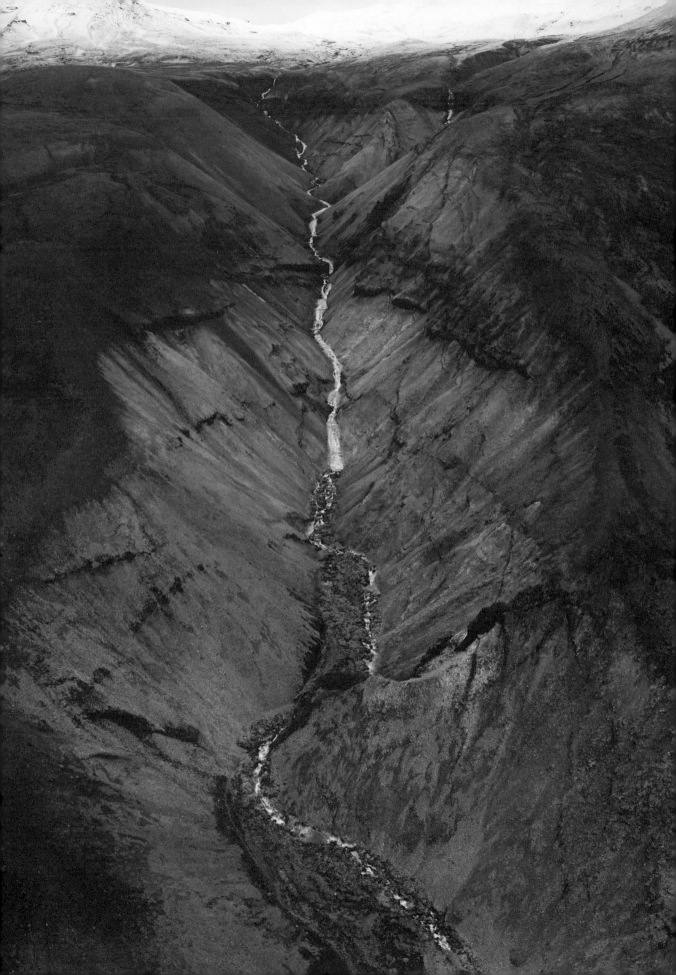

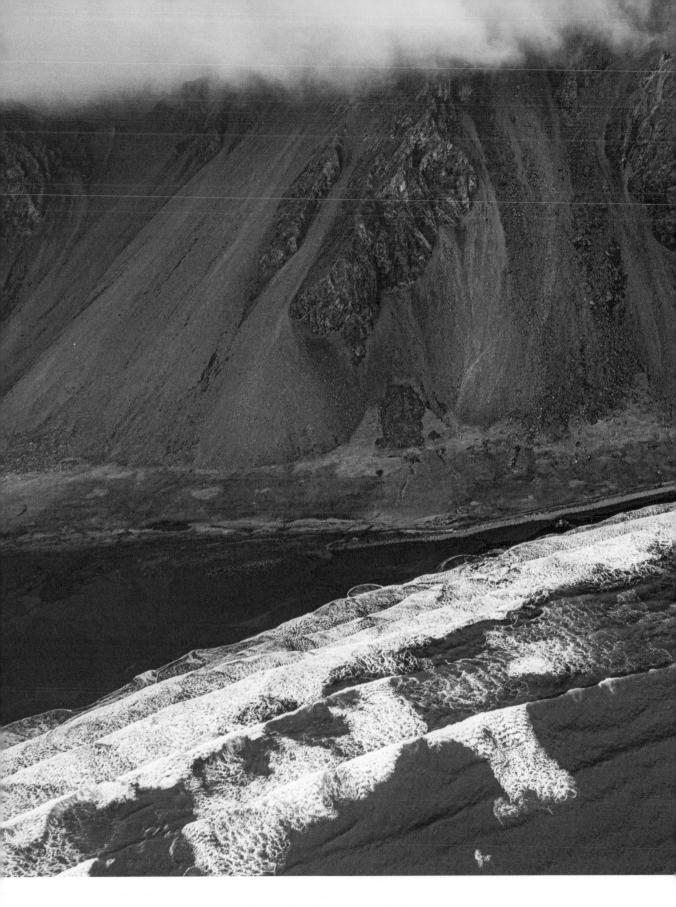

*Some see Brunnhorn mountain (in the background),*
*southeast of Vestrahorn, as evoking Batman, the comic book hero.*

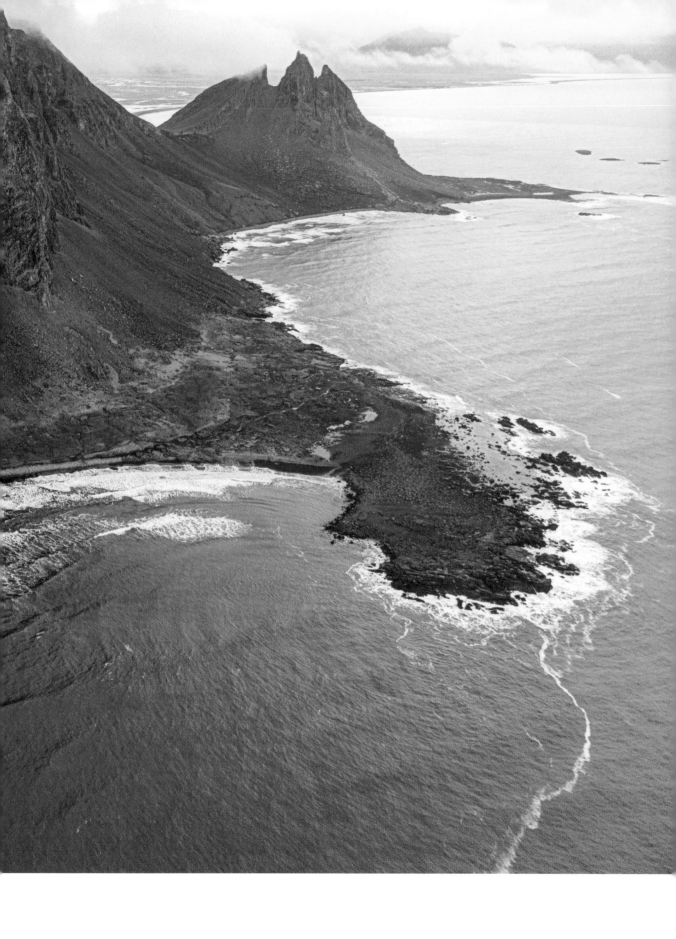

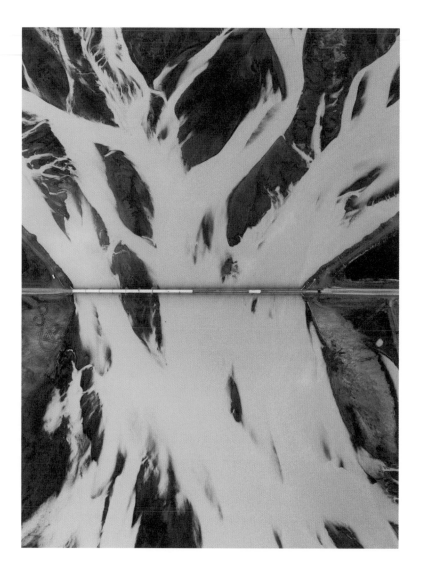

**ABOVE**

*The aerial view of the Lónsá glacial river, traversed by a bridge
that allows the ring road (Route 1) to circle the island.*

**RIGHT**

*Riders stroll the black-sand beach of Stokksnes beach at the
base of Vestrahorn mountain.*

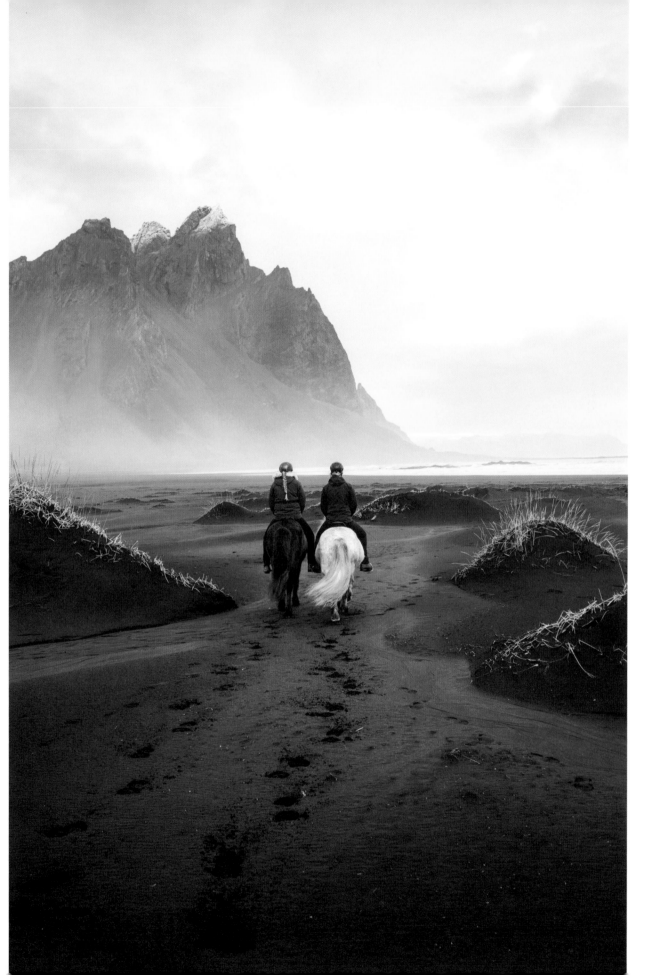

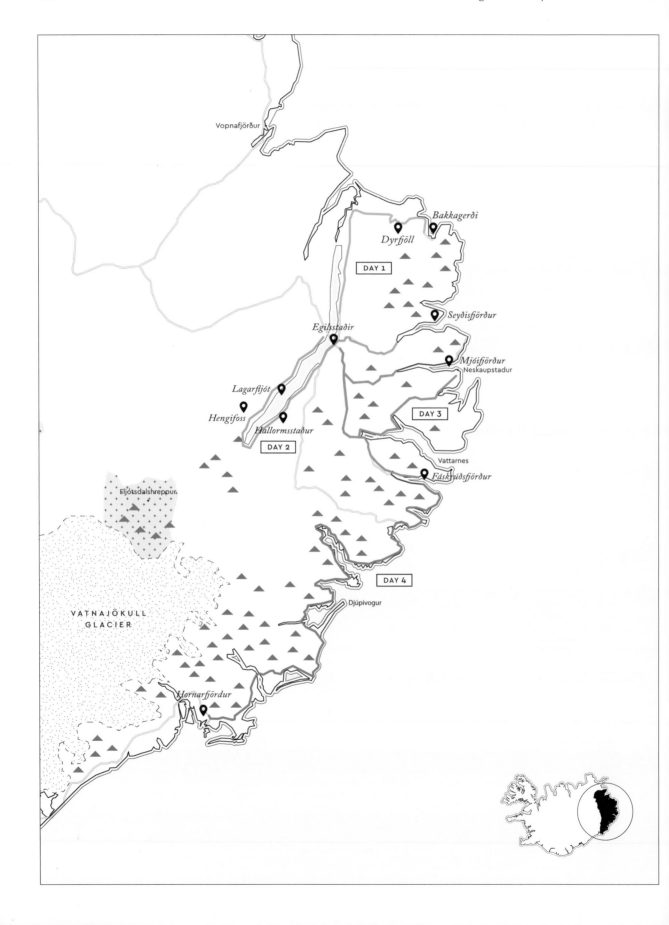

# 4 DAYS IN THE EASTFJORDS

Iceland is typically divided into different geographical regions.
The East is undoubtedly the region often most unexplored,
but unjustly so, as it offers many points of interest.

### DAY 1: BAKKAGERÐI TO EGILSSTAÐIR

The village of Bakkagerði sits in Borgarfjörður eystri, a corner of the island full of charm nestled in its mountain setting. Visitors will first come upon a very small village connected to the rest of the island by an improbable winding road, which may not be open all year round, with its colony of puffins nesting at the foot of pastel-colored mountains. When in a 4x4, it's difficult to resist the temptation to take this route and leave the village to go deeper into the massifs where you can enjoy breathtaking views from above of the nearby fjords, inlets, and bays. Hikers will be delighted by the Dyrfjöll massif with its ambiance worthy of a Tolkien novel. The day can end in the baths of Vök near Egilsstaðir.

### DAY 2: FROM LAKE LAGARFLJÓT/ EGILSSTAÐIR TO SEYÐISFJÖRÐUR

Travel around Lake Lagarfljót and discover the magnificent Hengifoss waterfall during a pleasant walk. Tree lovers will be relieved to see that there is at least one forest in Iceland, in Hallormsstaður, and lovers of organic products will probably want to tour Vallanes farm. This will be a good time to head toward the fjords and the small village of Seyðisfjörður lurking at the edge of the fjord surrounded by mountainous scenery.

### DAY 3: FROM MJÓIFJÖRÐUR TO FASKRUÐSFJÖRÐUR

Among the treasures of east Iceland, Mjóifjörður deserves special mention. Mjóifjörður means "narrow fjord," so you should not be surprised if you first experience a feeling of approaching a landlocked lake. Once lower down, after a series of switchbacks, you will wonder how inhabitants could have come to live here. Turning around, you can admire the river that descends in the same manner as the high roads, making its way through the different layers of compacted volcanic rocks. To leave, you'll have to turn around, but you'll be delighted to have made the trip. It will then be time to continue along the route to other fjords and villages, including Fáskrúðsfjörður.

### DAY 4: FASKRUÐSFJÖRÐUR TO HÖFN I HORNARFIRÐI

Fáskrúðsfjörður's small cemetery includes the graves of Breton sailors who left to go "fishing in Iceland." The exhibition that commemorates this epic tale is rich in information. It is now time to head back to the road: You will be surprised, while scanning the mountains, to see sloping geological layers, the many injections of magma, and hanging glacial valleys. The small church of Stafafell and the memorial dedicated to other fishermen of Iceland, located in Lónsvík Bay, will mark the region's exit. The mountains have now adopted other forms, and the scenery and region have changed. You have to go through a tunnel to reach Höfn í Hornafirði. You can now feel satisfied with your discovery of the East.

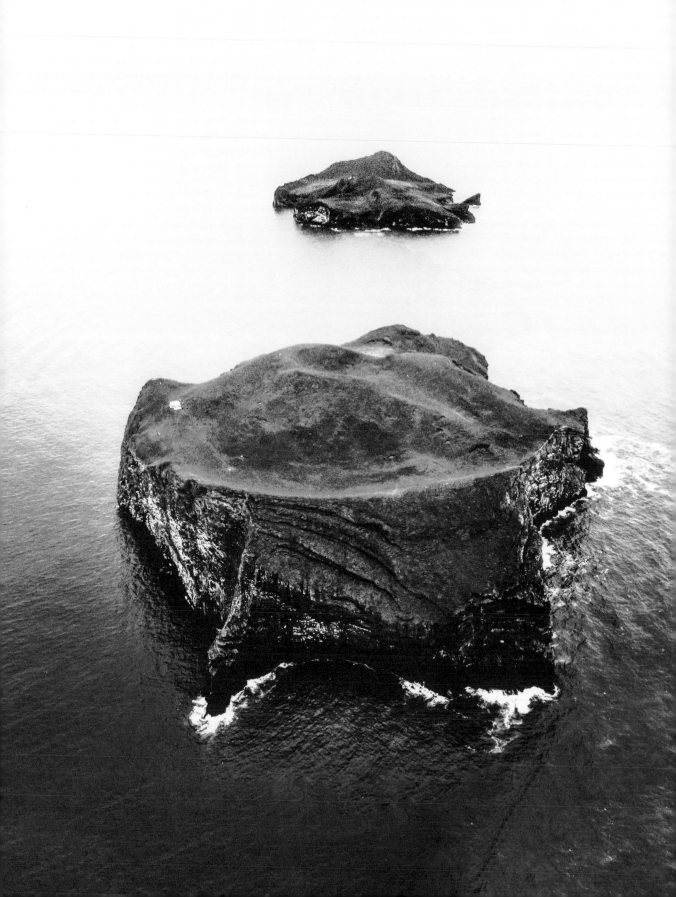

# THE SOUTH
## AND THE WESTMAN ISLANDS

Imagine a black-sand beach stretching just over two hundred miles
(three hundred fifty kilometers). In the distance, the horizon is interrupted
by steep cliffs and sea stacks. Generations of fishermen have lost their
lives here, including several Icelanders, hopelessly pushed by the chilly
wind against this hostile, deserted coast.

P. 182

*Underwater eruptions created the islands and islets of the Vestmannaeyjar archipelago.*
*One occurring in 1963 gave birth to the island of Surtsey.*

RIGHT

*The district of Suðursveit is one of the most beautiful on the island. The ring road (Route 1),*
*which circles the island, winds to accommodate the shape of the land.*

Because the only natural harbor in this region dedicated to fishing was located on the island of Heimaey in the Vestmannaeyjar archipelago, Icelandic writer Þorbergur Þórðarson tells how, as a child growing up near Höfn, he would watch men leave to search the wrecks of schooners for hard liquor, hoping to find cognac. They used any means to bring back what they found, including taking off their boots to fill them.

The south of Iceland offers a striking contrast to the north. Here, nature stubbornly prevents settlements by the sea, except by those who were brave enough to make the attempt. On this inhospitable land, habitable spaces have been painfully carved out at the foot of glaciers, which release a deluge of water when eruptions occur from the many volcanoes imprisoned under their ice, resulting in cataclysmic floods; these are what created this black-sand coast. With glaciers and volcanoes, abundant glacial rivers, lava fields, and sandy deserts, the south offers a striking scenic spectacle. And, from time to time, these landscapes, located at the end of the world, are brightened by an occasional field of green. You must travel to the southwest to experience a more peaceful nature, but the procession of natural disasters that overwhelm the country appear here was well: eruptions, rising waters, subglacial floods, earthquakes, and storms. Humans have learned to live with it here just as elsewhere on the island.

This is a place, however, to admire sunsets over the huge glaciers dominating the coast, to spot seals that arrive in the lagoon of Jökulsárlón to lounge among drifting ice, to marvel at the limping gait of a puffin, or to be moved when seeing the ground covered with a carpet of flowers during an ephemeral summer; flowers here must often wait for summer before they can bloom. The south is that part of Iceland where the horizon suggests this could indeed be the very end of the world.

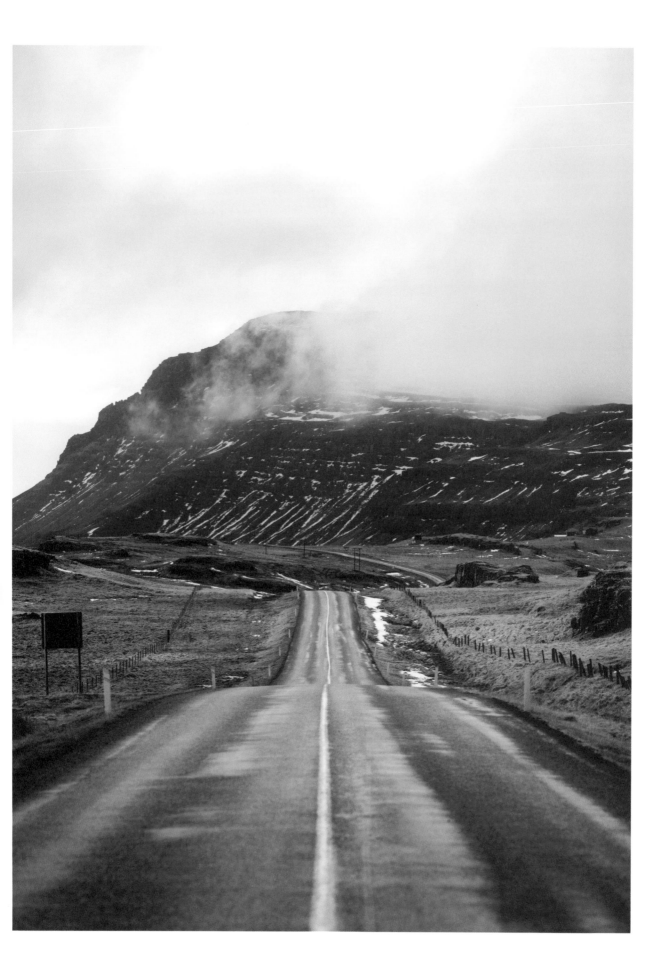

# THE ESSENTIALS

**56**

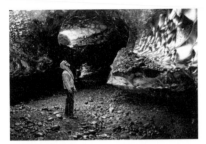

### VATNAJÖKULL

Between October and March, a visit to one of this glacier's ephemeral caves of natural ice to experience the incredible colors is a must.

**57**

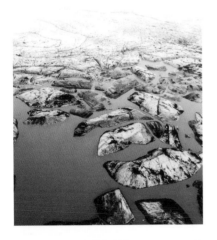

### SKAFTAFELLSJÖKULL

The waters from glacial tongues, loaded with silt, are murky, creating deep contrasts in the landscape.

**58**

### LÓMAGNÚPUR

Lómagnúpur mountain looms over the landscape at an altitude of approximately 2,800 feet (871 m).

**59**

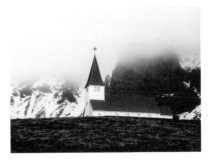

### VÍK Í MÝRDAL

The church of Vík í Mýrdal watches over this small village at the foot a beautiful cliff.

**60**

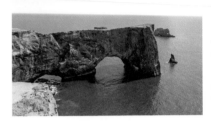

### DYRHÓLAEY

As a promontory barely attached to the land, Dyrhólaey provides a sanctuary in summer for a colony of puffins.

**61**

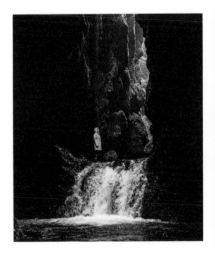

### ÞÓRSMÖRK GLACIER VALLEY

From one end to the other, this glacial valley hides many canyons carved out in friable tuff, accented with many waterfalls.

**62**

**HRUNALAUG**

This natural hot spring, accessible day and night, is worth the dip, although you'll have to undress in the open air.

**63**

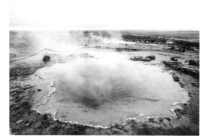

**BLESI**

This spring's location is in the same geothermal area as the famous Geysir geyser.

**64**

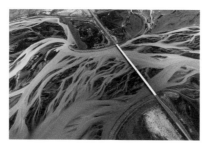

**SOUTH COAST**

It was not until 1974, when the last bridge was constructed, that the entire island could be toured by car. Crossing these expanses never ceases to surprise travelers.

**65**

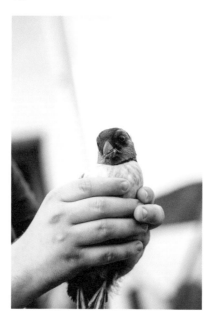

**HEIMAEY**

At the end of summer, children in Heimaey pick up and send back to sea the young puffins who were attracted to the city's lights at night.

**66**

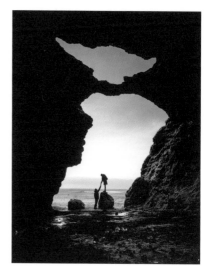

**HJÖRLEIFSHÖFÐI**

With its magnificent green slope, this small island made up of silt from successive eruptions of the subglacial volcano Katla offers a breathtaking view of the surrounding black sand.

**67**

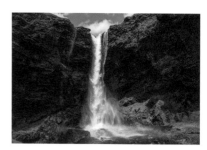

**KVERNUFOSS**

This sumptuous high waterfall of approximately 65 feet (20 m) is set within a green landscape and hidden just a few minutes walk from the famous Skógafoss waterfall. A detour to see it is a must!

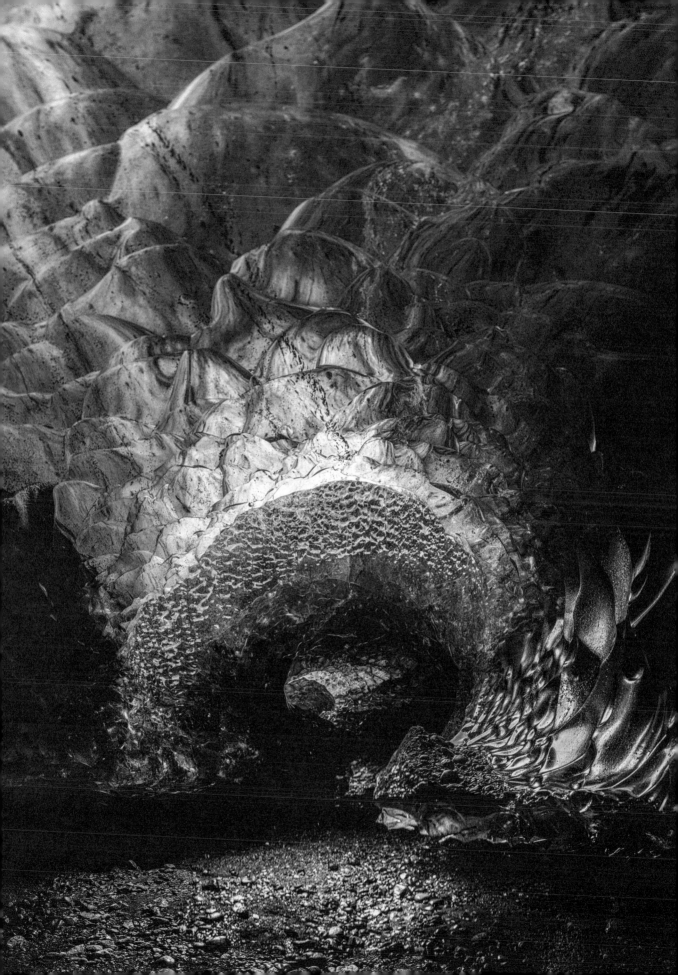

UNDERSTANDING

# NATURAL DISASTERS

**Southern Iceland is probably the region most affected
by the myriad natural disasters that impact the island.**

Considering its volcanic eruptions in both inhabited or deserted areas, subglacial lava flows carrying away everything in their paths, the famous *jökulhlaup* outburst floods, earthquakes, sudden advances of glacial tongues, violent storms, avalanches, and tidal waves, southern Iceland blows both hot and cold.

Whether at sea—the south coast is particularly inhospitable when a boat, trawler, or container ship runs aground on the huge sandy beach that borders this part of the island—or on land where a lava flow destroyed a third of the village in Heimaey on the Vestmannaeyjar archipelago in 1973, danger is ever present and the population stays on alert: Civil security and researchers work daily to monitor the island thanks to numerous sensors capable of reading the slightest vibrations in the earth.

Weather reports are frequent and are intended to be as accurate as possible, with trawlers at sea assisting. No vessel leaves its home port without referring to the appropriate authorities. Iceland has more than two hundred active volcanoes and experiences an eruption every three or four years. GPS stations make it possible to measure the rate of spacing between tectonic plates, the height of the ground in susceptible areas, and to track, minute by minute, some of the island's most famous volcanoes: Askja, Katla, Hekla, Grímsvötn, and Bárðarbunga. Thus, in February 2000, the radio announced on the six o'clock news that the Hekla volcano would erupt in about twenty minutes; it belched at exactly 6:17 PM. Studies of previous eruptions had revealed that, depending on a certain magnitude and frequency of earthquakes and the release of magma, the volcano would discharge within a maximum of thirty minutes.

On the other hand, in March 2010, no one saw coming the eruption that gave rise to the formation of two craters and two lava flows at Fimmvörðuháls pass between the Eyjafjallajökull glaciers to the west and Mýrdalsjökull to the east. The huge plume of smoke it generated caused European airports to close for several days. But, thanks to modern methods of research in volcanology, knowledge is advancing to better predict what has often been considered the unpredictable.

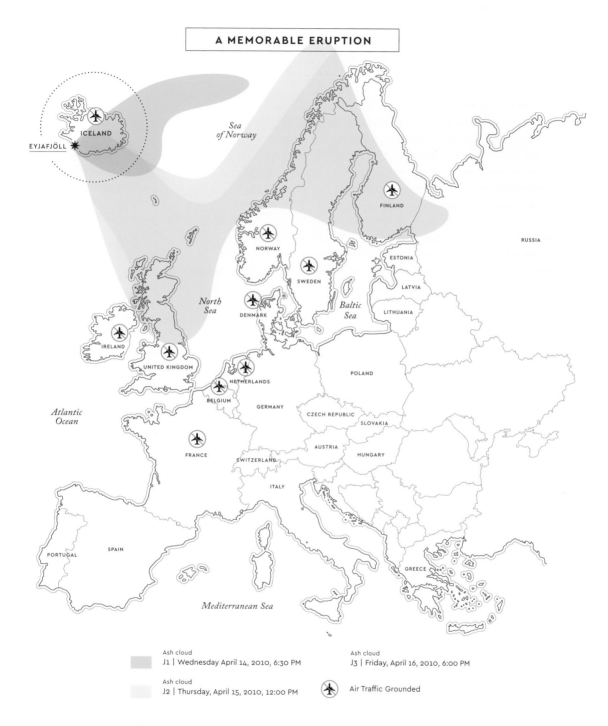

## A MEMORABLE ERUPTION

**Ash cloud**
J1 | Wednesday April 14, 2010, 6:30 PM

**Ash cloud**
J2 | Thursday, April 15, 2010, 12:00 PM

**Ash cloud**
J3 | Friday, April 16, 2010, 6:00 PM

Air Traffic Grounded

Eyjafjöll is a volcano in southern Iceland. On March 20, 2010,
it erupted. On April 14, it ejected lava into its caldera covered by the
Eyjafjallajökull and Mýrdalsjökull glaciers. As the ice melted, it caused huge
glacial outburst floods (*jökulhlaups*) as well as a volcanic plume of water vapor,
gas, and ash. The cloud spread throughout continental Europe, disrupting
air travel and forcing the closure of several airspaces until May.

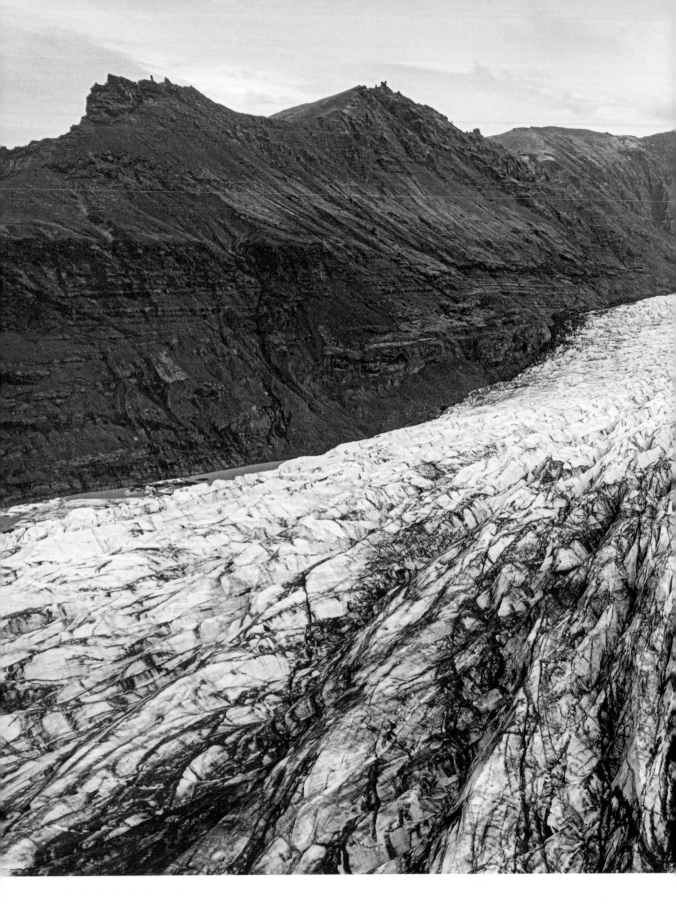

*An outlet glacier, Skaftafellsjökull is one of the many tongues of Vatnajökull glacier.*
*As it recedes, previously covered rocks are revealed.*

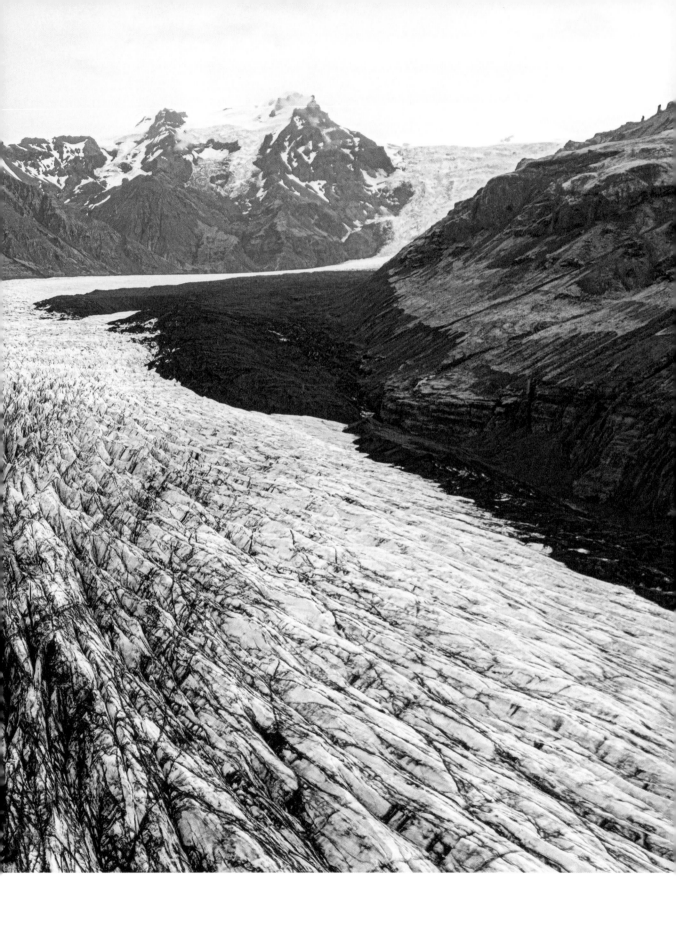

**ABOVE**

*As it retreats, a glacier often leaves behind a lagoon of murky waters where
blocks of ice drift. The black sections are made up of volcanic ash and sand.*

**RIGHT**

*South of Skaftafell, various subglacial eruptions have generated enormous
amounts of erosion material.*

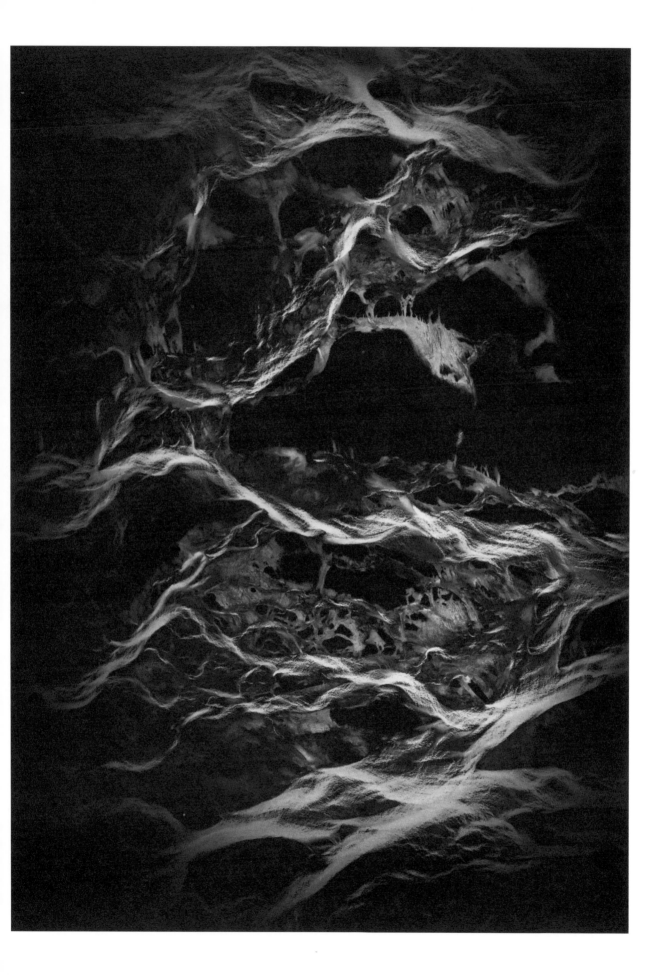

# GÍSLI MATT

## A CIRCUMPOLAR COOK

In the span of thirty years, Icelandic cuisine has undergone a true
revolution. Although traditional recipes still have a privileged place on
the island's plates, its new cuisine, propelled by young creative chefs,
offers beautiful surprises in flavors.

Traditional Icelandic cuisine has its roots in its rural past, when farms were self-sufficient and families consumed livestock or fish products. Lamb, dairy products, and fish were the basis of an islander's diet, as the harshness of the environment and the lack of exposure to other cultures did not provide for much creativity with food and cooking techniques; smoking, salting, and marinating made it possible to preserve food through winter. Some traditional specialties—such as smoked sheep (*hangikjöt*), once reserved for celebration days, boiled mutton's head (*svid*), whale steak (*hval*), and cured, fermented shark meat (*hákarl*)—are common items on restaurant menus.

Today, Icelandic cuisine is one of the most beautiful discoveries visitors to the island can make. After just one generation, the country has become the scene of an astonishing gastronomic revolution, which has created what is now a leading Nordic cuisine, upsetting preconceived ideas about the influence of tradition on know-how. Eager for new experiences, Icelanders turned the disadvantage of their geographic position into an asset and concluded that, although tradition remains an

essential part of their cuisine, the purity of local and seasonal products as an asset is undeniable. Based on the fundamentals of Icelandic foods— fish, lamb of incomparable flavor, and *skyr* (a kind of yogurt)—Icelandic chefs began to travel to glean ideas from other cuisines of the world to best complement the island's gifts from nature.

More and more Icelandic chefs have traveled abroad to study and returned with new recipes and techniques. Some have participated in global competitions, such as the prestigious Bocuse d'Or. A first generation of these cooks was soon succeeded by another generation, even more daring in their approach to food, grateful to the those who cleared the way before them.

Gísli Matt, originally from the Westman islands, is part of this generation of young chefs who dared open a restaurant far from Reykjavík, adopting the precepts of the Slow Food movement, respecting the natural resources of his archipelago. To not compromise his approach to using fresh and local products within this proud Nordic cuisine, he closes his restaurant in winter.

# I WAS BORN IN VESTMANNAEYJAR.
# I COME FROM A HARD-WORKING FAMILY
# OF FISHERMEN AND COOKS.

### 1. A GAMBLE

Gísli Matt took a risk by opening a restaurant on the only populated island of the Vestmannaeyjar archipelago.

### 2. LOCAL CUISINE

Here, the chef's key word is "local" for creating a cuisine anchored to the island.

### 3. GÍSLI MATT, CHEF AND GARDENER

The secret of good food is obtaining fresh products. For Gísli Matt, he has access to them because he grows them himself.

### 4. ON THE PLATE

Living at the edge of the planet does not mean plates cannot be prepared as found in some of the world's best restaurants.

### 5. VEGETABLE GARDEN

On an island where soil is scarce, fast-growing, robust vegetable species are cultivated.

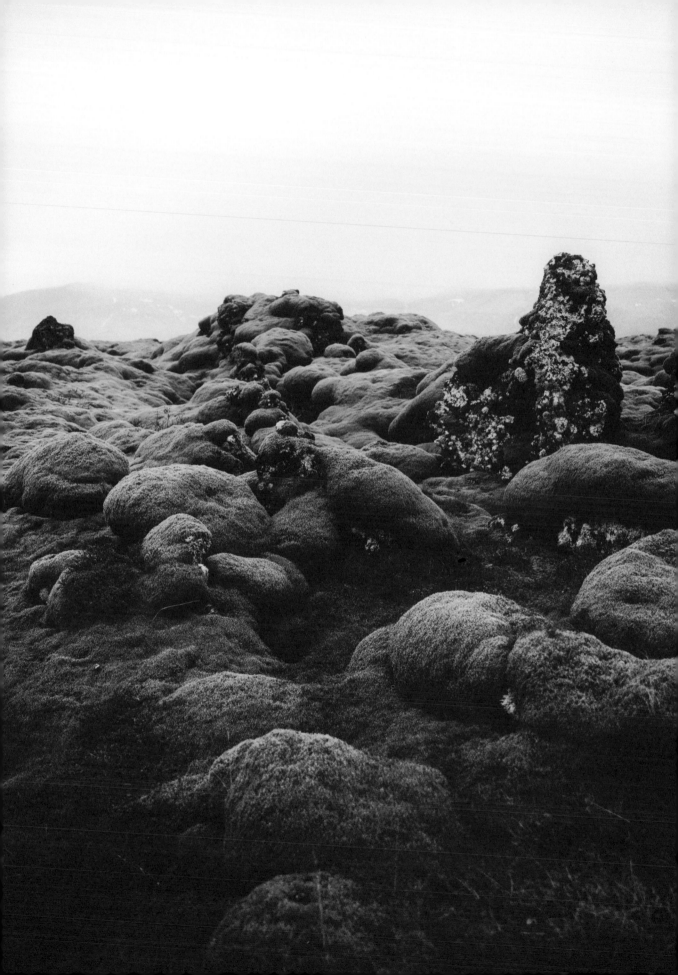

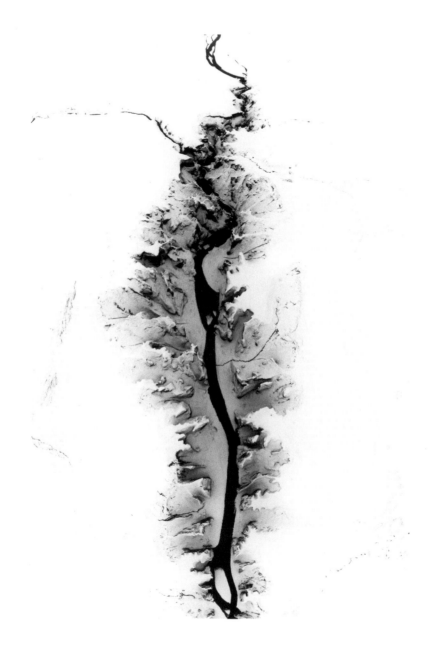

The Fjarðrá river gave the gorges of Fjarðrárgljúfur their beautiful,
chiseled features.

The lava expanses of Eldhraun are covered with mosses and lichens
of which there are five hundred varieties in Iceland.

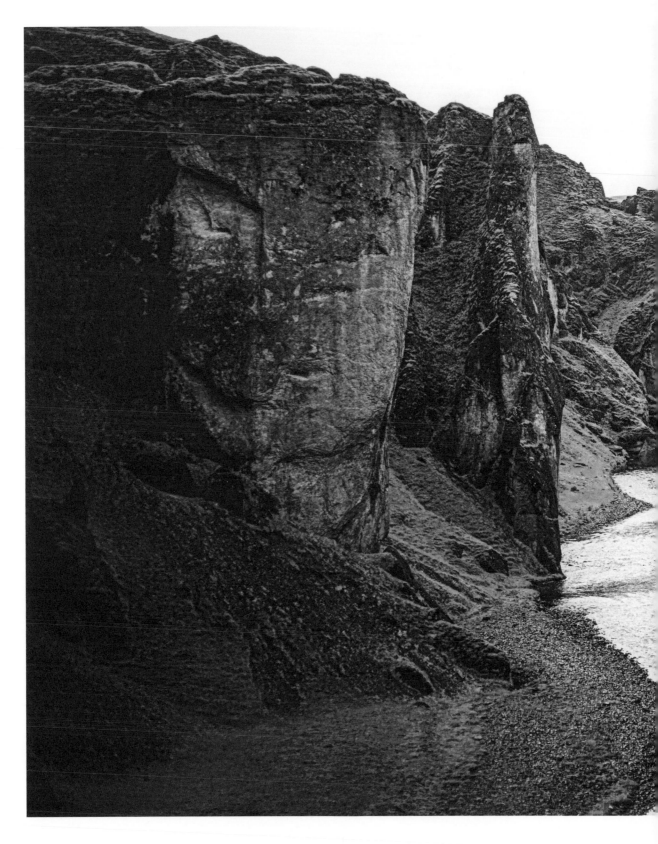

*The Fjarðrárgljúfur gorges alternate vertical and sloping grass-covered walls.*
*A river meanders through the bottom before flowing into the Skaftá glacial river.*

NATURE

# THE GLACIERS OF ICELAND

### GLACIER FRONT

A glacier front never has a definitive shape. It is often formed by numerous gaping and deep crevices, making it difficult to access.

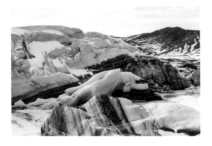

## PURITY

The purer the ice, the more dominant its blue color.

## CONTRASTS

The color of the glacier also depends on the volcanic origins of the ash and sands.

## PRECIOUS STONES

This clump of ice, shaped by water, sun, temperatures, and waves, looks like a large diamond.

## DRIFTING ICE

Ice makes its way through a channel to eventually be tossed back on the beach by the tide.

## JÖKULSÁRLÓN

Aerial view of a block of ice detached from the Breiðarmerkurjökull glacier front.

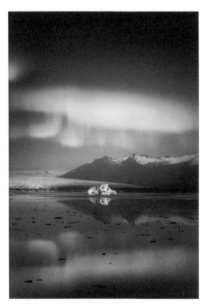

## AURORA BOREALIS

From the end of August to mid-April, festivals are held celebrating the northern lights, whose reflection in the waters and on the ice is an unforgettable sight.

## CLOSE-UP

The texture of this glacier's surface looks like elephant hide or the bark of a tree.

## CONCENTRATION OF ICE

The quantity of ice depends on the seasons and winds of the years.

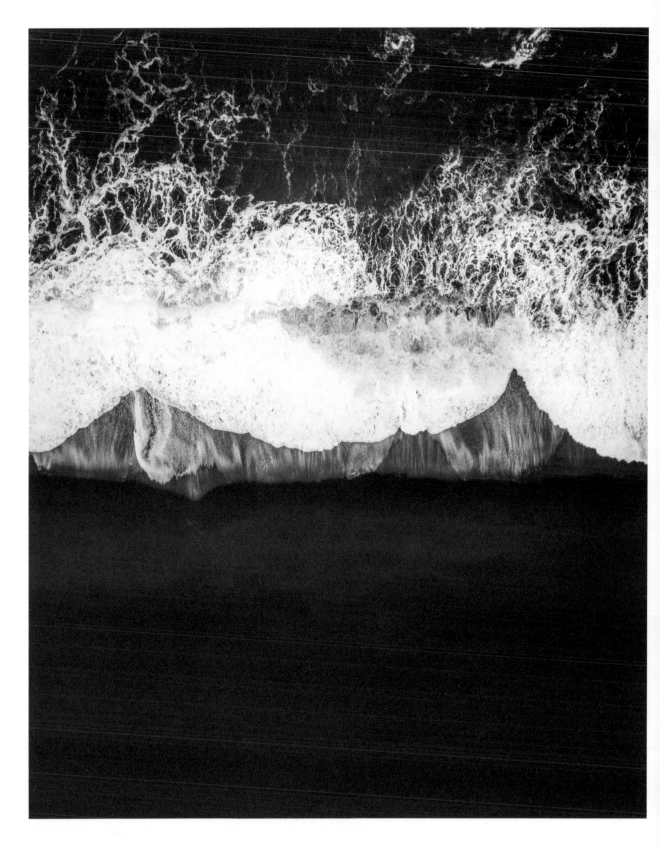

*Iceland's black sands exist thanks to the presence of volcanoes
under its glaciers.*

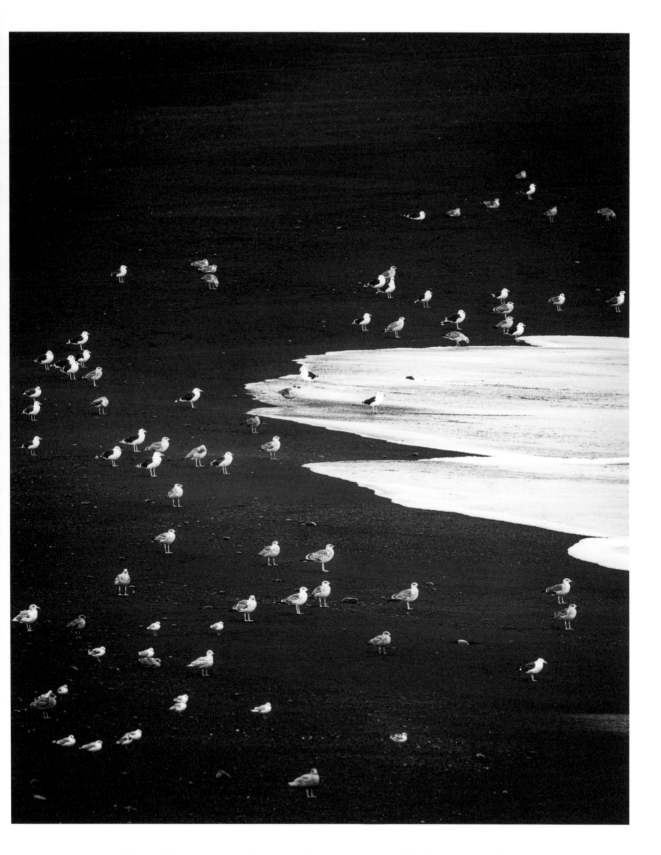

*Gulls, which have taken up residence in the hostile surroundings of Breiðarmerkursandur beach, must compete with great skua, who also claim this territory.*

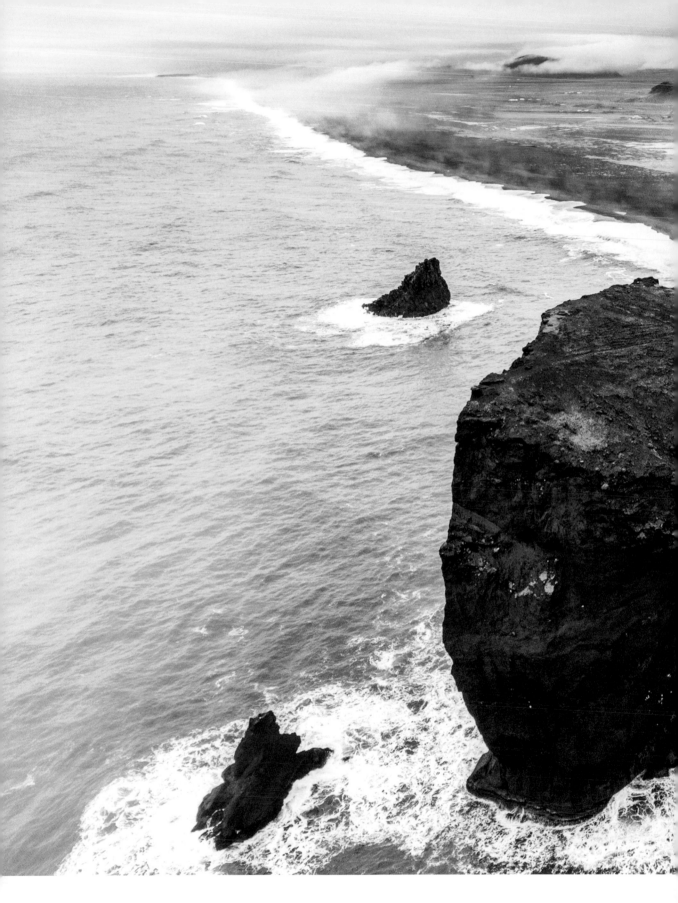

*The cliffs of Reynishverfi, Ingólfshöfði, and Dyrhólaey make up the southern coast.*
*Puffins and storm petrels have established their colonies here.*

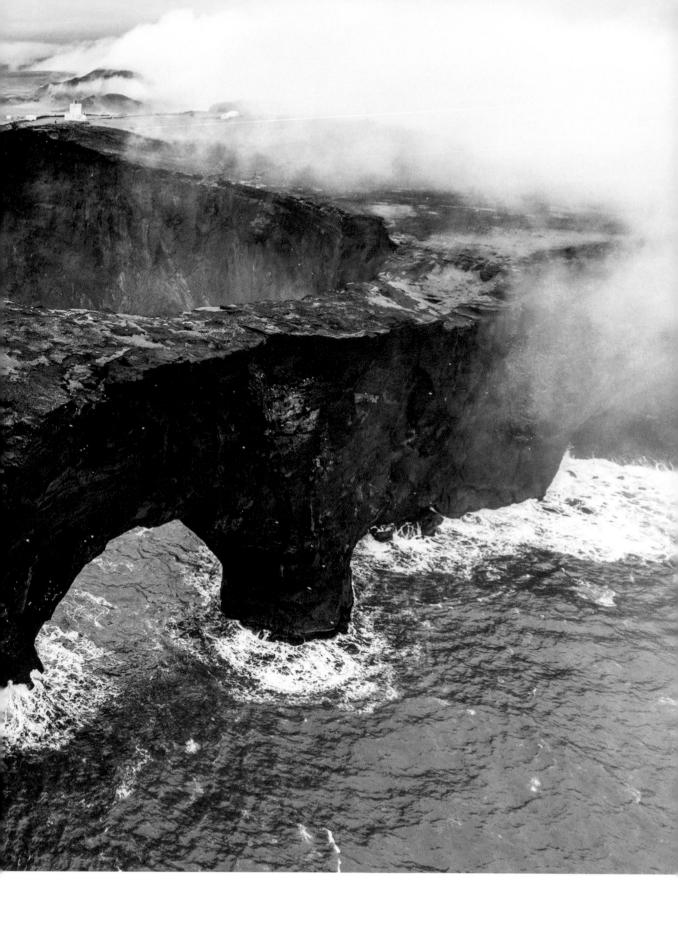

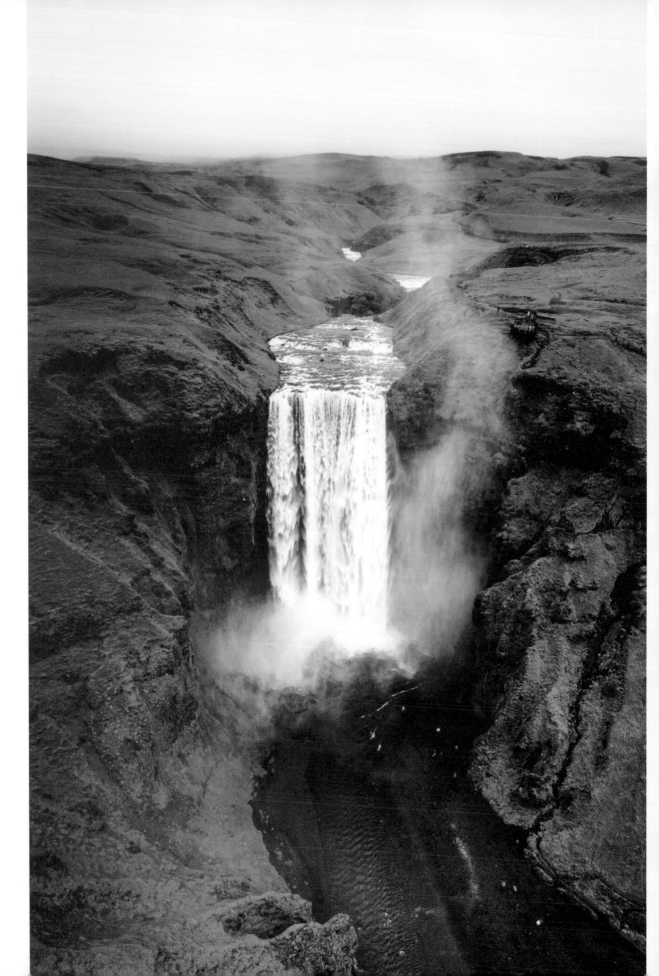

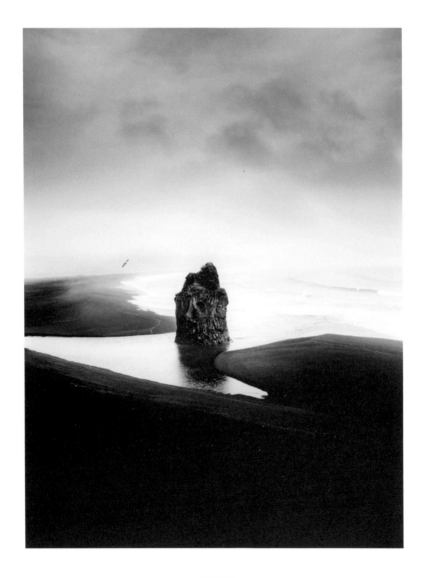

ABOVE

*Near Vík, a river and its sea stack separate Dyrhólaey
from Reynisfjara beach.*

LEFT

*At about 200 feet (60 m) high, Skógafoss waterfall is the last
in a chain of waterfalls on the Skógá river.*

FOOD & DRINK

# THE TASTE
# OF TOMATO

Isolated for centuries on their rocky, wind-battered island
covered with snow for two-thirds of the year and plunged for
many weeks into near-darkness, Icelanders have continually
waged a merciless struggle against the elements.

Among the many challenges presented by their country's geography, Icelanders possess three gifts from Mother Nature: coastal waters, which constitute a huge reservoir of fish, enormous quantities of water in either a liquid or solid state, and geothermal activity that is unique in the world. Although Icelanders were livestock breeders before they were fishermen, they quickly understood what a formidable asset such a food supply represented along their coastlines, and they did not hesitate to brave the harsh conditions of the North Atlantic to obtain it. Although water from rivers and glaciers existed in abundance, they did not make much use of it. As for the hot water from the springs, they used it mostly to warm themselves and for enjoyment, as several sagas recount, but attempts to exploit it remained anecdotal.

Since the first half of the twentieth century, Icelanders began to take advantage of all this natural wealth. The fishing fleet was modernized thanks to motorized trawlers; the first dams were built to produce electricity; and naturally hot water was used to heat houses, public buildings, and greenhouses to grow flowers and early seasonal produce. It was not until the 1950s that tourism slowly began to develop. Eventually visitors arrived in more and more numbers to enjoy the natural springs and uncovered pools while also enjoying local products

such as tomatoes, cucumbers, peppers, and lettuces, which flourished in greenhouses.

The financial collapse of 2008 caused the loss of twenty percent of jobs on the island. But Icelanders, who have always demonstrated strong resilience, met the challenge with great creativity. Several original initiatives emerged as tourism developed, such as that of the Friðheimar farm in the region of Geysir and Gullfoss.

Knútur Rafn Ármann and his wife, Helena, had been on the same land breeding horses and managing greenhouse crops, which were exclusively powered by energy from underground sources. Riding the wave of the popularity of organic produce, they had the idea to offer visitors a taste of the fruits of their labor, specifically their tomatoes, and eventually opened a restaurant offering a fixed-price menu within one of their greenhouses. Today, visitors can enjoy a menu whose common theme is tomatoes cultivated using renewable and clean energy. Visitors can also tour the greenhouse to better understand their entire production process.

This initiative, which has experienced great success, has been emulated, as another greenhouse operator in Flúðir now offers the same experience with cultivated mushrooms.

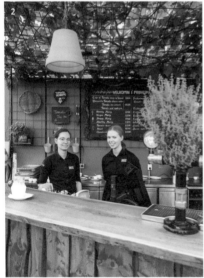

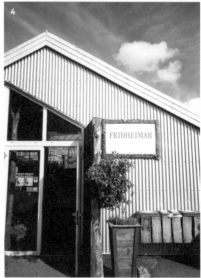

### 1. AT THE TABLE

Along with his family, Knútur Rafn Ármann had the idea to open a restaurant in which he serves products grown in his greenhouse.

### 2. WELCOMING

The warm reception invites you into verdant surroundings.

### 3. POLAR SOUPS

It's a surprising pleasure to enjoy a soup made from tomatoes grown near the Arctic Circle.

### 4. SHEET METAL AND GLASS

Made of sheet metal and glass, Knutur Rafn Ármann's greenhouses employ typical Icelandic architecture.

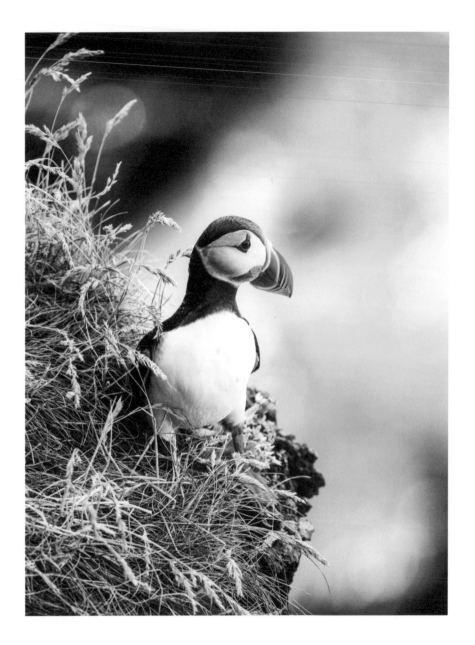

**ABOVE**

*Like other bird species, puffins are less abundant in the south of the country
because of overfishing.*

**RIGHT**

*In summer, razorbills gather on the Reynisdrangar reefs to nest.*

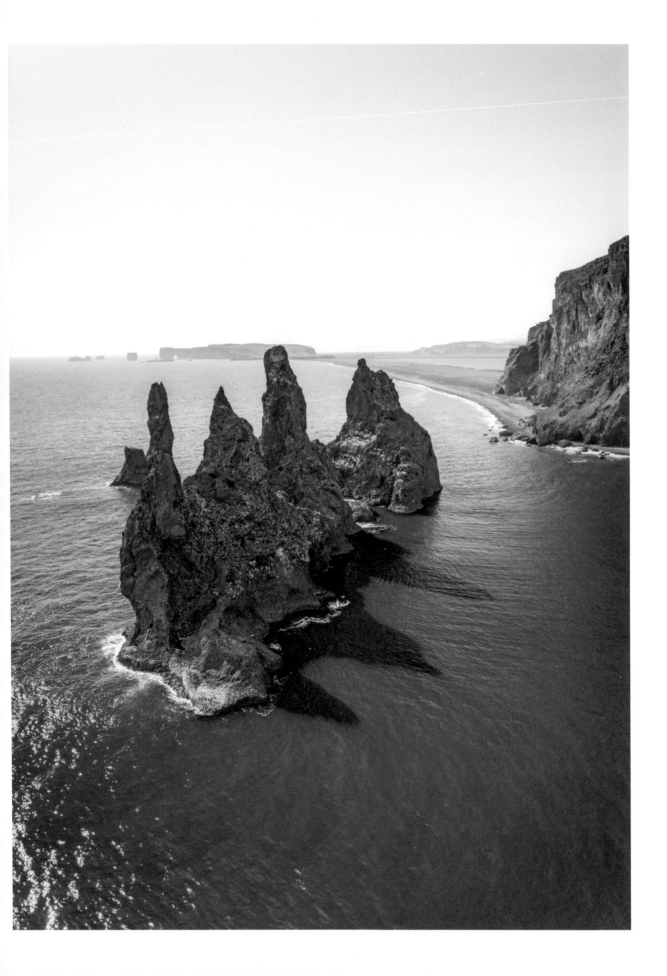

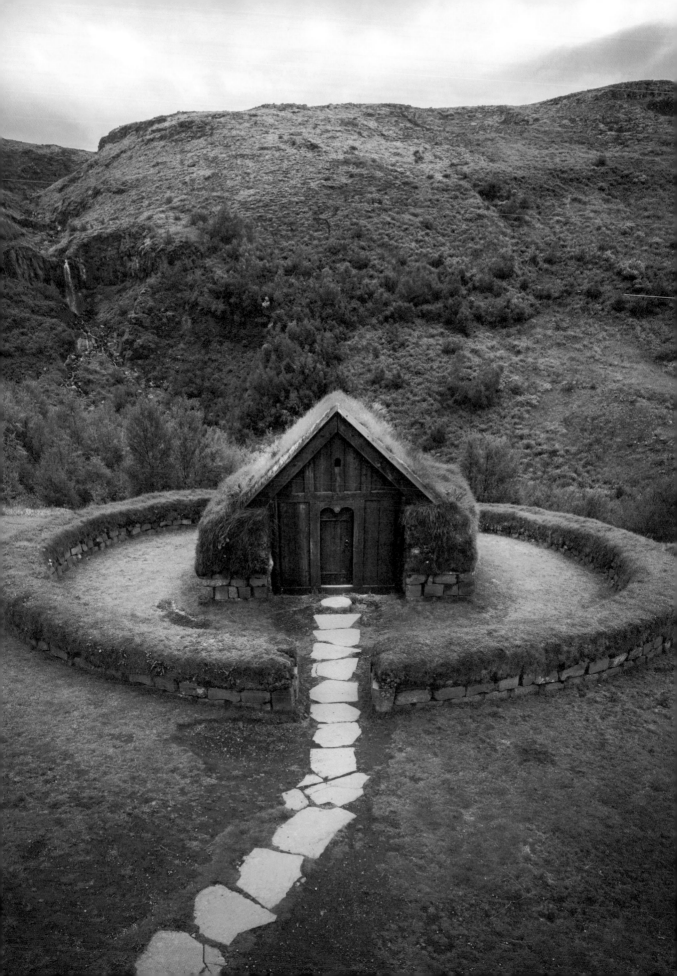

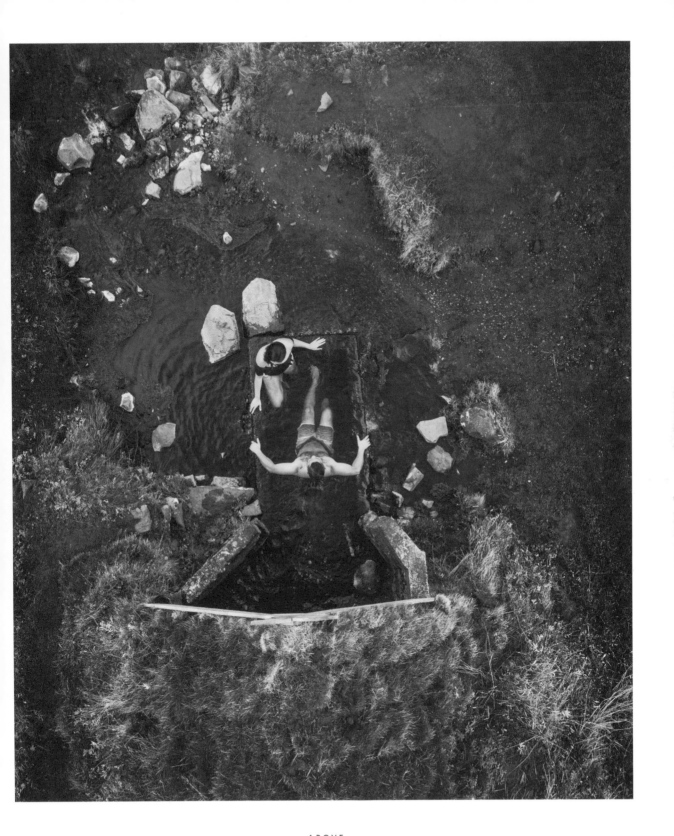

**ABOVE**

*For a small fee, you can bathe in ancient springs such as those in Hrunalaug.*

**LEFT**

*In the Þjórsá river valley, this replica of the Stöng farmstead, which was originally destroyed
by the eruption of Hekla in 1104, was built using the remains from the original.*

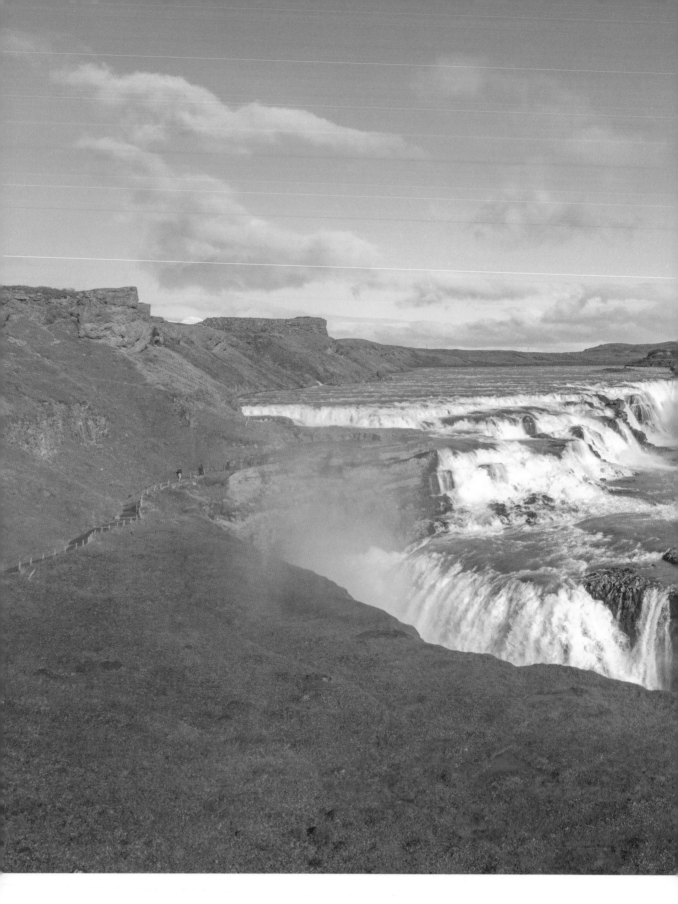

*The famous Gullfoss waterfalls, the "golden waterfalls" in Icelandic, gets its name from the rainbow that appears above the waterfall once the sun comes out.*

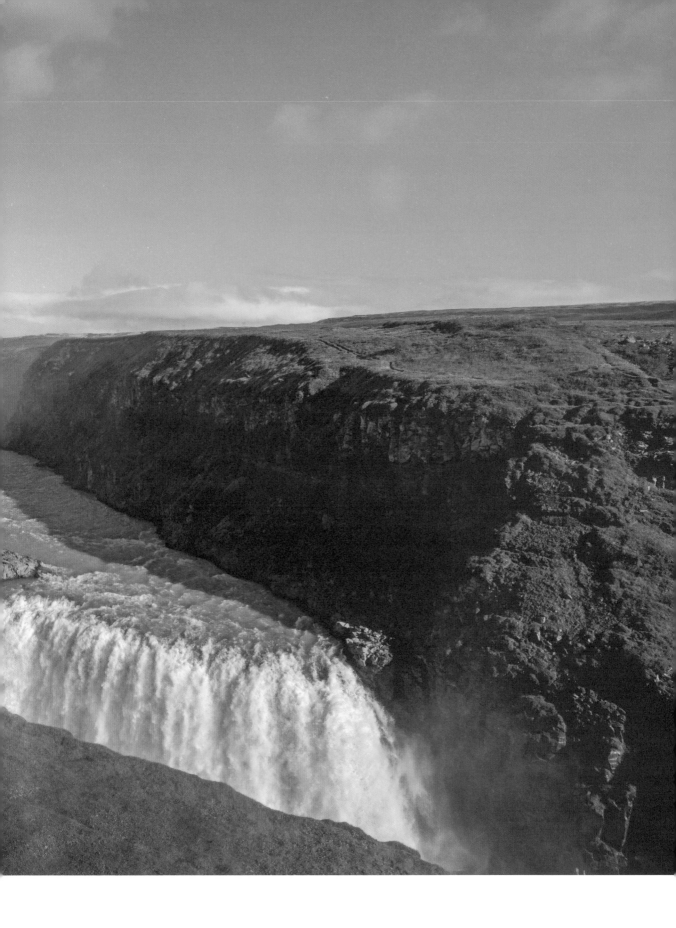

**ABOVE**

*Located near the geyser in Geysir, from where the word "geyser" originates,*
*Strokkur (meaning "churn") is the most active geyser in the country.*

**RIGHT**

*During his visit to Iceland in 1874, the king of Denmark, Krístján IX, passed*
*on horseback along the route near the Brúará river and Brúafoss falls.*

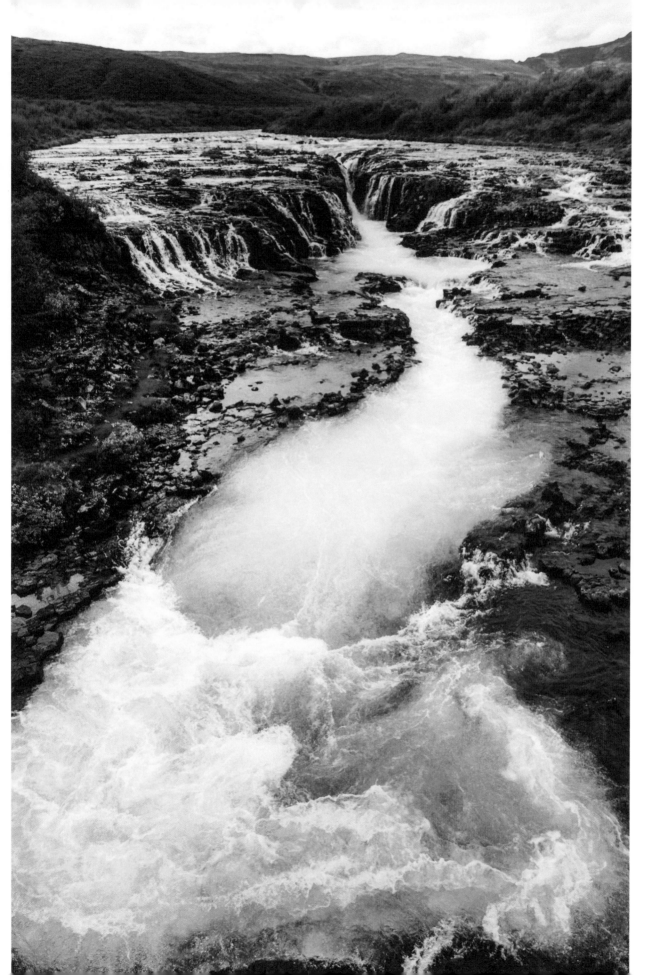

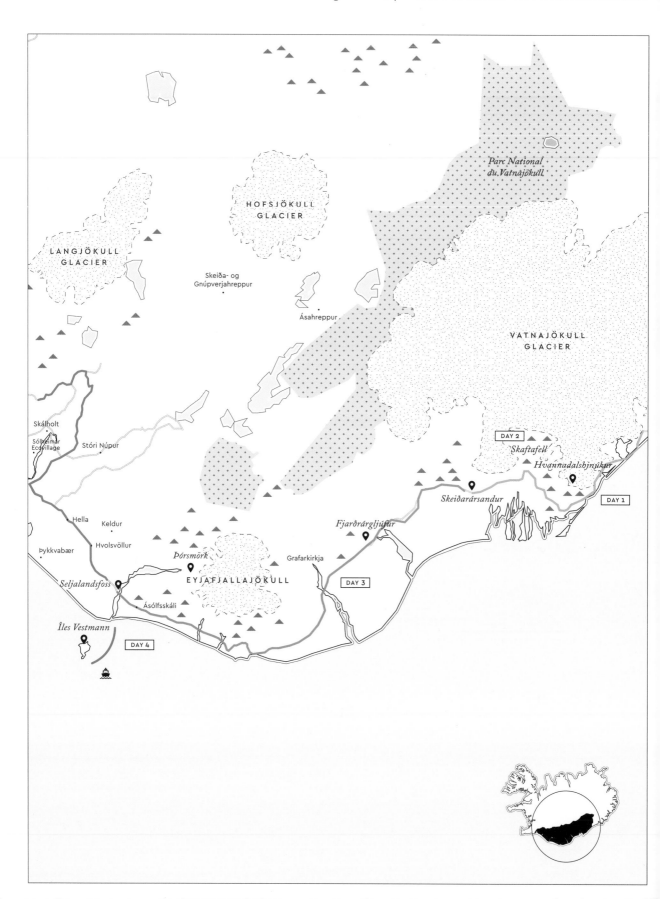

Parc National
du Vatnajökull

HOFSJÖKULL
GLACIER

LANGJÖKULL
GLACIER

VATNAJÖKULL
GLACIER

Skeiða- og
Gnúpverjahreppur

Ásahreppur

Skálholt

Sólheimar
Ecovillage

Stóri Núpur

Skaftafell

DAY 2

Hvannadalshnúkur

Skeiðarársandur

DAY 1

Hella

Keldur

Fjarðrárgljúfur

Hvolsvöllur

Þykkvabær

Þórsmörk

Grafarkirkja

DAY 3

EYJAFJALLAJÖKULL

Seljalandsfoss

Ásólfsskáli

Îles Vestmann

DAY 4

# 4 DAYS ON THE SOUTH COAST

Imagine a black-sand beach stretching just over two hundred miles (three hundred fifty kilometers). In the distance, the horizon is interrupted by steep cliffs and sea stacks. The south is a dramatic contrast to the north. Here, nature has denied man the right to settle villages by the sea.

### DAY 1: FROM HVANNADALSHNJÚKUR TO SKEIÐARÁRSANDUR

From here begins the discovery of an Iceland of extremes: one of cataclysmic floods at the foot of glaciers and eruptions that shake the many volcanoes they cover. It was not until 1974 that bridges were built to cross the vast expansive Skeiðarársandur plain and made it possible to circumnavigate the island by the ring road that runs along the Vatnajökull glacier, reputed to be the largest glacier in Europe. A rare green countryside is followed by a brutally icy landscape. A Zodiac boat tour allows you to approach the drifting ice and the glacier front that moves away from the coast at a rate of just over four miles (seven kilometers) each century. The stunning character of this landscape is overwhelming. The Fjallsárlón lagoon offers the pristine slopes of the Fjallsjökull glacier. Take a Zodiac boat tour or try kayaking at the foot of Heinabergsjökull and reach the cliffs of Ingólfshöfði, a sanctuary for both birds and daydreamers with its stunning views of the island's highest point, the Hvannadalshnjúkur.

### DAY 2: SKAFTAFELL AND SURROUNDINGS

Discovering the peculiar landscapes of a glacial tongue while donning crampons under the watchful eye of a guide is an experience that will delight all. Situated here within a national park, you'll be in a beautiful area surrounded by glacial tongues reaching almost to sea level but separated from it by the famous sandar plains. You'll have to exert some effort to discover the Svartifoss waterfall and its fringe-like basalt columns, or to walk a vast plateau that leads to a breathtaking aerial view of the Skaftafellsjökull, or to climb and enjoy a breathtaking panorama at the top of the Kristinartindar mountain.

### DAY 3: FROM FJARÐRÁRGLJÚFUR TO SELJALANDSFOSS

Sandar, lava fields, meadows, deserts, waterfalls, glaciers, volcanoes . . . the day promises to be rich in contrasts. The intricately carved Fjarðrárgljúfur gorges are second to none, the Hjörleifshöfði sea stack offers splendid views of the expanses of black sand, and it is again possible to approach the sea to admire one of the most beautiful landscapes on the island between the basalt columns of Reynisfjara beach and the cliffs of Dýrhólaey overhanging it. On the coastal plain are Skógafoss and Seljalandsfoss waterfalls not to mention the Skógar ecomuseum. If you had to time to visit only one museum, it should be this one.

### DAY 4: THE WESTMAN ISLANDS AND THE GOLDEN CIRCLE

By ferry, head to Heimaey, the only populated island here. Its village, ravaged by the eruption of 1973, experienced the birth of a second volcano. Next, it's time to visit the classic sites within the Golden Circle, where few places on earth offer, in the span of about forty miles (seventy kilometers), so much to see: one of the most beautiful falls, Gullfoss; an area of geothermal activity whose star feature is the Strokkur geyser; and the valley of the Parliament of Þingvellir—a vast rift valley adjoining a fault several miles long and now a UNESCO World Heritage Site—the former site of the open-air parliament founded by the first settlers in AD 930.

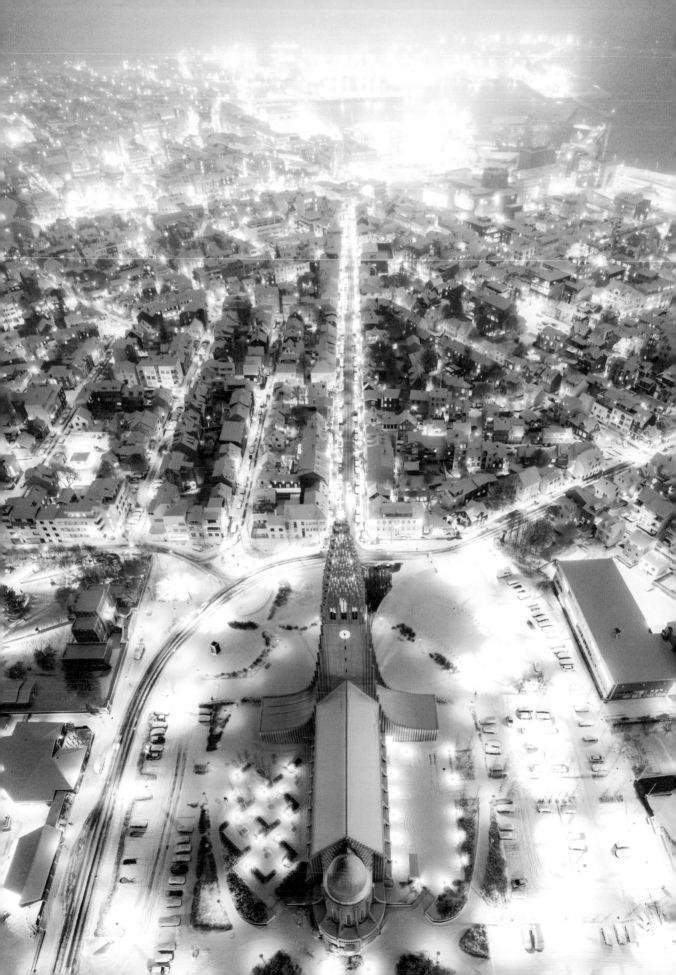

# REYKJAVÍK
## AND THE REYKJANES PENINSULA

When arriving in Reykjavík, literally "bay of smoke,"
travelers may wonder if this is considered a village, town,
capital, or city-state—it's a bit of each of these all at once.

P. 222

*The design of the Hallgrímskirkja church, built between 1945 and 1986,*
*was inspired by the basalt columns of the Icelandic landscape.*

RIGHT

*Hallgrímskirkja's tower offers a beautiful viewing spot over the city.*

Settled by a people arriving by sea, Reykjavík had less than two hundred inhabitants when it received its municipal charter from the Danish crown in 1786. At the turn of the twentieth century, it had little more than six thousand inhabitants. The city's small colorful houses—made of wood but uniquely covered with painted sheet metal—give it a cheerful and warm charm among its cosmopolitan bustle, making it a "big city" with a small-town feel. It is only beginning to grow denser, still remaining rich in open spaces. Its inhabitants, the Reykjavíkingar, are making it a city of tomorrow and desire more than ever to remain anchored to the modern world.

Despite its air of a beautiful yet gangly teenager, Reykjavík is the beating heart of Iceland and proudly displays its status as capital. With its trendy cafés, boldly designed restaurants offering an innovative approach to Nordic cuisine, theaters, cinemas, and universities, the city offers all the services worthy of a capital to its now two hundred twenty thousand inhabitants (including suburbs) making up two-thirds of the country's population. Visitors could easily forget that its fishing harbor is the largest on the island, as surrounding new construction tends to hide it from view. Lacking architectural tradition, Reykjavík's development has something of a haphazard architectural approach, yet it ends up revealing a kind of harmonious chaos. For example, you can walk, in just a short distance, from an ancient house to the Harpa concert hall, which was desperately needed for the Iceland Symphony Orchestra and is now the pride of the city's inhabitants who maintain a thirst for culture as a remedy to their isolation. This imposing building's design, based on the country's basalt columns, can be symbolically viewed as the link to the surrounding natural landscape.

In Reykjavík, nature is omnipresent, inside and outside the city. The many swimming pools that can be found, heated by geothermal energy, are a large part of the art of living of the Reykjavíkingar. Mount Esja, which dominates the city with its three thousand feet (nine hundred fourteen meters) is very popular with hikers. Its rather easy ascent allows you to enjoy a magnificent view of the city, reminding you that the city is, in fact, a mere fragment of inhabited land bumping up against the edge of an inhospitable world. After just a few minutes of driving time, you can find yourself in the austere lava landscapes of the Reykjanes peninsula to remind you just how close Reykjavík, the planet's northernmost capital, is to the active volcanic rift where the island emerged from the Atlantic some twenty million years ago.

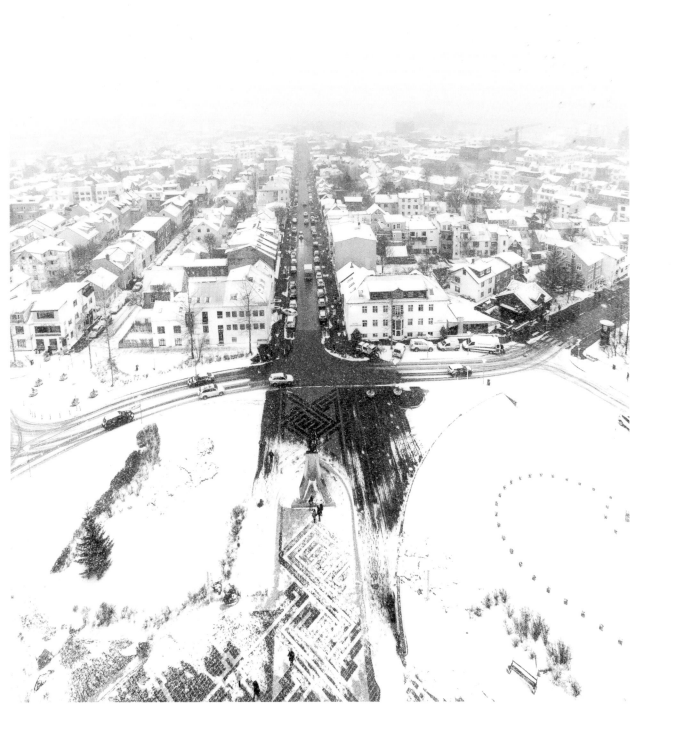

# THE ESSENTIALS

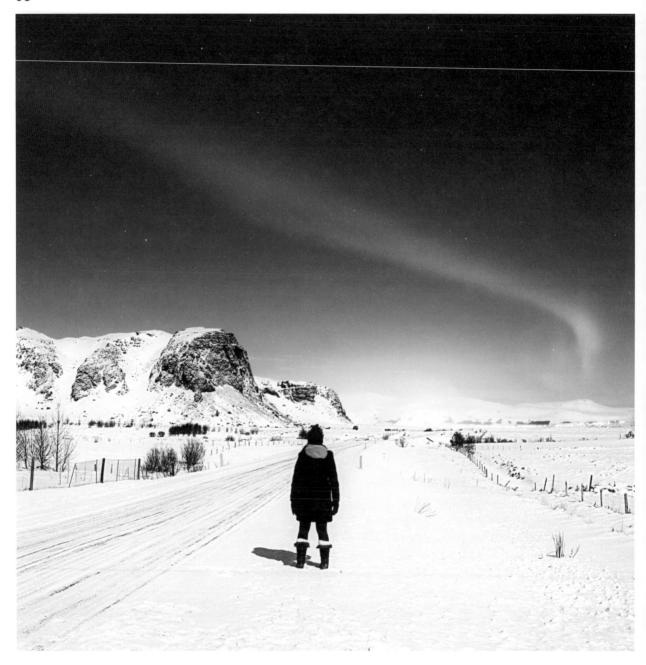

## AURORA BOREALIS

Even though they can appear somewhat faded due to the city's lights,
the northern lights can also be seen in Reykjavík.

**69**

### EINAR JÓNSSON MUSEUM

In this small museum, the shaded garden presents copies of works by sculptor Einar Jónsson and houses the originals in its rooms.

**70**

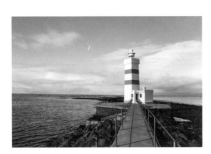

### GARÐUR

Garður lighthouse guards the entrance of Faxaflói Bay and offers a breathtaking view of the surroundings of the capital and the Snæfellsnes peninsula.

**71**

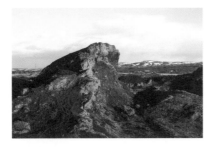

### HEIÐMÖRK

At the gates of the capital, this wooded and recreational nature reserve is the ideal place to take a deep, relaxing breath.

**72**

### HARPA

A cultural center housing a 1,600-seat classical music concert hall.

**73**

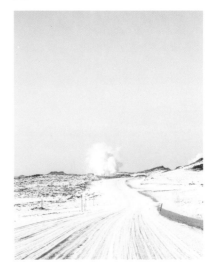

### AROUND REYKJAVÍK

Just a fifteen-minute drive away, the wide-open spaces offer city dwellers a moment amid Icelandic nature.

**74**

### SÓLFARINN

The vantage from this sculpture offers spectacular views of Faxaflói Bay and Mount Esja.

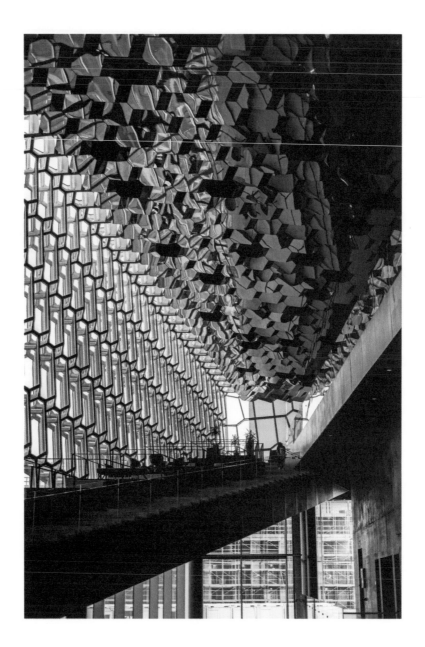

**ABOVE**

*The inauguration of the Harpa cultural center and concert hall as the home
of the Icelandic Symphony Orchestra and Opera in 2011 breathed excitement
into the city after the 2008 financial crisis.*

**RIGHT**

*Designed by Ólafur Elíasson, the Harpa concert hall is architecturally seductive,
with its glass facade and geometric forms inspired by the island's basalt columns.*

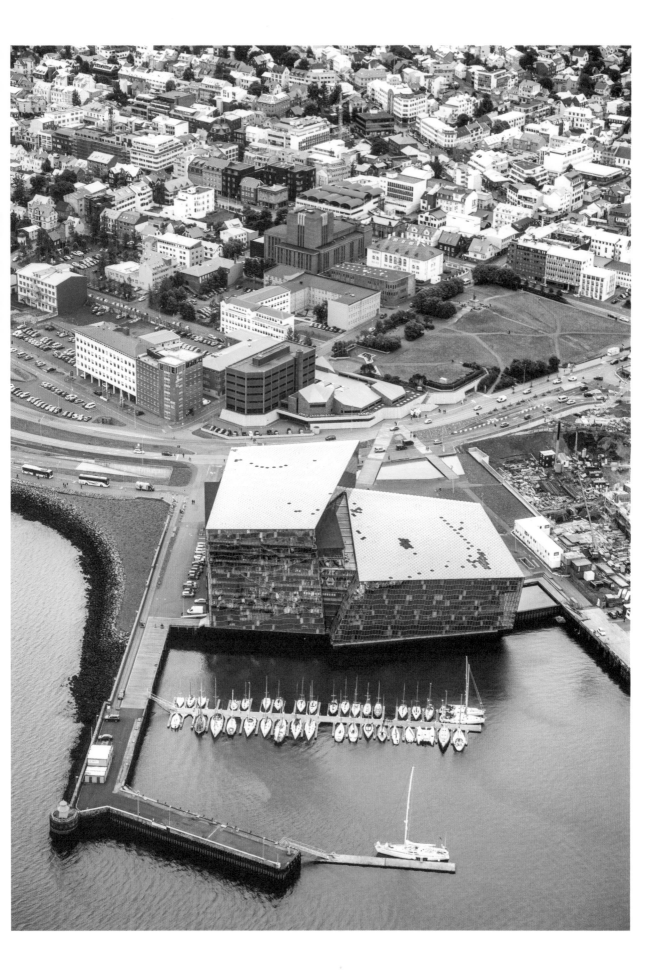

UNDERSTANDING

# THE GEOTHERMAL

## WAY OF LIFE

When you live in a country located at the edge of the Arctic Circle, it may
seem unbelievable to have an abundance of hot water available to you.
But throughout Iceland, geothermal activity provides an infinite number of
warm sources from hot springs, mud pools, solfataras, and geysers.
Icelanders owe these blessings of nature to the island's volcanic activity.

These ample geothermal resources are the key to the Icelanders' way of life. Without them, most homes could not be heated with inexpensive energy, and without that energy, architects would probably lack the ability to design detached, modern houses.

Visitors often ponder while standing in front of large windows open to the outside how such a feat is possible in a country where summer lasts only a few weeks—though, as Icelanders will point out, the summers can exceed 68°F (20°C). With such inexpensive energy, inhabitants can have fewer qualms about heating interiors while leaving the windows half open, a habit that can leave visitors

quite surprised. Hence the saying: "In Iceland, it is 77°F (25°C) all year round . . . inside!"

Icelanders are masters in the development of outdoor swimming areas, equipped with swimming pools where the water temperature is on average 79°F (26°C). These pools are flanked by smaller pools, the famous *heitir pottar*, literally "hot water pots," available to those who may not have them within their own gardens and where the water temperature ranges between 95 and 111°F (35 and 44°C). Icelanders have developed a lifestyle around these small spas where they love to meet up after a long day to relax, chat, or talk business.

### 1. HEATING GREENHOUSES

The heating of greenhouses by geothermal heat began in 1924. This technique allows the cultivation of such products as tomatoes, cucumbers, peppers, and flowers.

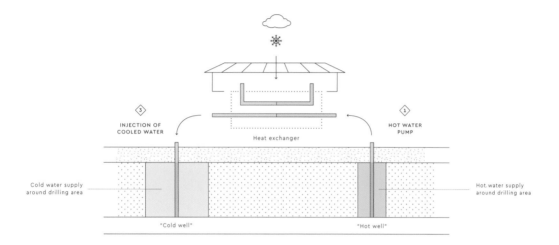

### 2. GEOTHERMAL COMFORTS

The energy is captured at a depth of a few tens of meters. The ground temperature is then increased by a thermodynamic system: the heat pump (HP).

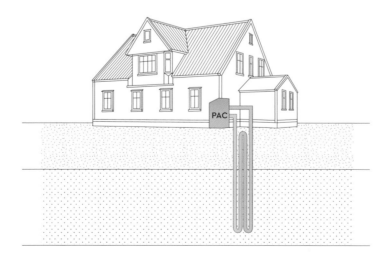

LIFESTYLE

# DAILY LIFE IN REYKJAVÍK

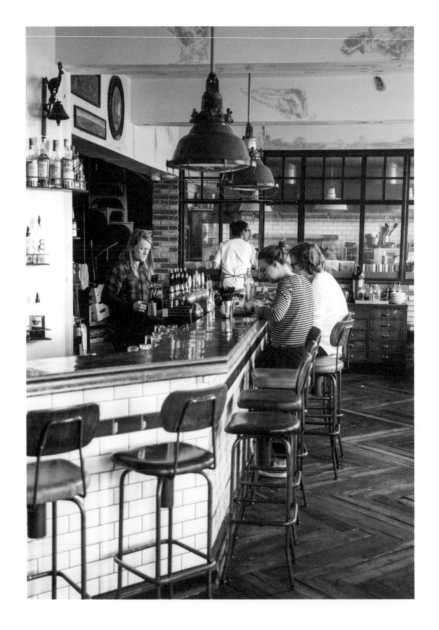

### RENAISSANCE

Around the late 1980s, restaurants, pubs, and cafés were scarce in Reykjavík.
Today, the city center offers many options.

## PROMENADE

The Grótta lighthouse makes a great destination during a pleasant walk through this nature reserve.

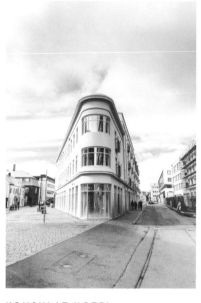

## KONSULAT HOTEL

There is a sense of New York influence in this Icelandic-style Flatiron building—but with fewer floors!

## LIVELY PLACES

Hotels, such as the Kex hostel, open their doors to Reykjavíkingar for concerts.

## NEW GENERATION

High-quality bakeries serving patrons to the sound of rock music have become popular.

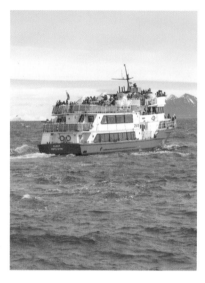

## A WHALE OF A TIME

Boats depart the harbor for whale watching.

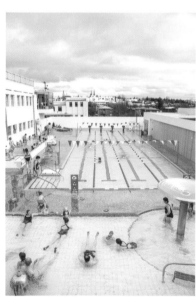

## SUNDHÖLLIN

The oldest swimming pool in the capital dating from 1930 has recently been renovated by adding outdoor pools.

## BOUTIQUE HOTEL

The Konsulat hotel is one of many hotels that opened during the 2000s.

## NORDIC CUISINE

A new generation of chefs create modern flavors using local ingredients.

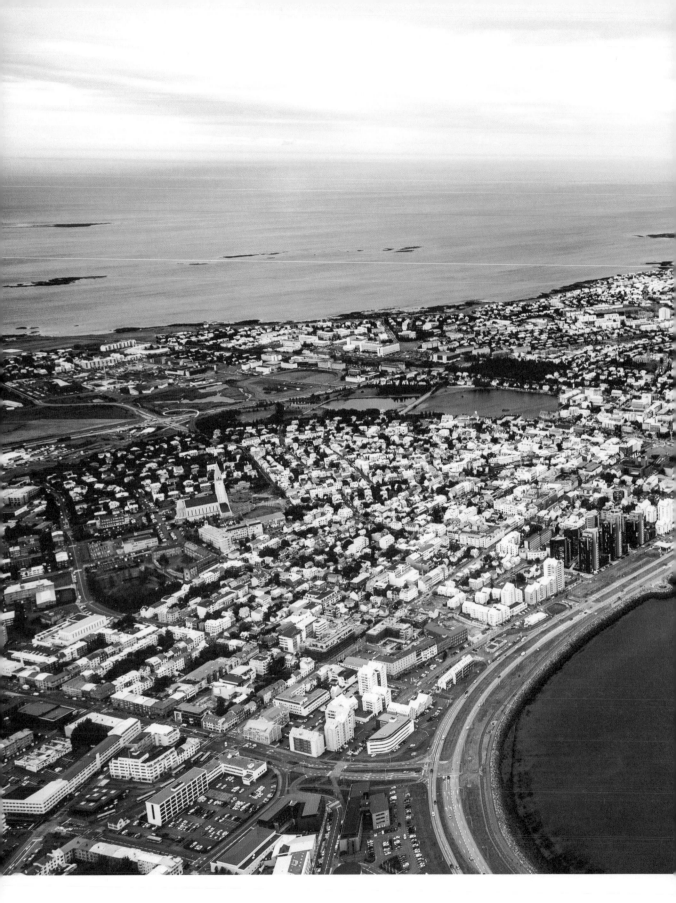

*Built on a peninsula, Reykjavík stretches from west to east for about 9 miles (15 km),
but only a few hundred yards from north to south.*

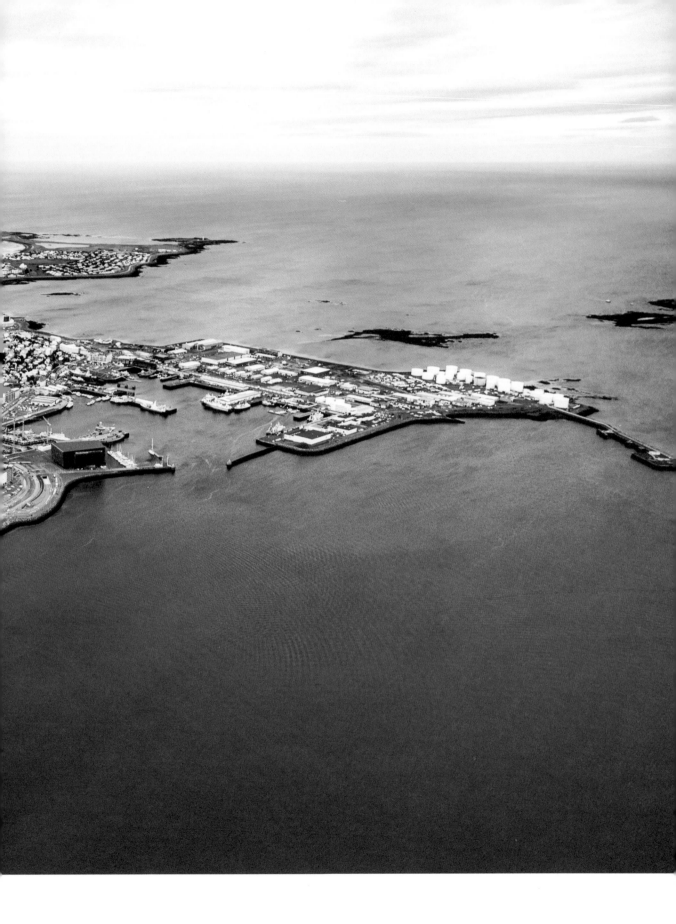

HISTORY

# WOMEN IN ICELAND

## PIONEERS OF EQUALITY

The question of what role women should have in Icelandic society is not new, as evidenced by numerous accounts in medieval literature. In 1980, Iceland proudly elected Vigdís Finnbogadottir as its first president. She paved the way for many other women in Icelandic society.

In Icelandic sagas, women do play decisive roles. For example, in the *Saga of Burnt Njáll*, the wise matron Bergþóra Skarphéðinsdóttir is pitted against the scandalous Hallgerður Langbrók. In the *Saga of Erik the Red Guðríður*, Þorbjarnardóttir accompanies her father and husband in the eleventh century during travels to Greenland and North America.

In 1908, Iceland was one of the first countries to recognize the right of women to vote. But it was not until 1970 that a woman was appointed as minister. In 1980, Vigdís Finnbogadóttir was the first woman to be elected president of the Republic by universal suffrage, serving for sixteen years. For this divorced mother, attaining the country's highest responsibilities, even if the position is largely an honorary one, was not easy, and she had to suffer a great number of vexations. But Icelanders, despite—or thanks to—their isolation, are used to accepting opposing views.

Even if the political ranks were not ready for change, the people were. Thus, in 1994, Finnbogadóttir chose another woman, Ingibjörg Sólrún Gísladóttir, as mayor of Reykjavík. She remained at the head of the capital until 2003. She was appointed foreign minister in 2007 but resigned in

2009 and left the leadership of her party, replaced by Jóhanna Sigurðardóttir. Serving as Deputy of Althing and Minister of Social Affairs, Sigurðardóttir soon became the country's first female prime minister, in charge of forming a new government in a country experiencing serious decline after the financial crisis of 2008. She remained in office from 2009 to 2013, with the heavy task of ensuring that Iceland's citizens regained their lost confidence in their institutions and representatives.

In 2017, it was once again another woman, Katrín Jakóbsdóttir, that Icelanders turned to during yet another political crisis. The newly elected president, Guðni Jóhannesson, entrusted Jakóbsdóttir with the delicate task of forming a tripartite coalition. This mother of three had been involved in politics as minister of education between 2009 and 2013 and found herself at the head of the Left-Green Movement starting in 2013.

As one of the most appreciated female politicians, Katrín Jakóbsdóttir embodied an uninhibited female political class possessing values that have made seasoned political veterans accept the idea that times have changed and that women have full legitimacy to attain the country's highest offices.

**KATRÍN JAKOBSDÓTTIR**

Between 2009 and 2013, Iceland's current prime minister, Katrín Jakóbsdóttir,
served as minister of education while pregnant.

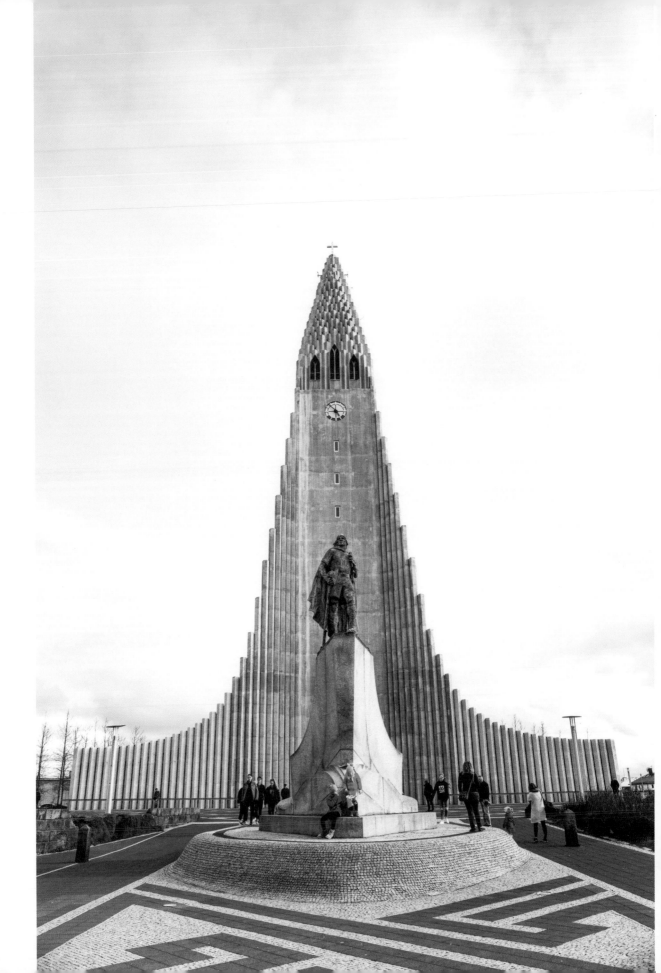

**ABOVE**

*In summer and winter, surfers take every opportunity to enjoy the waves along the city's coast.*

**LEFT**

*The statue of Leif Eiriksson, standing in front of Hallgrímskirja church, was donated by the United States to commemorate his discovery of America.*

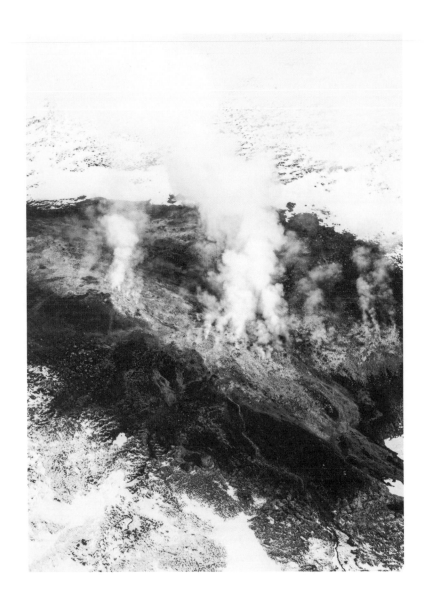

**ABOVE**

*Visiting the surroundings of the Reykjanes peninsula provides an idea
of the landscape on which the city was built.*

**RIGHT**

*Lake Arnarvatn is surrounded by a chain of subglacial volcanoes located
on the mid-Atlantic ridge.*

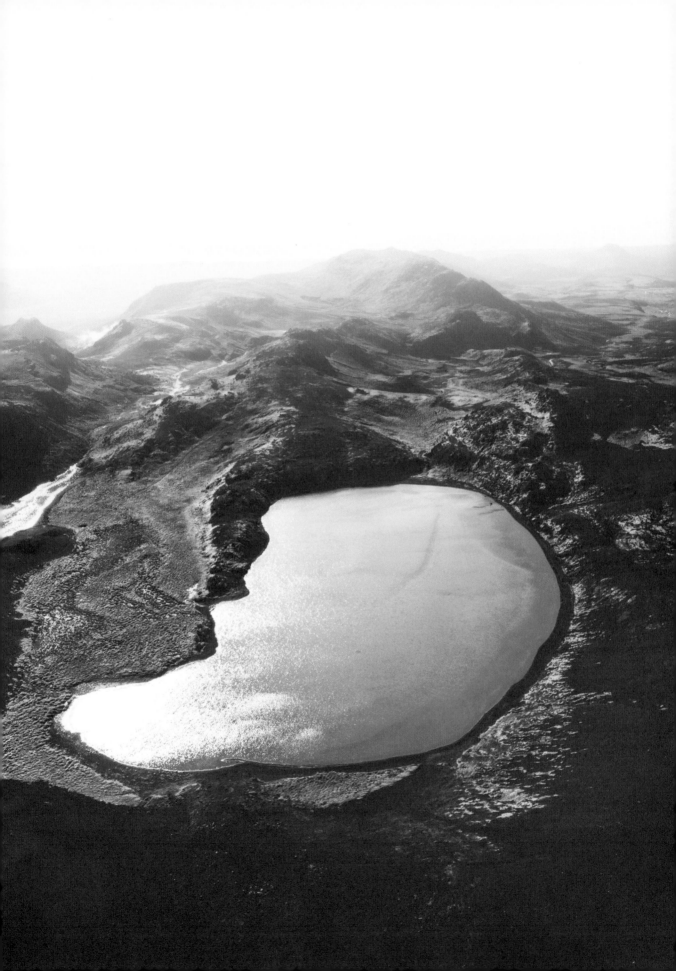

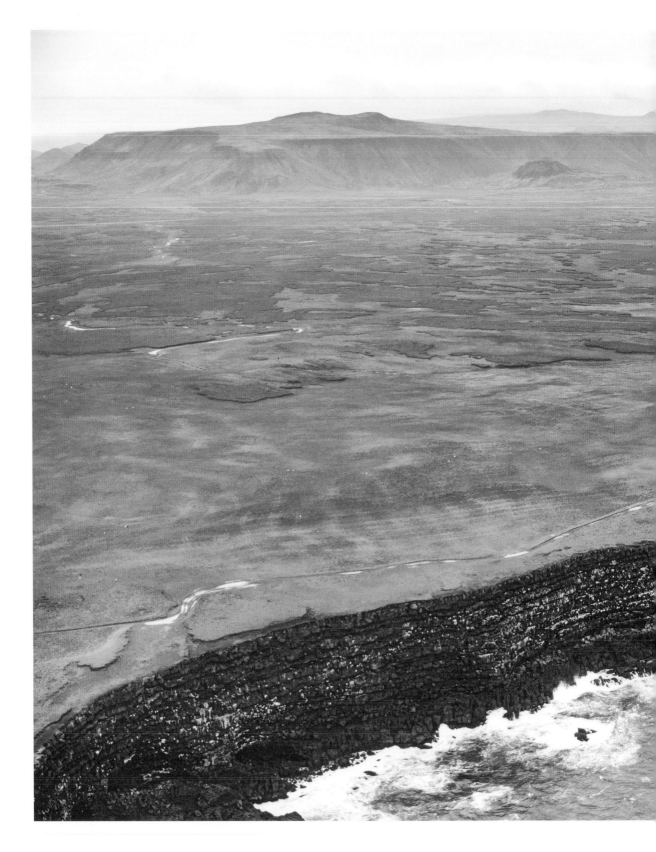

*In summer, the cliffs at Krýsuvíkurbjarg are populated with thousands of birds.*

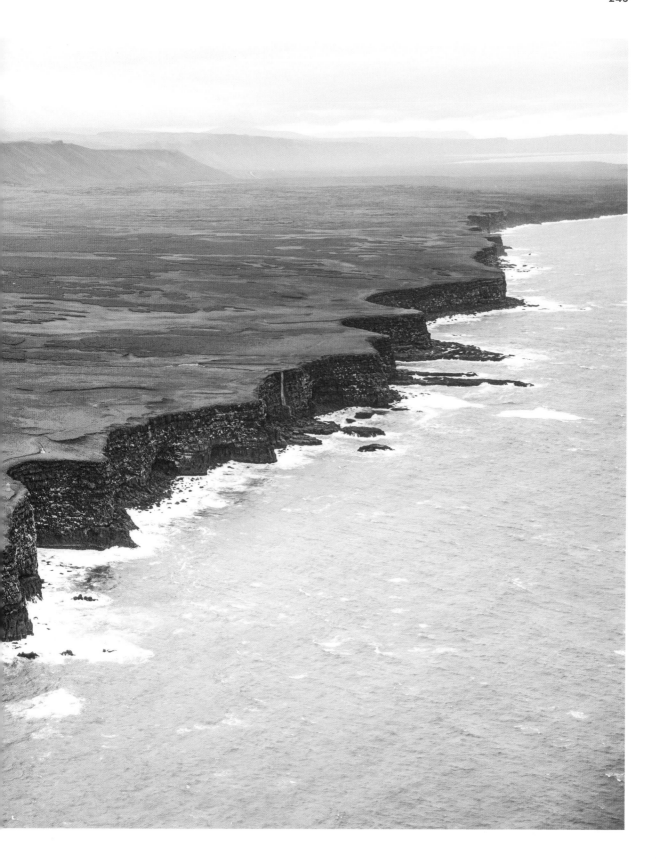

**ABOVE**

*Thermal mud pits are constantly bubbling in Seltún.*

**LEFT**

*Water is scarce on the Reykjanes peninsula
due to soil composed of porous lava.*

LIFESTYLE

# HAPPINESS IN THE LAGOON

**Ambitious projects can also often be controversial. As a response to the ever-increasing wave of tourism, the Retreat at Blue Lagoon was developed near Grindavík.**

The project was immediately criticized by those who thought that encouraging more tourism would essentially kill the goose that lays the golden eggs. Yet others praised the project, claiming Iceland greatly needed such a hotel to help tourism grow.

For its developers, the idea was to create a place that combines comfort and well-being with elegance and modern design in the unique, natural setting of the warm silica-rich waters of the Blue Lagoon. This would be an exclusive place where the key word would be *relaxation*; a true retreat in the middle of a thick moss-covered lava field in a landscape like no other—and all this would be less than half an hour from Keflavík International Airport, an easy gateway in and out of the country.

Today, the hotel houses about sixty rooms spread over two floors in order to better integrate into its immediate environment, including a suite of twenty-one hundred square feet (two hundred square meters). Depending on the location of the rooms, the balconies overlook a horizon of lava or the blue waters of the lagoon. The hotel also has relaxation rooms, saunas, steam rooms, two restaurants (including a gourmet level), and an outdoor hot-water pool reserved exclusively for guests of the Retreat. Massages can be given in the water to provide an intoxicating effect of weightlessness. The restaurant, Moss, is run by a chef who takes his guests on a journey of Icelandic cuisine, providing them with a warm welcome without being ostentatious.

The spaces, resolutely modern with clean lines, have been thought out so that time spent indoors provides an equal effect of relaxation. In short, everything has been considered to ensure the stay is as pleasant and unforgettable as possible. And for those who may, at times, want a little less seclusion from the outside world, they can rest assured, as there is access to the Blue Lagoon for a little more mingling with others.

At the Retreat, the Moss restaurant offers a great opportunity for gourmands, and the rooms offer splendid views of the lava fields or the hot water pools. In short, this is paradise!

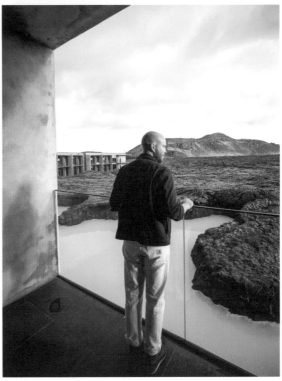

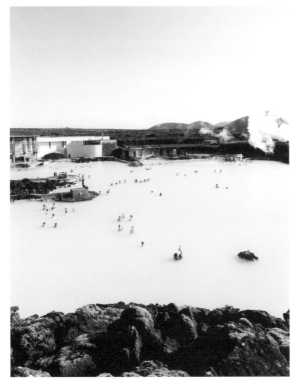

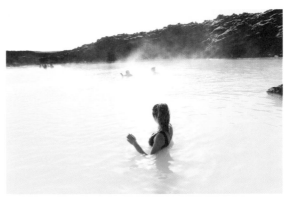

## ANOTHER WORLD

Away from civilization, a swim in the Retreat and in the Blue Lagoon opens the doors to another world, where the blue water evokes those of the tropics.

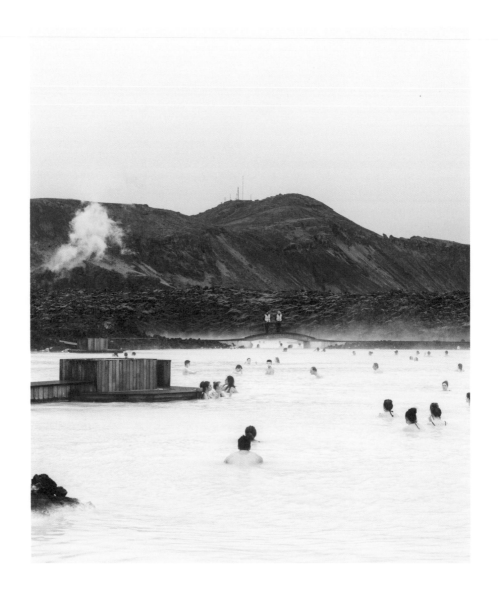

**ABOVE**

*In the Blue Lagoon, the warm waters are rich with silica and
get their color from microscopic algae.*

**RIGHT**

*In Svartsengi, drilling to create a geothermal power plant has released
incredible waters, benefiting the Blue Lagoon.*

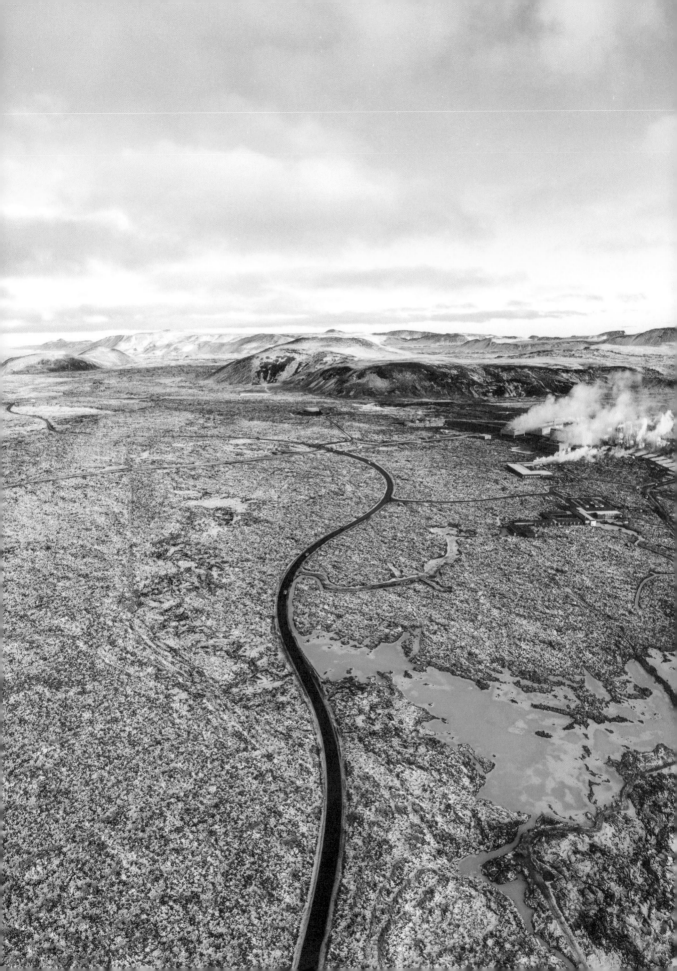

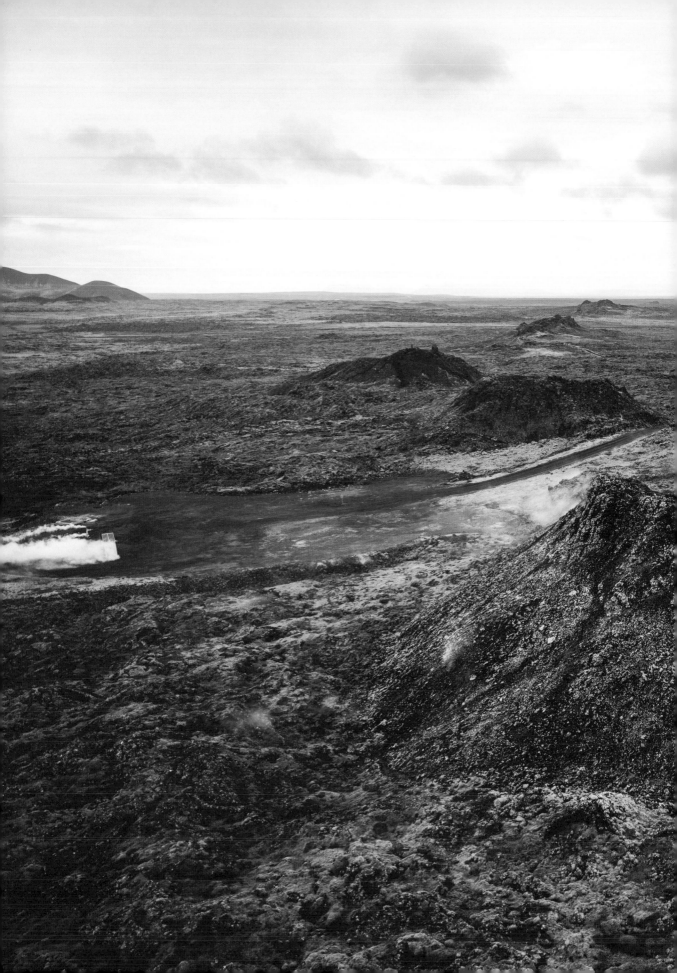

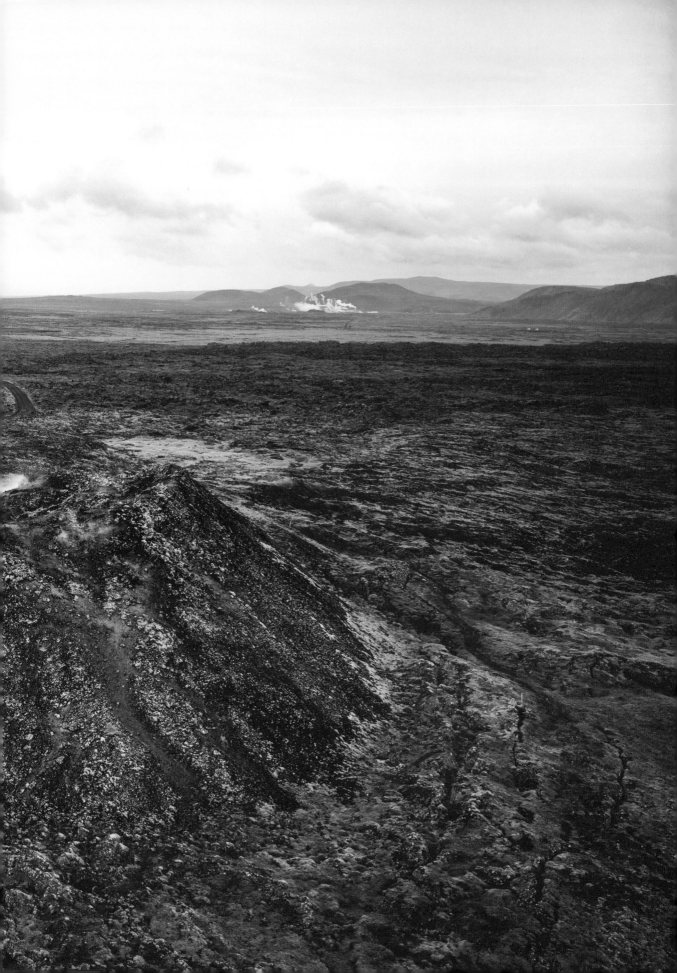

P. 250-251

*Scientists have learned that the alignment of the Eldvörp craters were caused*
*by the volcanic fissure vent located on the mid-Atlantic ridge.*

ABOVE

*Sulphur and its brittle structure are a typical feature*
*of geothermal sources.*

RIGHT

*View of Lake Arnarvatn. In the distance is the larger Lake Kleifarvatn.*

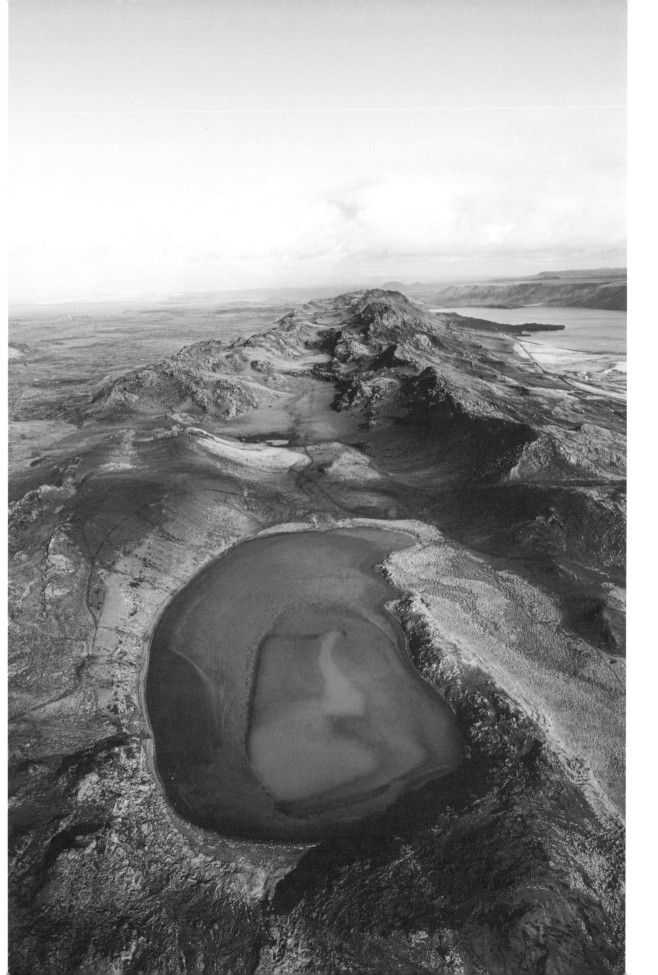

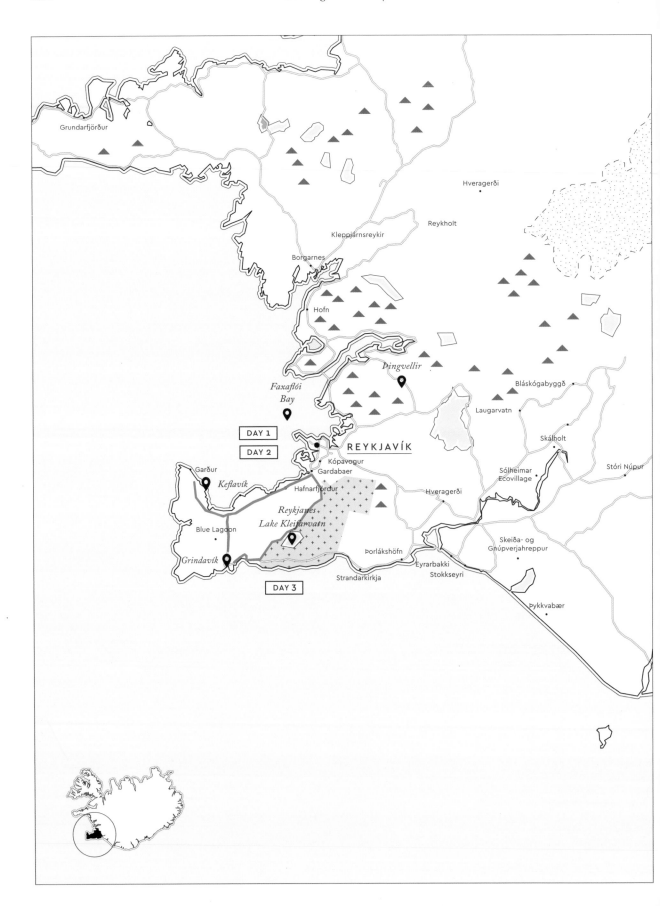

# 3 DAYS IN REYKJAVÍK AND REYKJANES

Village, town, capital, city-state—Reykjavík is a little of each of these all at once. A still-young, vibrant metropolis, the city is the beating heart of Iceland and proudly displays its status as capital.

### DAY 1: REYKJAVÍK

The day can begin with a trip out to sea for whale watching in Faxaflói Bay with Mount Esja, an omnipresent table mountain very popular with hikers, looming nearby. Back on shore, discover the Harpa cultural center and concert hall, a true architectural wonder with its facade reminiscent of the basalt columns so present throughout the island's landscapes. Next, continue on foot to reach the Sólfarinn sculpture. Since being out at sea can make you feel a little chilled and increase your appetite, take a dip in one city's uncovered pools or in one of the small hot-water pools, as the Icelanders do, for a moment of relaxation. These many outdoor baths, heated by geothermal energy, are part of the Icelandic way of life; it's a transformative moment from which you'll emerge relaxed—and perhaps your skin feeling a bit softer. It's now time to enjoy some food and to sip a local beer in one of the many pubs in the city's center, such as Kaldi.

### DAY 2: REYKJAVÍK (EVEN MORE!)

Reykjavík's architecture is an eclectic mix of old with modern. Start your exploring at the Lutheran church Hallgrímskirkja, an unmissable landmark, at the top of Þingholt (Parliament) hill. From there, walk the narrow streets of the residential areas to Lake Tjörnin by the small park Hljómskálagarðurinn. You will discover that the Reykjavíkingar love statues, and you'll notice them here and there. The town hall houses a raised map of the island and is not to be missed. The Parliament House and its square are next door. Pass by the Catholic church and the lovely houses in Vesturbær then make a detour to the harbor, a new lively and attractive area around the Maritime Museum. Next head back to Ingólfstorg square and the shopping streets of Bankastræti, Laugavegur, and Skólavörðustígur. Highlight your stay with several other stops such as at the art gallery 18 on Hverfisgata; the Museum of Modern Art; the oldest black house in the city on Aðalstræti; or the Maritime Museum, the Sjóminjasafn.

### DAY 3: THE REYKJANES PENINSULA

Exploring the Reykjanes peninsula gives you the impression of being at the gates of a desert, but one of stark lava—steep, shaggy, mossy—located along the active volcanic rift. Walk along Lake Kleifarvatn and its móberg ridges chiseled by erosion to reach the bubbling mud pots of Seltún—so close to the capital and yet so far away. The road then passes through a series of lava fields and a few scattered craters to arrive at the village of Grindavík and the Blue Lagoon. Swimming is not required, but it's a safe bet you'll have a great time if you take the plunge. You can continue through increasingly lunarlike landscapes to another geothermal area in Gunnuhver, with its isolated lighthouse perched on its base and just a stone's throw from the Reykjanesvíti cliffs. Here you are on the point of the divergence of the mid-Atlantic ridge, which has just moved thousands of miles under the ocean. It's time now to head back to town—back to Reykjavík!

## BIOGRAPHIES

**Bertrand Jouanne** is French by birth. He fulfilled his childhood dream of living in Iceland, and for more than twenty-five years has been working there in tailor-made and adventure tourism and closely follows the changes in this country.

**Gunnar Freyr** was born and raised by Icelandic parents in Denmark. He always had a love for Iceland and a desire to live in his homeland. A self-taught photographer, he works with several local and international groups on photography projects ranging from landscapes to wildlife and lifestyle.

## PHOTO CREDITS

All photographs in this book, including the cover, are by Gunnar Freyr, except:

Page 19: AKG-images/Pictures From History, Page 102: Getty Images/Nick LaVecchia, Page 103, top: Getty Images/Cavan Images; bottom: Getty Image/Jennifer Adler, Page 171, top and bottom: Vesturfararsetrið/The Icelandic Emigration Centre, Page 235: AFP/DPA Picture-Alliance/DPA/Bernd Von Jutrczenka

---

HarperCollins books may be purchased for educational, business, or sales promotional use. For information please email the Special Markets Department at SPsales@harpercollins.com.

Published in 2022 by
Harper Design
*An Imprint of* HarperCollins Publishers
195 Broadway
New York, NY 10007
Tel: (212) 207-7000
Fax: (855) 746-6023
harperdesign@harpercollins.com
www.hc.com

Distributed throughout the world by
HarperCollins Publishers
195 Broadway
New York, NY 10007

ISBN 978-0-06-321194-0
Library of Congress Control Number: 2021049100
Printed in China
Third Printing, 2023

General manager: Emmanuel Le Vallois
Editorial manager: Valérie Tognali
Editor: Franck Friès
Artistic director: Sabine Houplain
Artistic creation and layout: Bureau Berger
Proofreading: Mireille Touret
Manufacturing: Rémy Chauvière
Photography: Colorway